PRAISE FOR PROFESSIONAL POKER

"Most people think that in order to play poker professionally, you just need to be a great player. Mark Blade shows you how much more to it there really is. This is the **best poker career guide ever written**, and if you're thinking about playing poker for a living, please don't quit your day job until you've read Mark's book. **"Professional Poker" is a must read** for anyone considering poker as a career."
> **-Lou Krieger**, author of *Poker for Dummies,*
> *Hold 'em Excellence*

"It is well-written, excellently organized, highly informative, very accurate, and **a needed addition to poker literature.**"
> **-Bob Ciaffone**, author of *Middle Limit Holdem Poker,*
> *Pot-Limit & No-Limit Poker*

"I've written many popular poker books over the years and I've read 400 more. Professional Poker by Mark Blade is **the best book on the subject of poker ever written.**"
> **-Ken Warren**, author of *The Big Book of Poker,*
> *Ken Warren Teaches Texas Hold'em*

"A sobering and refreshingly frank examination of playing poker for a living. Anyone who has the romantic impulse to make professional gambling a career needs to **read this book first -- and reread it for guidance** when the chips are down and up."
> **-Michael Konik**, FoxSports Poker Commentator,
> author of *Telling Lies and Getting Paid*

"If you're even considering making poker a career, **the first hand to play is to buy this book.**
> **-Greg Dinkin**, writer for "CardPlayer" Magazine,
> Author of *The Poker MBA*

PROFESSIONAL POKER

POKER

The Essential Guide To Playing For A Living

Mark Blade

www.MarkBlade.com

First Edition
Revised

BROWNFIELD
PUBLISHING

Brownfield Publishing

Contact Information:
info@BrownfieldPublishing.com
Toll-Free # (877) 257-1620
318 S. Sunset Canyon Dr.
Suite #101
Burbank, CA 91501

CONTENTS

About The Author

Mark Blade was the valedictorian of his high school, has a B.A. from UCLA and an M.B.A. from USC's prestigious Marshall School Of Business. After attaining his M.B.A., he did what any other young man who was highly-educated and hotly pursued by the corporate world would do. He spurned all job offers and decided to play poker full-time instead. Having made his living from poker for over 10 years, he decided to share everything he has learned from his experience so that others could enjoy the same dream life he has had.

Introduction

Before you get started, let me explain a couple things about the book and how it should be used. First, you can rest assured that every piece of advice you read in this book is advice that I believe in 100%. It is the exact same advice I would give to my mom or any family member who was interested in playing poker for a living. It may seem strange that I would even feel the need to profess my honesty to you, but the recent slew of erroneous poker information and advice that I have come across has made me desperately want to separate myself from these poker charlatans. When I see ads, even expensive TV ads, claiming that you can become a winning poker player after an hour of watching some video or after two hours of reading a book (with no other time or effort required after that), I almost get sick to my stomach. The most appalling thing is that I know these poker peddlers can't possibly believe in their own preposterous claims. C'mon, if it was that easy, don't you think everyone would be doing it? It isn't easy. But if you really love poker, you'll enjoy the hard work required to become a professional poker player. Personally, I would rather sell fewer books than give you a false impression of what it takes to play poker for a living, setting you up for likely failure. I couldn't sleep at night if I did that.

Although this book may seem especially geared toward someone who wants to play poker as a full-time job, it is just as beneficial to you if you simply want to play poker on the side for some supplemental income or as a second job. Actually, I suspect that the vast majority of my readers will use this book to do just that.

One chapter in this book, "How Much Money Do You Need? (Bankroll Management)," is very long. In fact, it is the most comprehensive and accurate examination of bankroll issues ever written. You may be tempted to just glance over it, and instead, spend much more time combing over every word in the chapter titled "How Much Money Can You Make?" I would much rather you did the opposite. While I understand that as a prospective professional player, you are going to be very interested in learning how much money you can make, knowing these facts will have very little practical impact on your own results. For example, you don't have to know how much money a doctor makes to become a great doctor. But knowing "how much money you will need" has a profound impact on your chances of having a successful career. In fact, once you have learned how to play the game of poker well, the only possible way that your poker career could be derailed is if you fail to read and follow the advice in this chapter on bankroll management.

Throughout the book I will occasionally use the word "luck" in the context of an idea such as "this or that is just due to luck." Or you can lose this certain amount of money "because of bad luck." Don't misunderstand me. I do not believe in luck as in some sort of cosmic force that causes a figurative halo or black cloud to hover over your head. When I mention "luck" in these terms, I mean random chance variance or mathematical fluctuations. Luck, as some magical force you can tap into, is something that the uneducated gambler believes in. If that is you, I hope that I break you of that notion by the end of this book.

One downside to a book like this is that it may attract some people who have compulsive gambling problems. Being a compulsive gambler actually makes it extremely difficult, if not impossible, to become a professional poker player. Think about it. A pro poker player needs to bet, call, raise, or fold because it is the strategically correct thing to do. A compulsive gambler craves action. He cannot control himself to be so disciplined in his playing decisions. The topic of compulsive gambling is dealt with extensively in the chapter,

"Avoiding Destructive Vices Including Gambling." If you suspect you may have a gambling problem or know someone who may have one, take the tests provided in this chapter to find out if this is the case. If you discover you do, in fact, have a problem, throw this book in the trash or sell it on eBay. I'm sorry, but a professional poker career is not in your future. Please seek some appropriate help before you wreak further havoc on your financial and family life.

One last note. In the interest of simplicity, I will not use "he or she" and "him or her" every time I'm referring to an unknown person. Because of traditional convention and the fact that most poker players happen to be men, I will just use "he" or "him." Do not mistakenly conclude that I somehow believe that women can't be professional poker players. Nothing could be further from the truth.

Even though I don't know you personally, I'm very excited that you are about to read this book. I spent a considerable amount of time, effort, and took great care in writing it. I had readers like you in mind every step of the way as I tried to think of the best possible advice I could give you so that you could become a professional poker player if you really wanted to be. I think you'll be pleased with the results.

Please visit me at MarkBlade.com so that I can give you updates to this book as necessary, and share valuable poker resources with you that can further assist you in your poker endeavors. I hope to meet you sometime at the poker tables.

Thanks,

Mark Blade

♦ ♣ ♥ ♠
SECTION 1
THE DECISION TO BECOME
A PRO PLAYER
♦ ♣ ♥ ♠

Section 1
Introduction

If a friend of mine asked me if he should become a professional poker player, my answer would be immediate and probably surprising to you. The answer would be no.

This is also the answer that I would give to anyone wanting to become an actor or a singer or a professional athlete. And if Tom Cruise, Madonna, or Michael Jordan took my advice, they wouldn't have the lives that they enjoy today. To become a professional poker player, you must have the motivation, determination, and love of the game that will not allow you to accept no for an answer.

If you asked a hundred pro poker players when they decided to play poker for a living, you might get a hundred different answers. Many stumbled into it. It was a cherished hobby for them, but then once, when they were between jobs or unhappy at work, they decided to give playing poker full-time a try and they've never looked back.

For every story like that, there are countless others that you never hear about. You never hear about them because they didn't work out. Those aspiring pros usually went broke and had to go back to the regular workplace with their tails between their legs. Most went broke because they were poor players, but many went broke because they didn't plan correctly. They didn't realize how much money they could lose in the short run. Not because of bad play, but simply because of bad luck. The shame of it all is that they could have had the poker career and lifestyle that they had dreamed of. It just required a little better planning and some vital information. Instead they are stuck in unfulfilling jobs, mistakenly believing that they just didn't have what it took to play for a living.

This section will help you to make a smart decision. If you decide to play full-time, you'll do so with your eyes wide open, knowing exactly what to expect. And you'll do so with an airtight plan to prevent you from the common missteps that prematurely derail otherwise promising professional poker careers. If there is one piece of advice that I could give you before you make this all-important life changing decision, it is this. Not only must you read this entire section, but you should read this entire book before you make your decision.

Chapter 1
Should You Quit Your Day Job?

Often when people get the poker bug, they can't get it out of their heads. It's hard to work at a boring job when you can envision the option of playing poker right now, this very second, instead. Fight those urges. You should not quit your day job until you have proven to yourself that you have what it takes to make it as a professional poker player. You must also be sure that being a poker player is really what you want.

There are common misconceptions that cause people to quit their day jobs prematurely. I'll refer to them here as "myths."

Quit Your Day Job Myth #1
"I'm a winning player. I could do this for a living"

First of all, just because you are winning doesn't mean you are winning enough to make a solid living. You may or may not be. This book will show you what you'll need to do to attain those winning skills. It will also show you if your current pace of winning is sustainable or possibly just based on mere short-term luck.

Another subject of scrutiny in this statement is the first sentence, "I'm a winning player." This isn't so much of a myth as it is a downright lie (or delusion) that people tell themselves. I'll surmise that for every 5 or 6 players that believe they are winners, only 1 actually is.

How can that be? Simple. People don't keep actual track of their winnings and losings. They remember the wins and forget about the losses. They forget about all the trips to the ATMs. "Where did all that cash go that was in my wallet this month?" They imagine that they spent it on other things, not primarily poker. Or they tell themselves that they really know how to play winning poker. Sometimes, however, they just choose not to for the fun of it. But if they played for a living, they would control themselves. Lies, lies, and more lies. There is only one way to know that you are a winning player. You must keep accurate records of every buy-in and cash-out

that you ever make at the poker room. On winning days and losing days.

This self-delusion is minimized for online players as their cashier history spells out the stark truth of their poker results. But it is only minimized. Some players would get perfect 10s for the mental gymnastics of their denial. "Those losses were just because of the tournaments I played. I'm a winner on the normal tables." Or, "I'm a winner at hold 'em, it's just stud and omaha that account for the losses."

But even keeping accurate records doesn't tell the whole story as you'll discover in myth #2.

Quit Your Day Job Myth #2
"I've kept accurate records and I've won $20 an hour for the last 40 hours of poker play. So I'm ready."

On the surface, this seems like a reasonable conclusion. However, the short-term effect that luck can have on your results is dramatic. Actually, this so-called "short-term" is much, much longer than most people realize. You will only start to see results that you can be sure are in the actual ballpark of your true expected average hourly rate after about 2000 hours of play. And even then, you won't be dead-on in your expectations. Don't get me wrong. If you are making 1 big bet per hour (for example, $20 an hour in a $10-20 game) after 500 hours of play, you are probably a $15 to $25 per hour caliber player. But if you want to be certain to a likelihood of 97% or more, you'll need thousands of hours of play. All of this may sound crazy to you, but it's true. So how does this affect your decision to quit your day job? To answer that, you'll need to read the entire upcoming chapter "How Much Money Do You Need?" In that chapter, I'll go into much greater detail on this short term luck effect, how it is calculated, and the practical implications of this information to you.

Quit Your Day Job Myth #3
"I'm a winning player on Friday nights so I'll be a winning player full-time."

Two issues are at play here. One is the fact that in many card rooms, the most profitable times to play are Friday and Saturday nights. This is when all the recreational players come out to play. If you are a $20/hour winner on Friday nights, you may only be a $10/hour winner on weekdays. This all depends on the card room dynamics where you play, but it is something to consider.

Also, a bigger issue is how you will play when the rent money is on the line. If you follow my advice in other parts of this book regarding bankroll management and how much money you need to get started, you should have all the breathing room you will need to avoid going broke. (Assuming, of course, that you play well enough to be a long-term winner.) But the simple fact is that some people play remarkably differently when they are playing recreationally with discretionary income from another job versus when they are playing poker as their one and only form of income. Playing with "scared money" may make you less aggressive than you need to be, or maybe the increased pressure will cause you to go on tilt. It is hard to know how this will affect you until you are in this position. But hopefully, just being aware of the possibilities will help enable you to keep yourself in check.

An alternate possibility is that playing with scared money will actually cause you to play better. Maybe you have a tendency to play too many starting hands. When poker is your job, you might have the fear of being broke as motivation to stay on the straight and narrow regarding proper poker strategy. But don't count on this being the case.

Quit Your Day Job Myth #4
"The grass is always greener..."

If your job is unrewarding in any way, you may imagine a poker career as the solution to all your problems. Maybe it is. But maybe it isn't.

Poker has the same drawbacks as many other jobs. You still have to put in the hours. Sure, they're a lot more flexible, but they are still necessary year-in and year-out. Also, if you don't love the game, it could become as much of a grind after awhile as your current job. Read the section of this book on "The Life Of A Poker Player" for more insight and a reality check on whether or not you will enjoy a poker career.

Your current job may also provide many benefits that you take for granted. Maybe you have free health insurance, a 401k, and a company retirement plan. You might have paid vacation and sick days. You probably at least get paid regularly for doing your job. How would you feel if you worked hard one day and your boss asked you to pay him instead? Well, that's basically what you'll have to do many days, weeks, or possibly even months if you become a professional poker player. Can you be happy with that? Sure, in the long run you might make the amount of money you desire, but will you feel satisfied coming home from work over certain spans of time with less money than you started with? You've probably already thought about the many upsides to being a pro player. Spend some time trying to think of all the downsides too.

Quit Your Day Job Myth #5
"Until I apply myself to poker full-time, I will never get very good at it. So I might as well take my saved-up bankroll and dive in head first."

If your current job allows you almost no free time whatsoever, there may be a slim grain of truth to this. But for the vast majority of people, you will be able to hone your poker skills and become a winning player in your free time before you quit your current job. Poker doesn't seem to be going away anytime soon. You will always be able to start your professional poker career next year or the year after that.

Be smart. Don't give up your day job, particularly if you have accrued career equity or company tenure that could be jeopardized should you leave your position. What if you discover you don't have what it takes or it's not as fun and exciting as you had imagined?

That would be a horrible shame. Think about it. Think about it again. And then think about it some more.

Quit Your Day Job Myth #6
"I can make more money playing poker than I can at my current job."

This may or may not be true. First, don't assume that you are going to win a $1 million tournament just because you see some amateur, who seems to know less about poker than you do, win one on TV. There is an incredible amount of luck involved in many of the tournament wins you see on TV, particularly the ones won by poker unknowns. Even some famous names that you see winning repeatedly could be having incredible streaks of luck.

That's not to say that you can't make a very solid living playing poker or even a small fortune. You can. And maybe the game of poker and the thrill of competing at it is more rewarding than any other career you could pursue. This is a valid reason for eventually quitting your day job and pursuing a full-time poker career.

But don't forget about the incredible fortunes that can be made in the business world. If you work at a big company, you might have a better chance of becoming a Senior V.P. and making $250,000 a year than you do of making $250,000 a year at poker. Most doctors and lawyers make more than most pro poker players. You could win the championship event of the World Series of Poker every single year and still not make as much money as many CEOs and not nearly as much as the most successful entrepreneurs in America make.

Actually, I have a theory that if you gave me this year's freshmen class from Harvard and had them all apply their intelligence and hard working instincts to poker, you would create a pool of very financially successful players. But their total income from poker careers would be less than if you had left them alone to pursue the other career paths they would have normally fallen into, even if they weren't allowed to take advantage of any family business connections.

What I'm trying to convey is that you should not pursue poker as a way to an easy buck. First of all, it's not easy. It takes a lot of study and dedicated work. You should pursue poker because you love the game. And if you do love the game, I mean really love it, then the hard work won't seem like work at all. It will seem like a fun challenge. You will not only be successful financially, but you will be more satisfied than you would have been with any other career, even if that other career could have made you even more money.

Chapter 2
Transitioning From Part-Time
To Full-Time Play

By reading the previous chapter, you've probably realized that I'm a big believer in playing poker part-time on the side before you quit your job and play full-time. There are typically two stages to a budding poker career.

The hobby stage is when you are first introduced to poker. You play in a home game or maybe you play recreationally in a local card room, during Vegas trips, or on the internet. You are probably an overall loser during this period as you play mainly by the seat of your pants or with a simple strategy that you learned from a friend or briefly read somewhere. You want to win, but you play with disposable entertainment money that you can easily afford to lose.[1]

The next stage is what I'm going to explore here. This is when you decide to take poker seriously. You want to win and you want to play your best. You'd like to become an expert. If you have aspirations of playing poker for a living (and I assume you do or you wouldn't be reading this book), this is the time when you must use your game as a testing ground for playing full-time.

Keep Accurate Records

The only way you can really test and grade your poker skills is by keeping accurate records. If you know how to operate a spreadsheet program like Excel, this will be even easier. There are also software programs designed specifically for keeping your poker playing statistics. This is the easiest way to keep your records. (Because these poker records-keeping software titles change so often and newer, better titles seem to keep popping up, I list the latest most preferred title(s) on MarkBlade.com. And as with all poker related items listed at my site, such as poker books, I have links to whatever discount deals I have found for them on the web.)

[1] At least I hope this is the case. If you are losing more than you can afford, you may want to skip right now to the later chapter, "Avoiding Destructive Vices Including Gambling."

However you keep track of your records, you must at least list the following:

- The day you played and where
- The number of hours played that day
- The limits played, such as $3-6 or $5-10
- The win or loss amount for that day
- The name of floor person on duty (you'll learn why in the chapter on taxes)

You should also write any notes that you have about that session. They could be anything from poker playing strategy notes to how you were feeling that particular day. Particularly when you are starting out or if you have a problem with maintaining discipline, these notes can be enlightening. So many players, who have a big losing session, think on the car ride home or after logging off from the computer, "Damn, after I lost that first $300, I really started to play like crap. I was calling with so many hands before the flop that I shouldn't have. And I was chasing every long-shot draw to the river. I probably cost myself that additional $600 just because of my bad play. I wish I could start the day all over again. I would play solid the whole way no matter what my luck was for that short period of time."

After a while, when you read back over your notes, lessons to yourself about maintaining mental discipline will start to sink in.

Other Records

Some people like to list what day of the week, what part of the day, or any other category they can think of to really keep track of the differences that these factors have on their results. That's fine. The more information, the better. But if you don't want to make this such a chore or you aren't much of a statistics fan, then only the first list of categories is essential. They will enable you to add up your total wins and losses over a time period and divide them by the total hours to give you a per-hour figure. What you should be shooting for per hour will be explained in detail in the chapters "How Much Money Can You Make?" and "How Much Money Do You Need?"

And remember – No Cheating Allowed! You could come up with a hundred excuses for why a certain portion of results or certain bad performing days shouldn't be included. But excuses won't pay your bills when you are playing poker as your sole source of income. While we're on the subject, making no excuses relates to your next goal during this testing phase.

Think Like A Pro – No Excuses

Although your skills will probably not yet be at a professional level, you can still think like a pro. What exactly does that mean? It means that you should play your "A" game – always. It doesn't matter that you don't know everything yet. You know a lot. You may have already read somewhere that you shouldn't play Q-10 from early position. So don't. Ever. You have to start taking pride in your game. Think of yourself as the professional player that you aspire to be.

Pros don't go on tilt just because their pocket Aces get beaten five times in a row. If a pro needs to go home at midnight, he doesn't play the hand that he's dealt at 11:59 pm just because it's going to be his last. And pros never try to get even. They just play their best poker every minute of every hour of every session that they play. They know that when they do this (which is the only thing they can actually control), the results will take care of themselves. The rest of this book will include many more ideas of ways to think like a pro.

Study The Books And Get Playing Experience

The rest of this book will also go into further detail on specific poker books you should study and ways to get experience. Use this time to study poker like medical students study medicine. And treat it as seriously as a medical resident treats his patients. Your financial life and dreams depend on it.

♦ ♣ ♥ ♠

Chapter 3
What It Takes To Become A
Professional Poker Player

There are many qualities needed to become a professional poker player. Some are related to poker playing skills and mental discipline. These won't be discussed much in this section as they are covered heavily in other portions of the book. What will be discussed here are other qualities which are just as important, but often harder to master for some people, as advanced poker strategy itself.

A Distaste For Common Gambling

It might seem strange that a book instructing you on how to play poker for a living would assert that you should not like gambling. But once I explain to you what I mean by this, I will assert that this distaste for gambling is the single greatest predictor of whether or not you have what it takes to become a successful professional poker player.

Let's not kid ourselves. Most people who love poker love to gamble. They love the excitement of the unknown outcomes and the vagaries of chance. Imagine you are standing in a casino watching from the sidelines as two Texas hold 'em tables are being played side by side. On one table is your friend, Gambling Greg. He is in the middle of a hand and the pot is huge. You peek at his cards to see that he is drawing to the nut flush.[2] The dealer slowly peels the river card off the top of the deck. Greg's breathing stops as his heart races. His fingers are crossed tightly as he prays for a lucky heart.

Just then you glance at the next table. Your other friend, who is Greg's twin brother - Smart Steve, is also in the middle of a hand with a huge pot. You can see his cards and see that he is also drawing to a nut flush. In fact, both tables have nearly identical board cards. Steve is also holding his breath and crossing his fingers. The only difference is that Greg is gambling and Steve is not. How can this be?

[2] The term "nut" or "nuts" in poker means the best possible hand considering all the possible hands currently available.

Distaste Distinction

It is because of one important distinction. A more accurate heading for this topic would have been "A Distaste For Long-Term Mathematically Unprofitable Gambling." Doesn't have much of a ring to it, does it? But it's a very important distinction. Show me someone who loves to gamble but doesn't appreciate the importance of having a long-term mathematical advantage and I'll show you a lifetime loser.[3] It's the difference between owning a casino and being the person who helped make the casino owner rich.

A professional poker player knows that when he sits down to play poker, his skills give him a mathematical edge over his opponents. He never checks, calls, bets, or raises unless he believes it is the long-term mathematically advantageous thing to do. A gambler checks, calls, bets, or raises for a whole slew of reasons, most of them revolving around the notion of "hoping to get lucky."

Getting back to your twin friends, let's look at their differences. Gambling Greg got to this point in the hand because he plays any two cards that are suited. Smart Steve played because his suited A-5 was in late position with a few callers already in and no raises before it got to him. Had he been in early position or facing a raise cold, he would have folded.

Greg also loves to play craps and roulette and bet on his home sports team. Steve gets a little ill at the idea of playing games like craps and roulette because he knows that the house has a mathematical edge over him. It's this same distaste for foolish gambles that enables him to always throw away his inside straight draws when the pot odds do not warrant a call. Greg, on the other hand, sometimes feels a gambling impulse to draw to unprofitable inside straight draws even when he knows from his brother's lessons that he shouldn't.

[3] There are rare exceptions to this such as lottery winners who don't gamble enough in their lifetimes to lose back their mountain of winnings.

This doesn't mean that Smart Steve doesn't feel a lot of excitement when he's waiting for that river card to determine the fate of this pot. He does. But in reality, it probably is kept in check a bit so as not to overwhelm his awareness of other important factors he needs to pay attention to.

Poker Pros Who Love Gambling

You may have heard about some professional poker players who also like to gamble on other things. This is true. Some pro poker players also count cards at blackjack or bet on sports or horses in a mathematically advantageous way because their expertise in these forms of gambling enables them to have a mathematical edge. But most pro poker players who gamble on the side do it for the same foolish reasons that your average gambler does. And guess what? They have the same results. Despite being lifetime winners at poker, they are lifetime losers at craps, roulette, slots, etc. It is just that they have the ability to allow their poker knowledge to override their gambling impulses so that they can make the smart strategic decisions necessary to win at the poker table.

Don't be misled by these examples. For someone with strong gambling impulses, becoming this type of player who can compartmentalize them or override them in a particular game (in this case - poker) is the exception rather than the rule. It is just that the pool of players attracted to poker in the first place is overwhelmingly made up of those with a *taste* for gambling. So these exceptions (the pros that play skillfully despite strong gambling impulses) are going to be a sizable representation of the professional pool.

Born Gambler Vs. The Monk

Let me put it another way. People often think that you need to be a gambler to be a great poker player. Actually, most successful poker players are winners despite their gambling impulses, not because of them. If a guy walked into my professional poker classroom wearing his lucky dice shirt and his royal flush tattoo and behind him was a Buddhist monk in full robe, I would immediately give the monk about a hundred times better chance of becoming a winning player than the born gambler.

So, if you want to have what it takes to become a professional poker player, you must paradoxically learn to control your desire to "gamble."

Be A Self-Starter

What it takes to be a professional poker player is often similar to what it takes to start your own business. You must be the type of person who doesn't need a boss to motivate you to get things done. Some people just aren't cut out for it. What if you found yourself next week without a clock to punch or a boss to answer to? Could you still get yourself out of bed every day if you really didn't have to? Just because your hours will now be flexible doesn't mean they'll be non-existent. Most professional players still need to put in roughly the same amount of hours as workers in other professions.

You also need to stay on top of your profession. Maybe your employer forces you to take "continuing education" or "ongoing training" courses to keep you on top of your game. Will you force yourself to read the latest poker books or articles or review lessons that you may have forgotten over time? Only honest self-reflection will give you the answers to these questions. Some people are more productive when they are doing things for themselves. Some are less. What type of person are you?

Discipline

This quality separates many would-be pros from the career of their dreams. If I had to bet on who had the better chance of succeeding as a professional player, I'd choose a player with discipline every time over one with great intelligence or an innate card sense. Don't get me wrong. To get to the very highest levels of success in poker, you need all of these qualities. But if you have discipline, you can work hard to drill into your head the proper poker strategy and make a nice living, even if you aren't a "natural."

When I mention discipline, I'm not just referring to the ability to control your impulses and play the best you know how. I also mean the discipline to work hard at your game. To review what mistakes you made during a session and learn from them. To give yourself

regular refresher courses on the game, including rereading many of the best poker books. You must also have the discipline to stop playing when you're tired, to switch tables when the competition becomes unfavorable, and to watch what you eat so that you don't get mentally lethargic. You must also have disciplined control of your finances so you don't blow your bankroll.

I could probably name a long list of areas related to your poker career where discipline plays an important role. If you struggle with discipline, get a handle on it before you even consider playing for a living.

Chapter 4
Does Age Matter In Your Decision To Become A Professional Player?

The answer to this question is no, yes, and maybe. How's that for a wish-washy answer? Let's start off with why the answer is no.

No, Age Does Not Matter

As long as your mental faculties are sharp, the cards certainly don't know if you are 21 or 121 years old. That's one of the great things about poker. It's the great equalizer. I've seen players in wheelchairs, burn victims, men, women, black, white, gay, straight, 7ft tall, dwarfs, and certainly I've seen people of almost every adult age at the table.

Many players don't even take up poker until they are retired. Don't believe the old adage that you can't teach old dogs new tricks. You can. As long as you have a willing attitude, you can read this book and the other poker strategy books that I'll recommend, and with the right amount of playing experience, you'll be playing poker professionally soon enough. In fact, I think that poker is one of the greatest vocations or avocations for older retirees.[4] It's a fun social outlet that keeps you active, especially mentally, and depending on your level of expertise, can provide at least some supplemental income.

Yes, Age Does Matter

It's a fact of life that our mental acuity can often decline in our later years. This may explain why the majority of major tournament winners and top-earning professionals are usually middle-aged. They have enough years of poker experience behind them to have really honed their skills, yet their mental acuity is still at its sharpest. I believe, however, that even with some minimal mental decline, a disciplined player can still earn a nice living at poker.

[4] Unless you are a poorly skilled player who loses more money than your retirement budget allows for.

The reason that an older player may not rise to the top of the tournament rankings may also have to do with physical stamina. Many older pros admit that they simply cannot play at their best for marathon sessions day after day as most of the bigger tournament structures require these days. If you are a cash game player, this isn't drastically important as you can just play for as long as you desire. But it still matters. Some of your biggest wins come when you are at a dream table of inept players. If they want to play all night, you stand to make a lot of money by joining them. Situations like this require stamina that may come easier to younger players.

Maybe Age Matters

Younger players can often make more flexible life decisions. If you are 21, you probably don't have any financial responsibilities beyond yourself. If you choose to play for a living full-time, you could afford to spend a couple of years making $20,000 a year at lower limit tables. Some players who are very slow learners or who suffer prolonged bad luck spells early on in their careers may need this additional time before moving up further. An older player may not have such financial freedom. He needs his current income to pay the mortgage, the kids' braces, college funds, etc. He may not have enough spare time to gain the needed experience to play winning poker, yet he can't cut down on his work hours without impacting his family's current living standards. He's stuck.

Chapter 5
Should You Play In Tournaments, Cash Games, or Both?

Personal preference has a lot to do with your decision. Many people love the heightened excitement of tournaments while others prefer the comfortable regularity of cash games. There are many factors to base your decision on. Here are most of the important ones:

Size Of Your Bankroll

As you'll discover in the upcoming chapter, "How Much Money Do You Need?," the amount of money that a winning player will win or lose in the short-run can have large fluctuations in cash games. In tournaments, these fluctuations can be even larger. In fact, the "short-run" in tournament results can be quite long lasting. This will prevent many professional poker players from considering full-time tournament play until they have built up a very sizable bankroll. Unless, of course, they don't mind the considerable risk of going broke.

Travel

While the travel aspect of following the major tournament circuit can seem fun and glamorous, it may not be all that it is cracked up to be. Initially, traveling the country and even the world can be a bonus for the pro tournament player. But the vast majority of players find it to be quite tedious after awhile. This is not unique to poker players. Most people who frequently travel on business from salespeople to rock stars come to the same conclusion. And poker players don't usually have road managers who plan their every hotel stay or arrange limos to pick them up and drop them off after each gig. If the allure of travel is the main reason you are leaning toward specializing in tournaments, please think long and hard about it.

Fame

No doubt about it on this one. If you want your poker skills to catapult you to stardom, then tournament play is your best option. If TV popularity continues, the most consistent poker tourney winners

could soon become household names right alongside sports stars.

Fortune

Many top cash game players avoid tournaments because they can make more money on average per hour in their high stakes cash games. If you have your dreams pinned on a huge payday, however, like first place in the World Series of Poker Championship tournament, then tournaments are probably for you. For example, you are never going to play in a cash game where the amount at risk is only $10,000 max over a few days and have any chance of walking away with multi-millions in your pocket. This kind of parlay can only happen in a tournament.

Regularity Of Winning

In line with the concept of bankroll fluctuations of cash games vs. tournaments is the notion of your earnings regularity. You will have much more consistent earnings in cash games. Most monthly or at least two-to-three month intervals will usually fall reasonably in line with what you would expect given your long-term per hour averages.[5] In tournaments, your earnings can be incredibly irregular. One big tournament win might compensate for years of losses. Along with the money management headaches this might cause you, there are significant potential psychological consequences. Can you deal with the prospect of losing your entire entry fee in the majority of tournaments that you play?

Consider if you're a typical tournament pro. You play in typical tournaments that payoff 10% of the entrants. If you are twice as good as the average player, you will still finish out of the money 80% of the time. If you play 100 tournaments a year and each tournament has 200 entrants, even being twice as good as the field, you should only expect to win one tournament per year. And that's just average. What if you have a streak of bad luck? You could easily go many years without a single first place finish. Or what if you play in tournaments that average 600 entrants? Now you're expecting to win

[5] Note that I stated "most" as there can be exceptions which will differ dramatically.

outright on average only once in every three years. And you could go decades without a win if you had some very bad luck. Of course, you would expect many in-the-money finishes over this time period, even with the worst of luck. But how will you psychologically handle not winning outright practically ever?

Here's a sobering thought. Think of whoever you consider to be the greatest tournament player in the world. Do you realize that even if this player plays in the WSOP championship event every year for the next fifty years and always remains at the top of his game, he will most likely never win it outright even once over those fifty tries[6]?

By comparison, the typical cash game pro can expect to walk away a winner from that day's play over 2/3 of the time. In many of these wins, you will also be the top winner from your table. Maybe the consistency of walking away a winner will be much more satisfying to you than the more dramatic, yet sporadic, wins associated with tournament play.

Caliber Of Competition

The formula for winning poker is fairly simple. Play against players who are worse than you. When deciding whether to play cash games or tournaments, this should be at or near that top of your list of factors. So where are you at a greater advantage, cash games or tournaments? It depends. Here are some of the factors that you should consider.

REASONS YOU'LL FIND A LOT OF BAD PLAYERS IN A PARTICULAR TOURNAMENT

Many Satellite Winners As Participants

Some tournaments have a large number of satellite tournaments that feed into their entry pool.[7] If you have a large percentage of satellite winners as entrants, you often have many players who are low skilled

[6] This is because of the very large entry pool for this tournament.

[7] A satellite is a mini-tournament where, for a smaller entrance fee, you can win the larger entry fee needed for the main tournament.

as they are usually low-limit players who are only in this expensive tournament because they got lucky and won a satellite.

Many of the bigger internet tournaments are like this, where most of the entrants jumped up from the lower ranks of players via satellites. You may even stumble onto unusual situations. A few years ago, Commerce Casino in Los Angeles had a promotion where anyone receiving a jackpot-style bad (extremely unlucky) beat would automatically win entry into an expensive tournament. You can imagine how this meant that many players from stakes such as $1-2 (who played like the average $1-2 player) were now playing in a high-entry tournament that they would otherwise never have dreamed of entering.

Low Buy-In Tournaments

You will have to decide for yourself if low limit tournaments are even worth your time, but I guarantee you that you'll find horrible players in any tournament where the entry fee is $100 or less. It's fairly obvious that the world's elite do not waste their time playing in these tournaments, so that leaves the rest of the lower level poker playing community gathering together to give you their money.

The Form Of Poker Is Very Popular

No-limit Texas hold 'em is currently very popular as that is the form of poker that all the poker newcomers are learning to play from watching it on TV. This often means that you will get large entry pools. You will also find some world class players among the entrants, but there are only so many of them to go around. The vast numbers of amateurs will often overshadow them by a large margin. This is true right now of the championship event of the World Series Of Poker. Despite most of the best players in the world being there, they are dwarfed in number by the amateurs. With the high ratio of bad to good players, it is a very attractive tournament for the tournament pro.

The one detracting factor to consider is that the larger the number of entrants, the greater your earnings fluctuations. So even though it might be much more profitable in the long run if you play in this sort

of tournament, you might not have a big enough bankroll to play where your earning fluctuations will be so unusually large.

The Form Of Poker Is Very Unpopular

It may seem contradictory to see this topic heading coming after the last topic, but this is also true. For example, take a game like lowball. It is rarely played anymore in most casinos, yet those same casinos may offer it as one of their tournaments during a month long series of tournaments. There usually won't be very many entrants, but some people will play in any tournament just because they were in town and wanted to play in a tournament that day. There are often players in a lowball tournament who have never even played the game before in their entire lives. Here's the catch. You probably haven't played it much either. So this is only advantageous to you if you happen to have an unusual amount of experience in a game that is not popular in this particular casino.

Tournament Popularity

Tournaments on the World Poker Tour or The World Series Of Poker or whatever tournament becomes popular on TV should always attract a lot of amateurs taking a long-shot at poker stardom. Players such as wall-street tycoons and movie stars come out of the woodwork despite the fact that they may have relatively little poker experience. Certainly nothing compared to a future poker pro like you. Again, this sort of tournament also attracts the best players. But this negative is more than offset by the positive of so many low-skilled amateurs being involved. Especially if the tournament has a large foundation of satellites feeding into it, you should always find an attractive situation.

The Second Biggest Tournament Going

Sometimes two fairly big tournaments will coincide with each other. For example, if a World Poker Tour tournament was happening in Las Vegas at the same time that a slightly smaller tournament was happening in Atlantic City, Tunica, or Los Angeles, you should think about playing in the smaller tournament. You will still be getting a large turnout of local amateurs and pretty nice sized prize pools, but you won't get all the world's elite players who most often gravitate to

the highest profile tournament currently being held, which in this example is the WPT one in Las Vegas. This is similar in reasoning to why the second highest limit game in your card room is often the most profitable. (More on this in the chapter on Table Selection.)

REASONS YOU'LL FIND A LOT OF GOOD PLAYERS IN A PARTICULAR TOURNAMENT

Very High Buy In

Here's a tournament you might choose to avoid. A few tournaments have entry fees starting at $25,000. If you look at the names on the entry list, you'll find a disproportionately large percentage of tournament pros. You could be in the top 100 of all tournament players in the world and still expect to lose money in the long run in a tournament like this. Do yourself a favor, take the night off.

Big Tournament With A Low Profile

Some of the major tournaments are widely known to the professional tournament players but not as well marketed to the average player. These usually have very few satellites or possibly none at all. They are not televised or part of any branded poker tour. Like the very high buy in tournaments mentioned before, these tournaments will have an unattractively large percentage of tournament pros. Look elsewhere for opportunities to play against more amateurs.

Invitation Only Superstar Events

Maybe after reading this book and really applying yourself, you will become one of the top names in poker. Why not, right? Recently they have been having a few tournaments with just about 8 or so top players duking it out among themselves. Some of these tournaments pay the players an appearance fee which might make it worth playing. But I know of at least one of these where they just decided to play for the sport of it with large amounts of their own money.[8] Maybe it was worth it to them for bragging rights purposes or maybe each one

[8] At least there wasn't a rake.

truly believed that he or she had an advantage on the field. But think about it. And this is a useful idea to take with you anytime you are evaluating your playing prospects. These may well have been the best eight players in the world. Yet on this given day, for maybe the first time in a long, long time, the eighth best player in the world had a negative profit expectation when playing poker. The 7th, 6th, and 5th players could probably expect to lose money in the long run as well.

Swallow your ego. Focus on your wallet. And always strive to play against players who are worse than you.

REASONS YOU'LL FIND A LOT OF BAD PLAYERS IN A CASH GAME

Tourists Are In Town

Many poker playing hotspots are in places where people vacation. Whenever tourists come to town in disproportionately large numbers for any reason, the poker should heat up.

The 9 To 5ers Are Off

Poker games will always be better when you have a greater proportion of amateurs vs. pros at your table. Most amateurs have to work for a living. So you will find more of them playing during traditionally non-work hours. This isn't rocket science. Cash games are best during weeknights, weekends, and particularly weekend nights.

You Spot A Fish

Here's an almost guaranteed way of knowing if a cash game is attractive. You've played with these players before and they've proven themselves to be bad.

Drunk Or Stuck

Sometimes later in the night or very early morning, you will find a table with players who usually leave much earlier in the evening.

The reason they are still playing is because they are stuck (down for the day and desperate to get even). Stuck players rarely play at their best and often play at their worst. A close cousin to the stuck player is the drunken player. These players also usually come out later in the night, but you can find them anytime. It may be sad that they're giving away their money like this, but what can you do? If they don't accept your offer to call them a cab, you can at least stack their chips for them… right on top of your own.

The Tournament Is In Town

When you were young, you probably got excited when the circus came to town. Now, as a cash game pro, you should get excited when a tournament comes to town. There is usually an influx of players and believe me, they aren't all world beaters. The other big plus is that they all spill out of the tournament room and into your cash games as losers. They are usually halfway toward tiltsville before they even sit down at your table. Remember, they came to the casino today with visions of tournament riches dancing in their heads. Now that their dreams are crushed, they attempt to win back their entry fees and then some in your cash game. It is like entering a casino where every single player is stuck. It doesn't get much better than this.

REASONS YOU'LL FIND A LOT OF GOOD PLAYERS IN A CASH GAME

The Stakes Are High

The stake level that you are playing is the single greatest determinant in whether you are more likely to find good or bad players in your game. Usually, the higher the stakes, the better the players.

The 9 To 5ers Are Working

This is the negative flipside to the previously mentioned notion.

Maybe You Should Play Both Tournaments And Cash Games

Probably the best option of them all is to play both forms of poker. The greatest advantage to this is that you can pick and choose the most profitable tournaments to play in and avoid the rest. Also, you won't get burnt out on the traveling aspect of tournament life if you don't do it so often. Plus, you will have the regular earnings that come from cash games to keep you afloat during long stretches of bad luck on the tournament side.

Many of the most famous names in poker do exactly this. It is also profitable to not waste your entire day if you should happen to get knocked out of a tournament in a very short time. There may be times when you are out of a tournament in less than an hour or two. You are still fresh, wide awake, and have the emotional control as a pro to let your tournament loss just roll off your back. So why not get some more profitable hours of play in on a cash game.

Then Again, Maybe You Shouldn't Play Both

Beside the bankroll limitation that might keep you from playing tournaments, there is another great reason why you shouldn't play both forms of poker. The reason is that you are not good at both. Many tournament pros cannot win at cash games, and vice versa. Uninformed players don't realize the many different skills required to excel in tournaments vs. cash games. After reading this book, you will know what it takes to excel at both, but maybe you don't want to expend the effort required to become so versatile. Also, some people, for whatever reason, just can't shift gears in the way you need to in order to win at both forms. If this is you, you may just want to pick one form only and specialize. There is no shame in it and your specialization should enable you to become even better at the one form than if you had to spread your study and playing experience time over both. However, the profit that comes from picking and choosing the best tournaments and best cash games amounts to the greatest profit potential of all for the versatile pro.

Chapter 6
Do You Need Expertise In
Games Other Than Hold 'Em?

The simple answer to this is no. With the current state of poker, you could make a nice living as a pro player while only knowing how to play Texas hold 'em. In fact, many successful pros today only know how to play Texas hold 'em. They would get crushed in seven-card stud, Omaha, or any other form of poker. But since there are so many hold 'em games available, it doesn't matter.

Specializing in one game will also enable you to become an expert at it that must faster. If you spread your playing experience equally among five different games, it might take you much longer to become an expert at any particular one. If I were designing an artificial intelligence robot and wanted it to have the best chance of winning the no-limit hold 'em championship of The World Series Of Poker, I would park him at a no-limit hold 'em game every minute of every day to learn optimal playing strategy.

That's not to say that there aren't any good reasons to learn to play other games well. There are. But I'd recommend you stick with hold 'em initially until you become an expert at it. After that, here are some reasons why I highly recommend you branch out and learn some more games:

Avoid Burnout

For many professional players, it becomes tedious to play the same game day-in and day-out, year after year. Playing a new game breaks up this monotony.

Have More Fun

This goes hand-in-hand with the burnout issue. Trying a new game is a lot of fun. It's a rewarding challenge to take on a new game and try to master it. No longer can you just sit back and coast, you are really engaged when you play a new game, which is very exciting.

More Table Selection Opportunities

Sometimes you may find yourself in a card room where the three hold 'em tables are full of rocks, but the stud table is teaming with fish. How much more profitable would it be to sit down at that stud game if you only knew how to play stud like an expert. Learn.

Tournament Advantage

If you specialize in tournaments, you may have to sit on your thumbs on the sidelines some days if the day's tournament game is not your specialty. How profitable would it be if you could be an expert at every tournament game offered throughout some of the longer spanning tournament series such as The World Series Of Poker. If you notice, many of the top names in tournament poker regularly win tournaments in a large variety of games. In fact, some individual tournaments are comprised of multiple games.

Another advantage to being an expert in games other than hold 'em is that in a month-long type series of tournaments, some players will try to play every day even if they don't know the game very well. You can use your lowball or stud high-low split expertise to crush these lowball or stud high-low novices.

High Stakes Mixed Games

If you ever graduate to the very highest levels of cash games, you will find that they are primarily played in rotation style. By this I mean that there are usually 2 to 5 pre-selected games that are played at the table. After a certain number of hands or sometimes it's every half-hour (or new dealer), you switch to the next game on the list. For example, it may go from Texas hold 'em, to seven-card stud, to Omaha, and then to lowball. Each for 8 hands. Then the cycle starts all over again. The games are usually chosen by the casino according to the tastes of their most frequent high-stakes players. Many large casinos stop offering Texas hold 'em as a stand alone game after around the $100-200 level. So if you want to play extremely high stakes poker, but aren't an expert in all of these games, you will probably lose your shirt.

Learn Universal Poker Skills More Easily

Different games stress different skills. For example certain concepts such as the importance of stealing blinds, position, getting free cards, calling, or check-raising may be stressed more in some games vs. others. But drilling the proper strategy into your head regarding these concepts will benefit you in all games. Maybe it won't be until you play seven-card stud and really think about when and why you should be stealing or defending the blind money (which for seven-card stud is in the form of "antes" and "bring-ins.") that you will apply the proper strategy in hold 'em.

What If The Popularity Of Hold 'Em Fades?

It probably won't happen overnight, but what if over the years Omaha becomes the more popular game? Or maybe something that hasn't even been invented yet. If you stay on top of all the various games, you will be ready whenever the popularity of one particular game begins to take off. Also, your versatility will make learning new games much easier.

♦ ♣ ♥ ♠

Chapter 7
Playing On The Internet

At the time of this writing, playing on the internet is extremely popular and growing more so everyday. But there are serious questions regarding its legality. International and U.S. courts have fought each other over the matter, yet many first world countries like England are making it completely legal. Within U.S. legal circles, many argue that the current laws on the books do not specifically outlaw online gambling while others argue that they do. So far, to the best of my knowledge, no individual citizen has yet to be charged with a crime because of wagering on the internet. But that's no guarantee that no one ever will. Perhaps you will be the unlucky first.

I hope that by the time you are reading this, more definitive rulings will be established and you will know if you're legally allowed to play online. In the meantime, you must decide whether or not to play. If you do play online, you will be far from alone. Vast numbers of U.S. citizens gamble regularly on the internet. Many recent winners of major poker tournaments won their entries through online satellites and readily boast of these facts without even a peep of response from anyone in the government. But if the legal uncertainty concerns you, I wholeheartedly recommend that you stick to brick & mortar, government-regulated casinos and card rooms.

Another serious worry is that the online casinos themselves (or other players) will somehow cheat you out of your money. There are many market force reasons to believe that this is not extremely prevalent. But if it happens to you, who cares whether or not it's prevalent? The best way to reduce your risk is to manage it. If you play online, don't leave more money deposited than you can afford to be stolen. If you have a big win, withdraw a large portion of it immediately so that it's in your possession. And if you believe you are losing more than your bad play or bad luck would probably explain, stop playing!

In the meantime though, I highly encourage everyone to call or write their congressmen or senators, asking them to legalize playing poker on the internet.

Now let's explore the many advantages and disadvantages of playing poker online.

ADVANTAGES OF INTERNET POKER

Deposit Bonuses And Other Promotions

Many online card rooms offer generous monetary incentives to players. These are often in the form of bonus money given to you upon signup or even every month if you deposit more money. Some sites offer frequent play gifts like books or clothes, or they may offer free or discounted entries into tournaments. Some poker promotion websites even offer "rakeback" for when you play at certain online poker sites. Rakeback means that you will be refunded a portion of the rake money you contribute at a particular site.

All these sorts of benefits translate into cold hard cash for the savvy player who keeps his eyes open for attractive opportunities. Who knows how long these will last? Internet poker business models are still evolving. But as long as they do, those who know how to work the system certainly stand to make more money than those who don't. Sometimes much more. MarkBlade.com has info on where to look for the best offers currently available.

No Tipping

Add up at least a couple of bucks per hour in tips over a year of regular playing and you've saved at least $4000. Wow! That's nothing to sneeze at.

Lower Rake

Many online casinos also have slightly lower rakes per hand than offline. This can really add up as well. Don't get confused by the fact that because online casinos deal more hands per hour than offline, your *per hour* house fees will actually be higher online. You are comparing apples to oranges. The only way to compare apples to apples is by comparing the average *per hand* rake.

Speed

On average, about twice as many hands can be played per hour online vs. live. Even a little more than double for split-pot games.

If all things were equal, this would mean that you could theoretically expect to earn twice as much per hour online for the same number of hours played. However, there are other factors besides just speed which affect your per hour expectations.

Accuracy

Online, dealers never flip a card over accidentally. They never push the pot to the losing hand by mistake without someone noticing. This happens more frequently than you think in brink & mortar casinos, particularly in split-pot games. No one accidentally reveals their hole cards to their neighbor. The cards are shuffled randomly instead of possible clumping that can occur with human shuffling.[9]

Convenience

What could be more convenient than playing in your house in your underwear? This also enables you to play when you only have a short amount of free time. Even if you lived in a casino, it would take you a while to walk to the poker room, signup, take a seat, purchase chips, and then cash out and walk back to your room. Online, all these actions in total could take less than a minute.

Table Selection

There is a huge selection of games online. All but the largest stakes are regularly dealt. And these games are available 24/7. If you aren't picky about your tables, the most popular online sites can have you seated and playing in usually less than one minute. Public card rooms can have waiting lists of more than an hour.

Play Multiple Tables Simultaneously

This is a unique feature that live casinos can never compete with. It also may enable your earnings per hour to multiply if you are skilled, or reduce your bankroll fluctuations dramatically.

[9] Yes, I realize that technically there is no such thing as a "random" shuffle, even by a computer. But it's certainly much more random (assuming it's programmed correctly) than it is with a human shuffle.

Let's assume for this explanation that you can win 1 big bet per hour at whatever stake level you choose to play. In the real world, to make $40 per hour, you would have to play in a $20-40 game. Online, you could play two simultaneous $10-20s or four $5-10s. Your bankroll in a $20-40 game would need to be 400 big bets or $16,000.[10] But if you made 1 big bet per hour in each of your four simultaneously-played $5-10 tables, you would only need a bankroll of $4000, not $16,000, yet earn the same $40 per hour. That's fantastic. Same reward, less risk. But playing four tables simultaneously at that expert level may not be doable for many players. Although I believe it is certainly possible for the very quick-thinking experienced player, at least at the lower limits. Also playing multiple tables enables some players to avoid the boredom that normally causes them to play too many starting hands in a real world environment.

Micro-Limits Available

It isn't economically feasible to have tables smaller than about $1-2 in live card rooms. Because of the fixed overhead, the rake would be so disproportionately large compared to the stakes that it would be almost impossible to win anything. Online they can have tables that are only 1-2 cents, or even free. This is fantastic when you are just starting to learn poker or even when you are just trying a new poker game for the first time.

Tournaments Can Have Enormous Fields And Small Buy-Ins

It isn't that difficult for a well-programmed site to handle 100, 1000, or even 10,000 entrants in a tournament. For a real-world casino to handle a tournament with 10,000 entrants would be a logistical nightmare. Large tournaments can be great for the pro as many of these players are almost certain to be lesser skilled. Also the parlay of entrance fee to payout is quite large.[11] Also, in brick & mortar card rooms, the tournaments must have decent sized entry fees or else they must end very quickly. It isn't economical for a tournament with

[10] You will learn much more about this in the upcoming chapter, "How Much Money Do You Need?"

[11] Of course, so is the expected variance of your results which you might not welcome.

a $10 buy-in and relatively small accompanying house fee like $1 or $2 to last even an hour, unless they wanted a loss leader to get people in the door.

Keeping Financial Records

Your total win/loss record is kept perfectly accurate by a review of your cashier history at each online site you play. If you have deposited $5000 over the past year with no withdrawals and your current tally is $2000, there is no deluding yourself with selective memory. You are a $3000 loser. Of course, this says nothing about your per hour rate which any aspiring pro should be tracking. But it is a great reality check for those who otherwise don't keep track of anything.

Keeping Player Records

Another great feature is that you easily keep records of your opponents' playing tendencies through the note-taking features on most popular sites. This information is very valuable. You probably won't remember anything about a player you've only played against for one hour sixth months ago in a real world casino. Online, your memory is instantly refreshed with the note you previously attached to this player.

DISADVANTAGES OF INTERNET POKER

Minimal Tells

There are some unique internet tells such as the use of pre-selected actions by players. For example, if a player checks instantly, you may read something into this, especially if the player always pre-selects the check option on hands that he will fold if bet into. But these few new tells that are unique to internet poker pale in importance to the vast number of tells you no longer can read from players. Just about every tell in *Caro's Book Of Poker Tells* by Mike Caro, along with any others you discover on players, no longer apply.

Reduced Importance Of Your Table Image

I think this is even more devastating to your earnings than the reduced use of tells. A lot of my profit comes from the table image I project. If people think I'm tight, I can pull off a bluff in the right situation. I purposely use subtle mannerisms in the way I bet, what I say, or even how I fake a facial reaction in order to illicit a call, fold, or even a bluff from an opponent. I believe this skill is greatly underestimated by many poker experts. It is also a skill that most experienced players acquire but don't consciously think about too much. It just comes naturally to you. Some psychology experts have asserted that 90% of communication is through body language. If this is even remotely close to the truth, imagine how much powerful communication you can do at the poker table to subconsciously affect your opponents' perceptions of you. And it is almost all lost online.

Less Memorable Impressions

Sitting at a table with someone in a real world casino and watching their faces and bodies can cast a powerful impression in your mind. When the bald, funny guy with the Irish accent, big nose, bushy eyebrows, and Rolex watch throws twenty hands in a row away before the flop, you notice it. When oreilly23 dumps the same twenty hands in a row away online, it may not even register with you. There are so many little things about seeing someone in person that enables your mind to make a quick memorable impression. You can even make a better-than-nothing assessment of how someone plays simply by the way they look or carry themselves when they sit down at the table. A dressed up tourist who sits down with a drink already in his hand is easy to distinguish from the regular pro. Just the way he asks for chips can tell you if he is a novice. You'd never know this online besides the tiny possible distinction you might make based on their username. Also, your opponents can make a quick memorable impression of you by the way you look or of how you play by the first few hands you show. If you are smart, you can figure out what these early impressions are of you and then use it to your advantage. Online, your opponents won't be observant enough for you to do anything sly based on your image.

Less Time To Study Competition

Many people play online for short sessions. They also jump from table to table much more frequently than in offline card rooms. These shorter playing durations mean that you get less time to study and evaluate your competition. Just as you get to know your opponent's playing patterns, he gets up and leaves. In brick & mortar casinos, the same players are often at your table hour after hour, which enables an observant player such as yourself to keep increasing your advantage over them.

Security Worries

Player collusion, while possible in live games, is probably much more common and easier to pull off online. Fortunately, most top poker sites are doing great things to try to thwart this. But their efforts can never be foolproof. I believe that most major online casinos are honest. Mainly because it is in their long-term financial interests to be so, just as it is with real world casinos. But until there is U.S. regulation, you will never be sure that some online casino isn't cheating you or isn't going to shut down at any time and take all your deposited money with them. As mentioned at the start of this chapter, if you play online, *you play at your own risk.*

Depositing Difficulty

Most poker sites have daily, weekly, or monthly deposit maximums, at least during your initial experiences with them. Also, there may be a procedural lag time in many of the ways you can deposit money with them. And your credit card company usually doesn't allow transfers to most sites. All of these hassles, besides impeding your efforts to play, impede your competitors from playing. This reduces many potential games from occurring that otherwise would have if depositing money was as easy as it is in real world card rooms. Imagine some guy who inherits a windfall and wants to play high stakes poker with it right now. If the local casino has a $100-200 game going, he can tell his bank to just hand him stacks and stacks of hundreds if he so pleases, and just walk right into the casino with them in hand, sit down, and blow his wad. If he wants to do this online, it's almost impossible.

Internet Connection Issues

If you have unreliable internet service, playing on the internet can be a nightmare. If it is just a cash game and you lose your connection, you will probably just lose your blind money (the small and big blinds that you already paid for that round) because you will be out for the "free" hands that you already paid for. Or you could lose a pot because although you will usually be treated as all-in, you may have otherwise made an additional bet that prevents someone from staying in and catching a miracle card that takes the pot from you. If you are in a tournament or satellite, you are usually just out of luck. What if you were near the payoff spots in a large tournament? You could get blinded off and just miss the money where your average expected finish would've been huge. What if you're playing in multiple satellites when you lose your connection?

I have a friend who claims he was in four $300 tournaments simultaneously when he lost his connection. An hour later when he got back online, he had been blinded out of every tournament. That's an expected $1,200 down the tubes if he's a break-even player, and even more if he's a winner. In a brick & mortar casino, short of a natural disaster or your own heart-attack, you will never be unexpectedly yanked away from your table.

Distractions

Although there are many distractions in live games, there can be even more at home. Phones ring, doorbells chime, or family members can loudly call out your name. You can watch TV, listen to the radio, or even surf the net as you play. It is very easy to let these and many other distractions affect your play. How can you possibly notice that riverjoe14 just bluffed for the third time in a row when you are looking out the window at your neighbor sunbathing in the nude? Try to concentrate on your internet poker play just as you would at an offline casino.

More Prone To Go On Tilt

I previously mentioned that the quick pace of games being dealt might reduce boredom and enable certain players to be more patient.

On the other hand, this speed of hands can cause some people to more easily go on tilt. Bad beats can come twice as fast or even eight-times as fast if you are playing four tables. This rapid walloping can make you feel like a boxer's punching speed-bag. Maybe you can normally avoid reeling from a bad beat in a real world table by taking some deep breaths. Online, you may not even blink when another bad beat knocks you down again so hard you can't recover. Of course, some of your competitors will also fall prey to this effect which evens the score a bit. But some won't. If you are prone to occasional tilt, online play will probably exaggerate this tendency.

Bad Players Give Up More Easily

This is just a theory of mine that may or may not be true. I believe that many bad players, who lose on the internet, immediately assume that they are being cheated, and then quit playing on the internet, possibly forever. If a bad player visits a real world casino and loses, he usually just chalks this up to bad luck. Remember, many, if not most, bad players don't really believe they are that bad.

These bad players also cannot delude themselves about their true monetary results on the net as the truth is right there in front of them in their cashier history. Even if they don't think they are being cheated, they may conclude that the competition is too tough online or that they are just unlucky online for some reason. All of these rationales will lead a bad player to avoid internet sites and gravitate toward brick & mortar poker rooms. That is why I believe that competition on the internet is actually a bit tougher than it is in real world casinos, although many people disagree with me on this.

Money Withdrawal Myth

There is also an interesting myth that may push some good players away from the internet as well. This myth that many believe in is that once you withdraw money from your account, the site operators rig the games so that you lose from then on. This is basically a punishment for your winning or withdrawing. The reason this myth started is because many people who have won money and then withdrawn some of it, have gone broke soon afterwards. But the reasons for this phenomenon are much more likely to be legitimate.

First, in regards to unskilled players, many will simply get lucky initially and have a win streak right off the bat. Then after they withdraw some money, their win streak ends and they lose everything. What's so unusual about that? They are *unskilled* players. Their luck was sure to run out soon anyways. As for skilled players, their withdrawal may very well have reduced their bankroll to an unsafely small amount. Maybe the $10-20 player had accumulated $8000. If he withdrew $6000, he would just have 100 big bets remaining. As you will learn in the upcoming chapter on how much money you need to play poker, this isn't nearly enough. People playing with 100 big bet bankrolls often go broke due to unlucky fluctuations despite their long-term winning expectation. But instead of blaming a too small bankroll, these players blame the site operators.

Some Final Thoughts

After reading all the positives and all the negatives, an obvious question you may have is, "So what's more profitable, playing on the internet or playing in a brick & mortar card room?"

How's this for an answer? It depends, and in some situations the jury is still be out.[12]

If you are very skilled at (or just want to play) one-table or multi-table tournaments year round and at all hours of the day, the internet is your only option. And, of course, if you don't live very close to a card room and much of your time would be spent on very long driving commutes to play in person, then, again, the internet is without a doubt going to be more profitable for you. Also, if you can continue to find very lucrative frequent play bonuses online, this can tip the scales significantly in the internet's favor.

But what if we compare them per hour of actual play? Here, it might depend on your skills as a player. If you are an expert at reading tells, then you may be able to make more at a brick & mortar card room. If you are capable of playing many tables simultaneously without a large drop off in your playing ability, the internet is probably going to

[12] Specific monetary figures on how much you can make per hour are detailed in the later chapter, "How Much Money Can You Make?"

be more profitable. If you are just a typical player comparing one hour of play at, let's say, a $10-20 table online vs. a $10-20 table in your local card room, it is probably going to be reasonably close, though the jury may still be out on which one is the winner.

The reason the jury is still out is two-fold. One is that internet play is still in its relatively early years. It is impossible to determine whether the breakdown of skilled players vs. unskilled players will be markedly different online vs. offline. If many skilled players start to embrace the profitability of multi-table play, this could really hurt your profitability online. Many of the previously mentioned pros and cons of internet play may also weigh in more or less heavily as time progresses. Another reason the jury is still out is that it takes a very long time to accurately assess your winning averages.[13] So although there are very many players who will attest that their results prove that the internet or the brick & mortar games are better, their results are not compiled over enough years of regular play to be statistically valid.

Preliminary Conclusions

So here are my conclusions based on preliminary evidence. It is close enough between the two that you should really just base your decision on personal preference. If you enjoy playing on the internet more, and are comfortable with its gray areas legality-wise, you should do so. The same goes for offline card rooms. There are many reasons why playing with live people right in front of you can be a much more enjoyable experience for some. And if you ever aspire to big poker tournament greatness, you should definitely play enough in the real world so that you can hone your skills on how to interpret body language and how to manipulate your own. Despite Chris Moneymaker's miraculous accomplishment of winning the World Series Of Poker in his first offline tournament ever, believe me, your chances will be much improved if you have more live playing experience than this.

[13] You'll learn much more about this in the upcoming chapter on bankroll management.

Chapter 8
Private Games

There are probably professional poker players who earn a nice living without ever stepping into a public card room. There are many advantages to playing in private games, but a lot of disadvantages too. Only you will be in the best place to decide for yourself whether to participate. When I mention "private" games, I'm mainly referring to home-type games without salaried personnel. There are also private "underground" poker clubs, like in the movie "Rounders," which some of these following points may or may not apply to.

ADVANTAGES OF PRIVATE GAMES

Sometimes There Is No Rake Nor Tipping

If you thought internet poker was attractive because you could save all your tip money, this is poker nirvana. You will pay a fortune over your poker career in house fees. If you play in a home game, especially among friends, there is often not a fee or expected tipping.

Get To Know Your Competition

Many private games have the same exact players every time you meet. This regularity can really give the more observant players, such as yourself, a great advantage. You will start to notice many finer points of distinction in your opponents' play. You will also know specifically how their game changes when they have been drinking a certain amount, or when they are up or down a certain amount of money.

Heavy Drinking

Many players in private games drink quite heavily. You will have a tremendous advantage over drinking opponents. No matter how much they (or you) think it doesn't really affect their play, believe me, it does. If you can get away with not drinking also, you will maximize your advantage. However, this may not be socially desirable to you. If you choose to also drink, do your bankroll a big favor. Take one sip for every two that everyone else takes.

If everyone can hold their liquor about the same, this will still keep you far ahead of the pack.

DISADVANTAGES OF PRIVATE GAMES

They're Often Illegal

This is something that you may not worry too much about. But I assume you're aware that playing poker for money, even small stakes among your friends, is illegal in many U.S. states. If you are hosting a game, welcoming people you don't know very well, and/or charging a fee for your services, you should be especially concerned. These actions will increase your chances of getting caught and prosecuted.

Stakes Often Not High Enough

You might be playing against very low-skilled players, but this won't mean much if you are playing for nickels and dimes. Your best days ever in a low limit private game might be just a fraction of what you can *average* per day in a public card room.

Regular Competition

A flipside to the advantage of having regulars as competition is that they get to know your playing tendencies as well. But your poker and observation skills should be so much better than theirs that the overall advantage will tip decidedly in your favor.

Social Pressure To Play Badly

Many home games are very social. People come to play. If you utilize your optimal professional style, you will be folding many of your hands on the first or second betting rounds. In many social circles, this may get you pegged as a buzz-kill or party pooper. Maybe you don't care if your friends criticize you for this. But you run the risk of not being invited back. You will have the best feel for what is required to fit in. One remedy is to just play all the hands that are close calls or maybe marginal losers. You will still come out ahead because of the added earnings you will have on your winning hands from playing against such unskilled competition.

Also keep in mind that when many players are entering every pot and sticking with their hands too long, many starting hands or early round drawing hands become profitable for you, even though they wouldn't be in a normal game.

Chance Of Getting Cheated Or Robbed

Public card rooms have significant security measures including armed personnel. They also have a long-term financial interest in providing a fair game for their customers. Because of this, you can usually feel pretty good about your chances of not getting cheated or robbed. Private games, on the other hand, can run the gamut from extremely safe to downright dangerous. You will have to use your best judgment to determine what kind of game you are playing in. Legendary poker players like T.J. Cloutier even have tales of Wild West style hold-ups at the tables of private games. Be smart. Never play in a private game that seems shady. There are too many safe and secure places for you to play poker nowadays that you should never need to put yourself in such peril.

Chapter 9
The Importance Of Game Selection

I'm convinced that two players of equal skill could have dramatic differences in their earnings simply because of game selection expertise. This difference could be as much as 50% or maybe even 100%. For example, one player who is capable of making $40 an hour if he utilizes expert game selection techniques might only make $20 an hour if he was extremely clueless or lazy about game selection.[14]

If your hometown casino only has one or two tables of poker going or you play in a regular home game, you might not have any opportunity to benefit from proper game selection. For everyone else, here are some things you should keep in mind.

Big Pots Don't Always Mean Great Tables

Most people think they practice good table selection simply because they keep their eyes open for the tables with the biggest pots. If you have nothing else to go on, this might be your best bet. But big pots are sometimes created because you have a table full of aggressive, but skilled players who like to raise a lot. This isn't a particularly profitable situation. If you recognize a lot of professionals at a table, you should probably avoid it.

Smaller Pots Can Mean Bigger Profits

A dream table to look out for is one where everyone is extremely passive. They never bet unless they have a strong hand and they never raise unless they have the nuts. Yet they call just about everything. Think about how great that situation is. When you have a strong hand, you always get paid off by multiple callers. Yet when they have strong hands, you know it and can get out cheaply. What would a table like that look like before you sat down?

[14] I'll use the terms "game selection" and "table selection" almost interchangeably, although poker linguists may quibble that "game" should refer only to the form of poker like hold 'em vs. Omaha while "table" should refer to the various tables available for each type of game in a given card room. But I trust that you'll follow me just fine.

It would have medium sized pots, probably smaller than your usual liking, yet many players holding their cards through the river.

Happy Campers

If you see a table full of smiling people enjoying themselves with drinks or laughter, this is probably a good table. People having fun play more. The flavor of the game becomes more like a friendly home game where everyone wants to be a part of the action. They don't mind giving you their money or at least they don't mind as much as unhappy people.

Players Who Love To Hold 'em

If you want to look for just one thing when you are evaluating your table options, it is this. You want a table full of players who hate to fold. Regardless of their playing styles, if they never fold, you can always make a killing. Some tables will have many players seeing the flop but then playing pretty good poker from then on. That's alright, but much, much better are those tables where players pay off turn and river bets with regularity. Cha-Ching!! You can back-up the Brinks truck if you find a table where everyone calls to the river.

Look For Fish, Avoid Fishermen

An upcoming chapter will vividly illustrate the powerful financial implications of additional fish (horrible players) or additional pros seated at your table. One of the most profitable skills you can acquire is a good memory of previous players you have encountered. No rocket science here. If you see many pros at a table, avoid it. And if you see a school of fish, knock over anyone in your path if you have to in order to be first in line.

Sometimes Less Is More

A common misconception by many players, even some pros, is that a higher limit game will always be more profitable. The upcoming chapter, "Is Poker Really Profitable?," will enlighten you to the fact that depending on the makeup of the competitors at your table, your expected results can vary dramatically.

Some $20-40 tables can be almost unprofitable while a nearby $10-20 table could be worth two big bets per hour. But you'll never know about this opportunity if you don't broaden your horizons and consider playing at a lower limit than you are usually used to.

How Do You Play Short-Handed?

Winning playing strategy is quite different between a full table and a short-handed table. If you don't believe you are very skillful or experienced playing short-handed, don't feel pressured to do so. If you think this short-handed situation may be very brief, you might consider playing a little longer in the hopes of keeping the table alive while you await more players. This may be a long-term profitable decision for you. But don't feel peer pressure by fellow players (or sometimes even by casino personnel) to continue. Unless you're a prop player specifically paid by the casino for this function, it's not your job.

On the other hand, if you have studied short-handed strategy and gained some necessary experience, seeking out short-handed tables can be very profitable for you. This is especially true when you are playing against others who aren't very familiar with short-handed strategy.

Game Selection Gaffes

Some players believe that a table with too many bad players cannot be beat. This is nonsense.[15] There are a few reasons for this misperception. One is that you will certainly have many more bad beats at this type of table and bad beats are usually memorable. But rest assured that your winning hands are going to get paid off so much more profitably that it will more than make up for these bad beats. Also, your biggest fluctuations will occur at crazy tables. Your all-time biggest one day losses will probably occur here which might make you immediately conclude that these games are bad for your pocketbook.

[15] *Side note to expert readers:* I'm aware of the theoretical concept of "schooling" but I believe it to be so rare, usually hand specific, and possibly undetectable as to when it is occurring, that it makes it basically impractical to consider when making your playing decisions.

But your biggest one day wins will also usually occur here and, again, these total wins will far exceed those losses. Another reason for the misperception is that you may not know the proper strategic adjustments required to play at a loose table. Also, you might get caught up in all the bad play at your table and end up playing poorly yourself. This is something you must guard yourself against, because if you can play properly, these tables can be a financial godsend.

Another inexcusable gaffe related to game selection is when you pick a great game and then sabotage it. The most common way that people sabotage a game is by chasing away the fish through ridicule. Another way is by trying to educate the other players at the table or show off your expertise. Players who do this, particularly those who ridicule bad players, are a disgrace to the poker playing profession. These topics will be covered in greater detail later in the book.

Table Hopping

If you are going to exercise optimal game selection, you are inevitably going to do some table hopping. By table hopping, I mean requesting table changes from the casino personnel and getting up and moving from one table to another more profitable one, possibly multiple times during a session. There are a few things to consider.

ADVANTAGES OF TABLE HOPPING

More Profitable Table

Obviously you are attempting to always be at the most profitable table that your bankroll will allow. All things being equal, moving to a more profitable table than the one you are currently at will be, guess what, more profitable. I'm sure you didn't buy this book for that brilliant insight, now did you. Here are some other reasons you may not have thought about.

Discount On Blinds

There is a benefit to table changes relating to the blinds. When your new table seat comes up, many card rooms allow you to play until you are about to pay your blinds on your current table.

Then, at the next table, you are usually allowed to come in "behind the button" which is just to the right of the button for only 1 big bet. This is quite a bargain. Normally when you sit out your blinds, you have to pay both the small and big blinds when you come in behind the button. This savings is so significant, combined with the fact that you are in second best position, that if it was always allowed (as opposed to only when you first sat down), I would never take my normal small and big blind. I would just sit those hands out, come in behind the button for only 1 big bet and laugh all the way to the bank. Well, when you table hop, that is effectively what you are doing. There are downsides however, which I'll explain later.

Establish Brand New Table Image

A fresh table image can be effective if you have been having bad luck at a previous table. This has nothing to do with luck, mind you, but just your opponents' perception of you and your "luck." If you have been losing, your competition is naturally emboldened. You cannot effectively bluff them as easily and they might even take profitable bluffing stabs at you that they would normally not have the guts to do. If, however, you have the good fortune to start off at the new table with a couple of strong hands right off the bat, you can parlay this perceived strength into profits by steamrolling over your opponents with properly timed bluffs and thin-out-the-crowd raises. You are able to do this because, although you are smart enough to know that there is no such thing as luck, your opponents are not so smart. They are shell-shocked by your strong hands and either believe you to be lucky or believe you to only play strong hands which, by chance, you seem to keep getting. This wind at your back can give great potency to your game. It can make a tremendous difference in your results, but is only made possible because of the strong table image you have acquired by way of your lucky fresh start at a different table.

Psychological Breath Of Fresh Air

Later in this book, you will learn numerous ways to stay mentally sharp while playing. It is difficult for many people to easily shake off the losses they are experiencing and not let them affect their play. A possibly successful technique for you may be to just switch tables. Those ugly faces which remind you of nothing but bad beats will not

be across from you anymore. Maybe you can put the losses behind you and feel like you're starting from scratch. Purchase a new rack of chips and imagine that you just arrived at the casino. Anything that can clear your head will increase your chances of playing your best.

DISADVANTAGES OF TABLE HOPPING

Acquired Knowledge Squandered

Probably the biggest negative is that you walk away from the knowledge you've gained about the players that you have been playing against. A lot of your profit comes from knowledge of your opponents' playing styles. This shouldn't be taken lightly. Even if the players are slightly worse at another table, you may be able to make more at your current table just because you've had possibly hours of observation of your competition.

Lost Time

A close second on the list of disadvantages to switching tables is that you may lose a bit of playing time. For example, if you go to your new table, you may find that you have to sit there for maybe seven or eight hands before the button passes you and you can come in behind the button. This could take as much as 15 minutes. That's a quarter of your hourly winnings down the drain. Even with the benefits of being able to avoid paying the small blind and enter with good position, it won't be enough to make up a quarter of your expected hourly winnings. This alone can often determine whether or not you should make a table change. If the decision is close to begin with, notice where the open seat is on your prospective next table and only take it if you'll be getting in soon. Of course, if the table is likely to be much more profitable, it will be well worth even the longest wait.

Fragile Table

When you switch, you may be put onto a table which doesn't have much of a waiting list for it. If that is the case, your new table may break up soon and then you'll be left twiddling your thumbs while you're waiting in a line to get back onto your old table.

Remember, time is money. Then again, maybe you'll switch to a table that remains intact even longer than your current one. The moral of the story is that you should get acquainted with the seating procedures at your casino. Notice which tables have waiting lists and how long they are so you can work this info effectively.

The Hassle Of Table Hopping

It might be worth a couple of bucks less an hour if you don't have to bounce around all day like a jumping bean. If it becomes a bit tiring, it could even reduce the total hours you end up spending at the casino which will make a bigger dent in your profits than the increased profits from the table changes will offset.

Table Hopping Reputation

Frequent table changers sometimes annoy people and can peg you as a non-recreational player. If people perceive you as a pro or a shark, they may tighten up around you which will reduce your profits. This is probably only a small concern but a bigger concern is that you might become known as the boy who cried "table change!" to casino personnel. They won't jump to attention if you are constantly bothering them with change requests. The next time you desperately need their help with a change to a dramatically more profitable table, you may be overlooked.[16]

SEAT SELECTION

What To Consider

Once you've figured out which table you want to play at, you may have the option of picking a particular seat if more than one is open. Also, when players at your table leave, you will always have the option of switching to that seat unless someone else at your table also wants it. If this is the case, then it depends on where you are playing as to who gets it. Some card rooms go by table seniority.

[16] The later chapter on "Tipping" will also address this issue.

Others just go by who asked for it first.[17] So ask as early as possible if you are in one of the latter card rooms.

Some poker experts, such as Mike Caro, have come up with very long lists of all the different types of players you should want on your close or immediate right at the table vs. those you want to have on your close or immediate left. Although these reasons are very valid and quite interesting, you don't have to learn them all for many practical reasons that I won't bore you with here. You only have to know the two most important ones. First is that very aggressive or loose players should be on your right. (There may be exceptions against certain pot-limit and no-limit players.) Second is that tight predictable players should be on your left. So if an opportunity arises, particularly to grab a seat where Mr. Happy Chips is on your right, you should pounce on it.

[17] I've never found a casino that gives dibs to the new player who hasn't even sat down yet.

♦ ♣ ♥ ♠
Chapter 10
The Long-Term Prospects
For A Poker Career

There are a couple of different aspects to this issue. One is whether or not your interest or desire to play poker full-time will sustain over a long period of time. That specific issue is dealt with later in this book in the chapter titled "Is Poker Still Fun When You Play It Full-Time?" In this chapter, we will only explore the question of whether or not you will be able to make a living at poker for decades to come if you wanted to.

If you choose to become a doctor, teacher, or police officer, I could guess with some certainty that there will be a need for your skills long into the future. But what about poker? The following three major factors will determine if profitable poker playing opportunities will continue in the future.

Legal Restrictions

The more that poker gains in popularity, the more it will be entrenched in American life. Politicians cater to voters. If most voters want legal poker to exist, it probably will. Certainly in Las Vegas, it is hard to believe that political will would change anytime soon and outlaw poker. And taking casinos away from Indian reservations might be even more politically unlikely. More casinos are gaining legal approval in America every year. As they become as much of an economic lifeblood to their communities as Las Vegas casinos are, it will be harder and harder to remove them. But there is always the possibility of a reversal. Fundamentalist Christianity is also growing more popular every year. Many Christian leaders preach against the vice of gambling. An organized effort by them could very well influence politicians to change their votes.

Currently, the most precarious poker situation relates to playing on the internet. Some U.S. politicians are trying to pass legislation that would definitively prohibit any wagering on the net. If interested poker players don't organize or voice their opinions loudly enough, this avenue of play could be shut down. That is at least legally.

The open nature of the internet might make it much harder to enforce any such laws.

All of these concerns should interest aspiring pros at least to some extent.

Poker Popularity

Maybe all forms of gambling will become perfectly legal someday soon. Maybe all you'd have to do is run a fair game and pay taxes and you could open up a casino in your backyard or basement. A casino could be on every corner. That still doesn't ensure that poker will be commonly played. The popularity of certain forms of gambling come and go. Or maybe the next big non-gambling fad will come along. They invented movies, then TV, and then the internet. Maybe they will come along with something new that is so fun and exciting, it will be the dominant choice for everyone to spend their leisure time on.

If you follow trends, however, you will conclude that poker is here for a long time. Many people who try poker easily get hooked on it. There are many recreational players who have been playing for decades. So it seems that it can sustain players' long-term interest, at least when played recreationally. Now that it is widely televised, it has become a life dream for many to win a large tournament. For the vast majority of us, who aren't likely to become sports stars, poker superiority is our only professional sport-type dream left. And it is available to just about anyone. It also has a great balance of skill and luck that entices people to think they can beat the game. And the fact is that in the short-run, at least, anyone can. To me, that is the perfect recipe for prolonged popularity.

Games Remaining Beatable

Of the three issues, this is the one that I probably think about the most. Not because I believe it to be the most likely culprit of a poker downfall, but just because I find it interesting theoretically. As you will learn more about in the upcoming chapter "Is Poker Really Profitable?," it is possible to be the best player in a poker game and still expect to lose money in the long run.

This is possible when the playing field is so level that the house rake supersedes any slight skill advantage you may possess.

Right now, there are more than enough unskilled players to go around, at least at most limits of play. Once you acquire the necessary poker skills, your advantage will be great enough to win money despite the house rake.

But will these favorable conditions persist? That is the question.

Pessimistic View

Some would argue that it is inevitable that poker games will get tougher to beat. As games such as Texas hold 'em are played by people year after year, their skills are bound to increase. The experts' skills will only increase slightly as there is less left to learn. This means that recreational players will soon play nearly as well as experts. When this divide closes, so goes poker profitability. The house will be the only winner. Everyone else will be losers in just slightly varying degrees from each other based on their small skill differences.

Two other likely reasons will account for most players' increased skill besides just longer playing experience. One is the availability of excellent poker literature (such as this book – toot, toot). As players read readily available poker books and magazines, and hear expert play commentary on TV shows, they will make great quick leaps in their skill levels.

The other reason is that as poker becomes more socially acceptable, the best and the brightest will be attracted. Many smart young people, who in previous years would have pursued careers as doctors, lawyers, professors, and business leaders, will now enter the poker world. Your typical poker table that used to be filled with dummies is now filled with geniuses.

Optimistic View

I happen to be in the optimistic camp believing that poker games will remain beatable for a very long time. First, I'll address the pessimistic arguments.

When new games are introduced to a community, the players are usually very inept at first and then improve. This is true. But I believe this happens fairly quickly and then tends to plateau at a certain level. Many experienced Texas hold 'em players have played ace-anything pre-flop for years and years and will almost surely continue to do so for the rest of their lives. There is a simple reason for this natural tendency to play poker badly despite any additional playing experience. It is more fun and exciting. Discarding many of your hands in the early rounds is boring for most people. If you crave action, you will usually play badly. Luckily, the majority of people attracted to poker craves action and probably always will.

When some of the first landmark expert poker playing instruction books came out, people feared that profitable poker was doomed. These valuable secrets were out of the bag and people were supposedly going to start utilizing them in mass. Well, it's now decades later and this still hasn't happened. Most people play poker without studying up first. Most people who buy poker books don't take the time to really read them. And most people who read poker books don't implement their strategy tips on a consistent basis for a number of reasons. You, of course, will be the exception. You will read this book and the other poker books I will recommend later and you will apply the lessons you learn. Don't worry about most of the other players. Believe me, they won't.

The prospect of a smarter pool of players entering the poker world is probably the most worrisome to me. I think this is true. However, the increased acceptability of poker that is attracting more smart players is also enlarging the pool of all players. The overall proportion of smart vs. not-too-smart players entering the arena might be reasonably close to the historically average breakdown. I do believe that as these smart players rise up in the limit ranks, however, there may be a negative impact at the higher limits. Maybe the $100-200 games and up, and/or the extremely high buy-in amount tournaments will be affected, which I believe is already occurring in the $25,000 buy-in tournaments. There may become a disproportionate amount of sharks without a large enough matching increase in rich fish to feed them. The chapter, "Is Poker Really Profitable?," may enable you to better see where my assumption stems from.

Even if a disproportionate amount of the best and the brightest did gravitate toward poker, there is always a counter balancing force in effect. If games stopped being profitable or were only marginally profitable for these super achievers, they would quickly drop poker and re-enter more lucrative fields. That's in their nature. So poker, I believe, will always provide a strong opportunity for a very good living. The $30 to $60 an hour caliber player will probably not be affected. Those who used to expect to average more than that may or may not be impacted, depending on if this purported disproportionate influx of sharks plays out.

The biggest reason that I am whole-heartedly optimistic about poker remaining profitable is because people love to gamble. When I first started playing poker, I used to foolishly worry that everyone would soon learn how to play better and I wouldn't have any advantage over them. I figured since I so desperately wanted to improve my skills, of course, everyone else must want to also. I couldn't imagine that people would be willing to continuously play in a low-skilled way that caused them to regularly go home as losers. But then I thought about it a little more. People play craps, roulette, and slot machines regularly. They don't seem to care that these games are long-term losers. People buy lotto tickets every week without blinking an eye. They don't care that these pay an average 50% return. Hey, they might get lucky! That's the same reason they will continue to play poker regularly for years and years. Sure, they will hope to win, but the majority of the time they will lose... to you.

Long-Term Advice: Have A Back-up Plan

There are three great reasons why you should have a back-up career plan if you become a professional player. One reason is that you could tire of playing full-time after years of it. The second reason is that I could be wrong about my optimistic viewpoint on the longevity of profitable poker playing opportunities. And the final reason is that you may lose your winning poker ways for some reason. The most likely reason for you losing your winning ways is that you turned pro too soon before you adequately proved to yourself that you had what it takes. (A mistake you will never make if you precisely follow the advice you will find in this book.) Another is that during your career you could have a prolonged bad luck streak

and don't have the recommended-sized bankroll to see it through, or the streak throws you for such a loop psychologically that your skills deteriorate into that of a losing player. (These are also mistakes that the lessons in this book will prevent you from making if you follow them precisely as I recommend.)

The great thing about poker is that if you do start to tire of playing it, it is an ideal job to have while you train yourself for something else. Your time is so flexible that you could easily take part-time college courses in any field you desire. Even online schools are becoming much more popular these days. If you played poker on the internet, you could play for a couple of hours and then attend class for a couple of hours. In your spare time, you could easily teach yourself computer programming or graphic design. The possibilities are endless. Remember that if you ever quit poker for whatever reason, you may have a hard time proving to many potential employers that your poker playing experience should mean something to them. If you develop some real marketable skills, you'll be in a much more secure position.

Recent experts have concluded that the average American entering the work place can expect to change careers, not just jobs, seven times during his lifetime. Get serious about a back-up plan from the very start of your poker career.

♦ ♣ ♥ ♠
SECTION 2
MONEY MATTERS
♦ ♣ ♥ ♠

♦ ♣ ♥ ♠
Section 2 Introduction

The entire topic of money as it relates to a professional poker playing career is probably the most generally misunderstood topic within the poker world. Amateurs often don't have a clue about how much money you can really win or how much money you need to play at certain levels. Poker experts, who are sometimes extremely smart about mathematical calculations related to these money matters, often neglect to analyze the practical implications these numbers have to your real world playing experience, particularly when discussing bankroll requirements.

In this section, you will find the most in-depth practical analysis of money matters for amateurs and aspiring, part-time, and full-time professional players that has ever been put into print. Many common myths will be dispelled and many truths will be elaborated on in a way that will enable you to most intelligently manage your playing career. This will not be a one-size-fits-all instruction. You will gain the necessary knowledge so that you can make your own money related decisions based on your life circumstances, risk tolerance, and long-term goals.

Most importantly, this section will teach you everything you need to know about managing a bankroll so that once you gain the expert playing skills required, you will never go broke. Many professional players in the past, who have had superior playing skills, ended up broke and had to give up their poker careers because they did not follow the lessons you will learn in this section.

♦ ♣ ♥ ♠
Chapter 11
Is Poker Really Profitable?

Here's a basic question that most people don't give enough thought to. The reason they don't is because people usually fall into two camps regarding their thoughts on poker. Camp one is made up of poker naysayers. They think that poker is a losing long-term proposition. They are usually averse to all forms of gambling, and frankly, I don't blame them. If you didn't know this, let me state for a fact that craps, roulette, and almost all slot machine gambling is a long-term losing proposition. These naysayers see poker and lump it right in with these games. And guess what? Most of the time they're right. For most people, poker too is a long-term losing proposition. If these naysayers had a friend who liked to play poker, they would probably be giving him good financial advice if they recommended that he never play poker again.

Now, let's discuss you. If you are reading this book, you almost certainly fall into camp number two. You are a poker optimist. You believe that poker can be profitable. You are right. It can be. But most poker optimists don't have a clue how to accomplish this. They play poker by the seats of their pants and scratch their heads year after year when they don't win. Even more advanced poker optimists, such as those who buy books such as this, don't always think too much about where their profits are coming from. They understand the truth in its simplest form, that poker is profitable because they play better than the other players at their table, and therefore they win money from these losers. That's basically true. But let me give you the advanced course. First a quiz:

True or False:

1. It is possible to be the best player at your table and still expect to lose money in the long run. (If you have read this book sequentially, I previously spilled the beans on this one.)

2. It is possible to be the second worst player at your table and still expect to make money in the long run.

Most people (even among those who would buy this book) would answer "False" to both of these questions. But the actual answer to both is "True."

If you got these answers wrong, don't feel too bad. You weren't that far off. If the questions had used "probable" instead of "possible," then "False" would have been the correct answer. But understanding the truth behind question #1 and #2 will help you to make the best judgment about whether poker can be profitable for you.

First question first. The reason it is possible to be the best player and still lose money is due to the house rake. If you were playing in a home game where no one took a house rake, it would, in fact, be impossible for you to be the best player and yet a long-term loser.

But let's get back to the world of casino poker. Imagine you are playing at a ten-handed $10-20 table where the casino takes $12 an hour from each player. Now imagine that everyone at the table is at least semi-skilled. Here is a possible way that things could go in an average hour before the rake is taken:

No Rake Taken

Player	Average Per Hour
You (#1)	Win $10
#2	Win $5
#3	Win $5
#4	Win $5
#5	Break Even
#6	Break Even
#7	Lose $5
#8	Lose $5
#9	Lose $5
#10	Lose $10

But remember, the house takes $12 per hour from each player. So now, after the rake, let's see how everyone makes out for the hour:

After Rake Is Taken

Player	Average Per Hour
You (#1)	Lose $2
#2	Lose $7
#3	Lose $7
#4	Lose $7
#5	Lose $12
#6	Lose $12
#7	Lose $17
#8	Lose $17
#9	Lose $17
#10	Lose $22

This theoretical example isn't that preposterous. It could easily happen. That's how powerful the rake is. Another way to think about it is that you are all playing with an 11th player. And guess what? This 11th player is the best player in the world! Not only is he the best player in the world, but he happens to follow you to every single table you ever sit down at for the rest of your life.

Thinking of the house rake as an actual player at your table is probably the easiest way to see where the money goes and how good you have to be to make a living playing poker. Let's look again at this $10-20 game. If you aspire to be a professional player, then you should expect to make about $20/hour in a $10-$20 game. (More about this in the next chapter.) And that is after the rake and tips. To account for tips, let's give our imaginary Player #11 an additional $30 per hour in winnings for a total of $150/hr (10 players x $12 each, plus $30 in tips).

Let's also try to replicate a typical real world breakdown of your likely competition. We'll have two pros (you and one other who is not quite as good as you), one semi-pro, a break-even player, three experienced small losers, two bad players, and one clueless fish.

Realistic Breakdown For $10-$20 Game

Player	Average Per Hour
House Rake (and tips) World Champion!	Win $150
You	Win $20
Other Pro	Win $15
Semi-Pro	Win $10
Break Even	Break Even
Small Loser #1	Lose $5
Small Loser #2	Lose $10
Small Loser #3	Lose $15
Bad Player #1	Lose $30
Bad Player #2	Lose $35
Fish	Lose $100

Notice a couple of important aspects of this realistic table breakdown. First, most players are losers. It's almost inevitable because of the overwhelming greatness of the house rake player. He absolutely dominates the table. You will often need to be the best or maybe of equal skill to the other best player at the table at these limits to make your desired 1 big bet per hour. Also notice what an impact the Fish has on everyone's results. If he leaves and a break-even player takes his spot, this table will go markedly south. He alone accounts for about $10 of each player's results.[18] When he leaves, you go from winning $20 an hour to $10 an hour. The semi-pro becomes a break-even player and the break-even player becomes a small loser.

Also consider how great it is to have multiple fish at the table. If two more fish replaced the semi-pro and break-even player, you could expect your profits to double. Also think about how tough it is to make money if the table was more loaded with skilled players. If a couple of pros replaced the Fish and Bad Player #2, you might find yourself in one of those weird situations where you are the best player at the table yet struggle to break even.

[18] This isn't perfectly accurate as the fish would not be losing on average the exact same amount to each player, but for illustration purposes, it's close enough.

What happens when the stakes are much lower like in a $1-2 table? First, the rake does not go down proportionally. The total house rake per hour at many casinos for $1-2 is about $75/hour. Even though the stakes are now just 10% of what they were at $10-20, the rake is a hefty 50% of what is was. Also, the tips aren't much different. Let's say $25 per hour instead of the previous $30. So our World Champion House Rake Player #11 is still making a staggering $100 an hour. You thought he dominated the $10-20 table with his $150/hr. At these lower limits, $100/hr is absolutely crushing the game. Here's a typical breakdown at these limits:

Realistic Breakdown For $1-$2 Game

Player	Average Per Hour
House Rake (and tips) World Champion!	Win $100
You	Win $5
Break Even	Break Even
Small Loser	Lose $2
Bad Player #1	Lose $5
Bad Player #2	Lose $8
Fish #1	Lose $10
Fish #2	Lose $10
Fish #3	Lose $15
Fish #4	Lose $20
Maniac #1	Lose $35

Take notice of how, at these limits, you are the only winning player at the table. It isn't just because the best players aren't attracted to these limits, although that is true. It is mostly because the proportionally crippling house rake (and even tips) will not allow for many winners at these limits. If the same exact ten players from the $10-$20 game all sat down here, no one would win. You are making about seven big bets per hour before the rake and tips. This is unheard of against the better caliber of players that populate higher limits. (Remember, we're talking about the <u>average</u> per hour. Of course, in any given hour you could easily win much, much more than 7 big bets, even at the highest of limits.)

Also notice how exceptionally bad the players are that play these lower limits. Sure they don't lose nearly as much as those bad players at the $10-20 table in real dollars, but proportionally, they are much worse.

Finally, let's get back to the questions that started off this chapter. Question #2 asked if it was possible to be the second worst player at your table and still expect to make money in the long run. It is possible. However, it requires higher limits. Here's an example of how this could easily happen using a $100-200 table. The house take is $26 per player for a total of $260 per hour. Add $80 per hour for tips and our House Rake World Champion Player #11 wins $340/hr.

How 2nd Worst Player Can Win In $100-$200 Game

Player	Average Per Hour
House Rake (and tips) World Champion!	Wins $340
Pro #1	Win $130
Pro #2	Win $100
Pro #3	Win $85
Pro #4	Win $75
Pro #5	Win $65
Pro #6	Win $60
Pro #7	Win $55
Pro #8	Win $50
You (2nd Worst Player)	Win $40
Fish	Lose $1000

Notice how at these limits, one fish, who loses five big bets per hour, can provide for nice winnings for the nine other players at the table. Although this table breakdown was specifically concocted to provide an example of how the second worst player could be a winner, this is not very far off from how a breakdown might typically look at this level of stakes.

The majority of players at these levels are professionals with just a couple of providers per table paying all of their salaries. You usually wouldn't see a fish who loses five big bets per hour at these limits, although you could.

More likely, you'd find two or three medium-sized losers who are paying off the six or seven pros or semi-pros. Notice also that even the best player at this table in not making 1 big bet per hour. At these limits, the competition is so fierce that no single player can usually ever stand that far above the crowd. Even ¾ of a big bet per hour is extremely hard to pull off at these limits.

Looking at this example, you might conclude that playing the highest limit you could afford is the most profitable idea. There are a couple of important issues to consider though. First, you will need a very large bankroll to even risk these waters. Much larger than you probably imagine. More on this will be covered later in the chapter "How Much Money Do You Need?" Also, many players who are winners at lower limits will be losers at these higher limits. For example, while you may be a $20 an hour winner at $10-20, you might not be able to break even at the $100-200 limit. That's how much better the competition is.

The Bottom Line

So is poker profitable? The answer, of course, is yes. But only if you are so much better than your opponents that your winnings from them can compensate for the guaranteed losses you are going to have to the house and dealer from the rake and tips.

How much better do you have to be than your opponents? As you can see from the various previous examples, you must be much, much better if you are playing low limits and only a bit better if you are playing higher limits. But the catch is that it is much easier to be better than your opponents at the lower limits than it is at the higher ones.

♦ ♣ ♥ ♠
Chapter 12
How Much Money Can You Make?

Professional poker players have average yearly earnings ranging from poverty wages up to millions of dollars in a great year. How much you can make will depend on a few things. The most important factor will be how good of a poker player you are. Another will be how hard you want to work. Other things such as where you choose to live and play, how much money you currently have to get started, how much money you need to live on during the initial stages of your career, and how much brainpower you bring to the table will all factor in as well.

I mentioned that some pros earn poverty level wages. Since to them, this is a viable option, they are technically playing poker for a living. Rest assured, however, that I expect you to make much more than this as a professional. If you graduate as a "C" student (the lowest passing score) from the imaginary school of How To Become A Professional Poker Player, I would expect you to make at least $20 an hour or $40,000 a year. A "B" student should make $30 an hour or $60,000 a year. And an "A" student should make $40 to $50 an hour or $80,000 to $100,000 a year.

Where it gets a little harder to quantify is for the "A+" students. These are people who can make from $100,000 to as much as $1 million or possibly more per year. The $100,000 plus per year crowd used to be a very small club. With the recent boom in poker popularity, however, it is getting much bigger. If you apply yourself, I mean really apply yourself, and have a fire burning inside your gut for poker, I don't see any reason why you can't enter this world. But having stated that, I will predict that due to hundreds of various personal reasons and excuses for not becoming the best players they can be, an extremely high percentage of readers of this book will never achieve this goal.

How about you? Do you really have what it takes to be the best you can possibly be at poker? Do you really want it that bad? Because dogged determination is absolutely required. I hope for your sake that you do.

I Can Make Millions!

If you have your heart set on making $1,000,000 or more a year, don't hold your breath. To do this in cash games, you are probably going to have to count on some things that are out of your control. Things like a Texas bank owner coming to town and blowing multi-millions at the table to you and a handful of the other top pros in the world. (This isn't hypothetical. It actually happened at the Bellagio in Las Vegas.) And to make a steady $1,000,000 plus per year in tournaments, you are going to have to count on tournaments being as popular, or even more popular than they are now, and you being at the very top of the food chain.

Although the following will delve into how much you can expect to make per hour in cash games or per tournament, the next chapter on "How Much Money Do You Need?" will explain how long it can take before your actual results match up with these expectations. Remember that even if you play at a level where you can expect to average, let's say, $50 an hour, the next stretch of so many hours might not exactly match that because of the short-term effect of luck on your results.

Expected Hourly Rates For Cash Games

Conventional wisdom, which is in fact fairly accurate for most games, is that a typical professional poker player can expect to make about 1 big bet per hour. So if a pro regularly plays $20-40 hold 'em, he can expect to make on average $40 per hour. But this does not tell the entire story. Lower limit games usually have a majority of players with poor poker playing skills. Higher limit games usually have a majority of highly skilled players. In any public card room, it is a safe bet to expect that the higher you go up in limits, the greater the skill level of your average competitor. Can there be exceptions? Of course there can. Maybe a group of high paid lawyers comes to town on vacation and they all sit down at the same high stakes table. For this brief moment in time, this $200-400 game could be easier to beat than the nearby $2-4. And home games can randomly vary depending on the selective pool of friends who choose to gather at any given time. But believe me, the vast majority of the time, the higher the stakes, the stiffer the competition.

This fact has common sense implications for your expected hourly rates. In lower limit games, you can expect to make a little more than 1 big bet per hour with your expert skill. In higher limit games, you can expect less. This is particularly interesting considering the contradictory effect of the rake in these various stake limits. Remember from the last chapter how the rake and tips in lower limit games are proportionally much higher compared to the stake limits than in the higher limit games. Even with the rake in your favor at higher limit tables, the impact from the increased caliber of competition is so great that it trumps it. So here is what you can expect to make at the various limits. Keep in mind, however, that these figures assume you to be an expert player. Many pros are great players, but not quite at that expert level. They still might earn a living at these limits by making three-quarters, one-half, or even one-quarter of what an expert can make.

The Actual Numbers - For Experts In Cash Games

Game Stakes	Average Winnings
$2-$4	$8 Per Hour
$3-$6	$11 Per Hour
$4-$8	$13 Per Hour
$5-$10	$15 Per Hour
$6-$12	$17 Per Hour
$8-$16	$22 Per Hour
$10-$20	$25 Per Hour
$15-$30	$34 Per Hour
$20-$40	$45 Per Hour
$30-$60	$60 Per Hour
$40-$80	$70 Per Hour
$50-$100	$75 Per Hour
$60-$120	$90 Per Hour
$75-$150	$105 Per Hour
$100-$200	$130 Per Hour

Note: All these figures already account for the rake or timed house charges plus the typical dealer tips you will be paying. So this is your actual "walk away from the table with this much more in your pocket" amount.

There are other factors that might affect these numbers a bit one way or the other. There might be communities where poker has just recently been introduced. For a short period of time, these areas can be particularly profitable as the locals are not very experienced players. There are also certain times of the year when certain poker communities receive an influx of less skilled players. For example, during holiday or convention times in Vegas. Or maybe when a big tournament takes place in Biloxi. These can present opportunities for better than normally expected returns. But generally, these numbers already account for the ebb and flow of good and bad playing atmospheres that you'll encounter in a typical professional poker career in the more popular poker playing centers of the world.

A Note Of Caution

A natural inclination for many readers is to see a figure like $60, $90, or $130 an hour and conclude that they are on the easy road to riches. It's not that easy. As mentioned before, many professionals never attain these higher ceilings of potential. It takes quite a bit of dedication and discipline, along with maybe a little inborn talent and intelligence to rise to the top. But if you really take your poker goals seriously, this is what you should be shooting for. Also, don't dare sit down at any of these high limit tables without first reading the upcoming chapter on how much money you'll really need for this.

No-Limit Cash Games

Most public card rooms, until recently, did not have no-limit cash tables. This is because the expert no-limit player has a great advantage over his competition. So much so that he could more quickly break his competitors and possibly deter them from ever returning. Casinos know that running customers off like this would severely affect their bottom line. However, due to the popularity of no-limit tournaments on TV, many customers have demanded no-limit cash games and most casinos are providing them. Pot-limit games (close cousins to no-limit) have already been popular in Europe for some time.

It is hard to state the expected hourly rates of no-limit for a few reasons. The blind structure can often be the same for two different tables but if the buy-in amount minimums or limits are still different,

then the stakes are quite different. Also, the playing knowledge and expertise of your competitors can vary widely from game to game, or region to region. Also the game is currently in a great state of flux. Many players are getting much more experienced at it because they can play it online and now regularly at many casinos. This is increasing the amount of no-limit experts which will hurt your expectations. On the other hand, some players who are brand new to poker are heading straight toward the no-limit tables because that is what they have seen on TV. These players are a real boon to your expectation. It is unclear how these opposing forces will shake out exactly. Because of all these reasons, the ballpark of expected hourly range is very large and so specific to your individual situation that I shy away from stating any specific figures. Suffice it to say that if your competitors are much less skilled than you, instead of just making 1 big bet per hour (or in the case of no-limit, 1 big blind), you can make several.

Expected Winnings For Tournaments

In the same way as "1 big bet per hour" is a generally accurate simplification of how much you can earn in cash games, a "twice the buy-in" return on your money is the general rule of thumb for tournaments. This is also commonly expressed as 100% ROI (return on investment). That means that if the tournament costs $1000 to enter, a typical tournament pro can expect to win $1000 in profits. In other words, he pays a $1000 entry fee and cashes out a $2000 payout (twice the buy-in).

Accuracy Of Tournament Expectations

However, this twice the buy-in return may not tell the whole story. For years, the majority of poker tournaments played were limit tournaments (as opposed to no-limit). This twice the buy-in return figure was the typical return for a typical tournament pro playing regularly in these sorts of tournaments. No-limit is obviously different. Skill can have a much greater impact. Right or wrong decisions in no-limit can much more easily affect dramatic shifts in your chip count. Many pros profess to make as much as five times the buy-in in no-limit tournaments, or even more. But is this kind of return expectation accurate?

I have no doubt that these assertions are truthfully based on accurate tallies of their real results. And I have no doubt that no-limit tournaments could provide a better return than limit tournaments. But here's where the questions lie. First, as you will see in the later chapter "How Much Money Do You Need?" tournament results have enormous fluctuations. Getting an accurate mathematical read on how much you can really expect to average over the long run in tournaments can take over a 1000 tournaments. And this still might not be all that accurate. So it is like taking an election poll with a tiny sampling. The margin of error can be huge. Many of these pros may discover over the years that they are not enjoying the same level of success as they had during their initial years.

Also, no-limit tournaments have exploded in popularity with many competitors not having a clue about the different strategies required for no-limit play. As time goes on, these strategies may become much more commonly known which would limit the overlay that the expert would have over the no-limit tournament competition. So theoretically, even if a 5 times the buy-in expected return is currently applicable, it may not be in just a few years from now.

So here's what I'm comfortable telling you:

The Actual Numbers – For Experts Per Tournament

Type Of Tournament	Average Return[19]
Limit	Twice The Buy-In
No-Limit	2 To 5 Times The Buy-In

Major Determinant In Tournament Profitability

One concept you should be aware of is that the more tournament chips you are given compared to the blinds and the slower the stakes rise, the more profitable it will be for skilled players such as yourself. This is because the skilled player has much more time to shake more

[19] So for example, "Twice The Buy-In" means that for every $1 in entry fee you pay out, you will be awarded back $2 in prize money.

of the luck factor out of the equation. Still, however, tournaments are so short in duration that almost anyone could win one by just being lucky.

This is why poker tournaments (and poker in general) are so exciting for most recreational players. You could never take an unskilled golfer and give him even a million to one chance of beating Tiger Woods in a golf tournament. But you could in a poker tournament. In fact, the World Series Of Poker Championship has been won more than once by relatively unskilled players. And this is despite the fact that this tournament is played no-limit style with a long-lasting structure, both of which favor the pros over these lucky amateurs. Yet the amateurs still often prevail because of the luck factor.

The short-term luck factor is so great that you could never expect in the long run to win twice the buy-ins in one table tournaments (sit 'n go's) or satellites, except possibly for the smallest internet tables or the very loosest pre-tournament satellites you could find. Yes, you have a definite advantage, but there is a lot more of the "crap-shoot" factor in play. If you could easily make twice your entry fee on pricey sit 'n go's or satellites, all the best players would be playing 4 simultaneous $300 buy-in one-tables on the internet and averaging over $2 million a year. The ROI of a satellite expert is probably somewhere in the range of 10 to 50%, depending on the stakes and situation. For one table $1000 buy-ins satellites, you'd be very happy with a 10% or 20% ROI ($100 or $200 profit) expectation. Depending on the competition, it could be more or even less.

The downside to the most profitable tournaments being much longer in structure is that they require many more hours of your time. Still, you should welcome the length because in most cases, your added profitability expectation should more than compensate for your additional time unless the buy-ins are very low.

OTHER TOURNAMENT CONSIDERATIONS

Tournament Fees

Some tournaments have higher house fees than others, even though you are contributing the same amount to the prize pools. For example, one may cost $500 (which goes toward the prize pool) plus

$25 (which goes to the house) vs. another card room which has a tournament for $500+$50. Of course, the lower the fees, the more profitable the tournament is to you. Not included in this concept are the tournaments that add dealer tips into your fees. Since the tipping is pre-paid and shared by all entrants, you don't have to tip anything extra even if you win. Although the fees may now seem much higher than other tournaments, they are really in your benefit because the losers now pay the same tip amount as the winners. And you, as a skilled player, will be a disproportionate winner. The only way this could hurt you is if you are such a cheapskate that you wouldn't have tipped appropriately otherwise had you won. But I hope you are not that cheap as your career relies on fairly paid, skilled dealers.

Final Thoughts For Both Cash Game And Tournament Players

As interesting as all these numbers may be to you, they have limited usefulness in many practical terms. Don't get me wrong, how much you can expect to make per hour is extremely important for bankroll management as you'll learn in the next section. However, what great players can make in general, which is all this chapter has been about, says nothing specifically about you. Maybe you aren't a great player, and for whatever reasons, will never be. Who cares what others are making if they aren't willing to give you any of it?

I guess there is some general use to these numbers as far as career aspirations go. But as you'll learn in the next section, I would never recommend you quit your day job until you prove yourself to be a winner at the minimum acceptable level to you. There might also be some motivational usefulness to your career because if you were underperforming some benchmark, it might make you want to try harder to perfect your game.

But in general, what practical purpose do these numbers serve? Once you are making 1 big bet per hour at a certain limit, are you going to all of sudden stop trying to improve? You should always be striving to improve. The best players read all the latest books by the top poker authors. They are always thinking of better or more refined playing strategies. They are always trying to perfect their mental and emotional control regardless of their most recent results, and you should too.

Poker is also unique in that your results will not immediately and accurately reflect your playing ability. It's not like in business, where a company can implement a new marketing strategy and immediately see its effect on their bottom line. You could learn that you should fold ace-ten off-suit from early position. But when you implement this into your game, it is not like this week you will make $100 more than last week and therefore be able to conclude, "Aha! Folding ace-ten from early position makes me $100 more a week!" The long term is so long that it is extremely hard to tell what is what.

Moral Of The Story

What I'm really trying to convey is that you should not be overly results oriented. This chapter dwells so heavily on results and I fear that you will become too focused on them. This is one of the biggest mistakes you can ever make in poker. You should always just play the best you can possibly play and let the results take care of themselves.

Chapter 13
How Much Money Do You Need?
(Bankroll Management)

Poker is a game of both luck and skill. You should be very happy about the fact that luck is involved, as this is the reason that many unskilled players are attracted to the game. If skilled players won every time they played against unskilled players, an obvious result would occur. The unskilled players would stop playing.

The luck factor, however, has a large downside to it. It means that even if you are a great player, you can lose money, at least in the short run. In the long run, skill will eventually win out and ensure that you make money.

That leads to two obvious questions. How long is this short run or long run? And how much money can a great player lose in the short run just because of bad luck? This chapter will delve into both of those questions in order to figure out just how much money you need to start and continue playing poker for the rest of your career. Cash games and tournaments are very different in nature and therefore will require different sized bankrolls. If you are only interested in playing tournaments, you may want to at least skim over the concepts examined in the cash game topics, as some of them will also apply to tournaments.

What Is A Bankroll?

A bankroll is the money that you set aside exclusively for playing poker. It is not the amount you bring to the card room for any particular playing session, but the larger amount that needs to withstand any prolonged string of losing sessions.

When you become a pro and even when you just seriously aspire to be one, you should have a separate pool of money that you treat as your bankroll. It doesn't have to be in the form of cash in you wallet. You could have most of it in the bank in a safe liquid investment like a money market fund. But you need to be able to access it if necessary at any given time to fund your playing. You set it aside for nothing else but poker.

Note About Living Expenses

More about living expenses will come later in this chapter. Just realize that when I start running through numbers on how much you will need to play at certain levels, this does not include your living expenses. Depending on your needs, this will differ dramatically from reader to reader.

DING-DING-DING-DING-DING-DING!!!!!!

Sorry, I just hit the fire alarm bell because I need you to pay close attention to what you're about to read. Failure to understand everything that follows in this entire chapter is the number one reason skilled players go broke. It is not the number one reason poker players in general go broke. That is simply because they are bad players. But if you, who are either a great player now or will become a great player after doing everything I recommend in this book, ever goes broke, it is probably going to be because you didn't take to heart everything you are about to read.

When analyzed at its core, playing poker for a living requires two abilities. The first one is expertise in card playing. The second is expertise in bankroll management. Failure to master either ability can easily lead to ruin. The odd thing is that despite both these subjects being of such crucial importance, the majority of serious players only focus on the first one. They may study numerous books on playing strategy and then rely on just one simple sentence about bankroll strategy. It's no wonder that so many very serious and dedicated players still go broke. In fact, it's sort of sad that many great players, who tried playing poker for a living in the past, didn't have the chance to read this chapter first. If they had, they would still be playing.

Wait, I take that back. Who needs all that stellar competition at our tables? We're glad those great players went broke. But lucky you, your poker future is brighter than the sun because you have the tremendous good fortune of being able to read this brilliant, masterful, dare I say "work of genius" book.

Alright, alright, I'll turn the alarm off now. The ringing might have made my head swell.

Bankroll For Cash Games

There is a mathematical science that can be applied to figuring out the required bankroll for playing at certain levels. Precise formulas can theoretically determine your bankroll size based on your average winnings per hour and your usual result fluctuations per hour or session.[20] Your fluctuations (sometimes expressed in the mathematical measure known as "standard deviation") will depend on your style of play and the stake limits you play at.

To determine your precise required bankroll according to this approach, I will direct you to two books, *Gambling Theory & Other Topics* by Mason Malmuth and *Poker, Gaming & Life* by David Sklansky. As you will discover in the upcoming chapter "Study The Textbooks," these are two books you will want to read for their wealth of poker information even if you don't care about bankroll issues or specific formulas. The reason I won't examine precise mathematical formulas right here is that you will not need them for practical application. The reasons why you will not need them will be quite evident once you've read this chapter in its entirety.

300 Big Bets

What you will need as a starting point for your bankroll education is a general rule of thumb. This rule is that you need 300 big bets to play at a certain level to withstand the bad luck fluctuations that may occasionally occur, without any real risk of going broke.[21]

300 Big Bet Fallacy

Most poker pundits stop right there when talking about bankroll needs. You ask them how big of a bankroll you need to insure that you will never go broke due merely to bad luck and they will ask you

[20] You'll soon learn that these formulas, although theoretically valid, suffer greatly in their practical application.

[21] I believe David Sklansky is also responsible for breaking it down to this "ballpark" number, but as this "300 big bet" figure has become such a common poker reference point, I'm not 100% positive who first stated it.

what limit you play. You reply, "$20-40." They'll say, "Bingo, you need $12,000 exactly. End of story. Thank you for paying to attend my poker seminar."

But this 300 big bet figure just scratches the surface of what you need to think about regarding your bankroll needs. In the following topics, you will learn all the factors that will go into your decision. In fairness to David Sklansky and Mason Malmuth, I am not implying that they are among these pundits who think that 300 big bets is the end of the story. They also understand that there is much more to it than that.

To best understand your bankroll needs, you need to become a bankroll expert. It is probably easiest to become a bankroll expert if you first understand the flaws in conventional bankroll advice and the limitations of mathematical bankroll equations. Once you fully understand these flaws and limitations, you will be best equipped to understand the correct advice I will give you.

First, you may not realize what the 300 big bet figure means. It refers to the limit structures such as $10-20 or $30-60. So for $10-20, conventional wisdom says you need a bankroll of $6000 because 300 times the big bet of $20 is $6000.

Note To Readers

The following several pages will detail many "bankroll myths" and "bankroll equation limitations." For some of you who lack an interest in math, it may be a bit dry. However, it is very important, as it will prevent many of you from believing the countless erroneous notions that you may come across throughout your poker career regarding bankroll strategies. These erroneous notions can easily cause you to go broke, yet they are included in most poker books published today. If you don't learn about these myths and limitations, you will be very susceptible to believing these authors when they tell you that you can safely play at a certain limit with less money than I will recommend.

If you promise to follow my bankroll recommendations, and I mean 'spit in your hand right now and then press it onto this page so I know you are serious' promise, then I will accept if you just skip over

the following myths and limitations and go right to the topic, "Recommended Bankroll Strategies For Cash Games."

Fair enough? For the rest of you brave souls, read on right here.

Bankroll Myth #1
"300 big bets is a good size bankroll for everyone."

You need to realize that this ballpark number generally assumes you are a "1 big bet per hour" player. If you average half that amount (for example if you only make $10 per hour in a $10-20 game), then you need double the bankroll size (which is $12,000) according to these popular bankroll formulas. If you average one-quarter a big bet per hour ($5), you would need 4x that amount ($24,000). If you are an incredible player and average 2 big bets per hour, then you only need 1/2 of 300 big bets (in this case, $3000) to play these limits.

Bankroll Myth #2
"300 big bets is a good size bankroll for every 1 big bet per hour player"

Wrong. You also need to realize that this 300 big bet figure assumes that you play a typical pro style in terms of your fluctuations. There could be three different pro players who each average $20 per hour in the $10-20 games but have vastly different styles. Average Joe has a typical style and therefore requires the typical $6000 bankroll. Conservative Chris is extremely selective about his starting hands, playing in many fewer hands than Joe. Chris also almost never slowplays, and he raises often to thin out the field of competitors once he's in a pot. This style of play earns him the same $20/hour, but his fluctuations are much less per session. So he may only need a bankroll of $5000 or even less. Wild Wayne plays a lot of starting hands. He also likes to slowplay his strong hands in order to keep in more customers for bigger pots. His style of play also earns $20/hour in the long-run but he has wildly fluctuating sessions. He might need a bankroll over $10,000.

Bankroll Myth #3
"If I get the proper bankroll mathematical equation and insert all the required factors such as my average hourly rate and standard deviation (which represents the level of fluctuations due to my playing style), it will spit out a precise bankroll number that will insure I never go broke."

This is one of the most misunderstood concepts, even by many extremely smart poker players. They read the Malmuth, Sklansky, or other mathematicians' bankroll equations but fail to read the fine print. These recommended bankroll sizes do not guarantee to a 100% certainty that you won't go broke. They usually only assure you to somewhere in the high 90 percentiles, like 97% or 99%. What does this mean? Well, even if I could assume that every reader would use these formulas exactly the way they were designed, 1 to 3 out of every 100 of you would go broke, even if you all played winning poker with the recommended bankroll size for your table stakes and particular playing attributes.

That's not good enough for me. I want you all to have long lasting careers if you have the ambition to dedicate yourselves to acquiring the required playing expertise.

Actually, I'm very surprised that so many poker authors nonchalantly throw out this advice without highlighting this important risk. Imagine if a medical textbook instructed doctors to perform a certain surgical technique and then a footnote at the bottom of the page said, "FYI – When you perform this technique you will have a 3% chance of losing your medical license." Or maybe in a textbook for lawyers, "If you make this argument before the judge, you will win your case. By the way, one time out of a hundred, you will also lose your bar card."

Bankroll Myth #4
"Okay, I understand that I have a 1% or 3% (or whatever it is for this particular equation) chance of going broke. I'll take my chances."

This is something that is hard to automatically grasp for most people. Even most poker experts who understand the truth about bankroll myths #1-3, don't understand this important concept: If the mathematical bankroll formula says that you have a 99% chance of not going broke, it is assuming that you will never take money away from your bankroll. Ever! This, of course, has very little practical application as every pro player is going to need to take money away from his bankroll at some time to live on.

Maybe you can understand this best with an analogy. Imagine that your bankroll was represented by a stock chart. You and 99 other players are all 1 big bet per hour players with standard deviations that require 300 big bet bankrolls for a 1% risk of ruin. You are all going to be represented by a different stock. On January 1, your stock, and all of theirs, all went public at $300 per share. (In this analogy, the $300 price per share represents the 300 big bets.) The graph line that represents your stock may start to dip toward $200 or maybe it rises to $400. Most of the other 99 players' stocks are heading up but many are heading down. If your stock dips, it may continue dipping to $100 or even lower. But even the worst performing stock will usually have some up days. So even if you continue your overall losing, your line on the graph will not go down in a straight diagonal. It will have some upward bumps along the way too. Only one of these stocks will go all the way to $0 and go out of business. In other words, your company has a 1% chance of going bankrupt.

So what happens to the 99 lucky stocks that don't go broke? Some may go as low as $1 before they begin to climb back up. These 99 stocks that don't go to $0 will spike and dip from time to time throughout their existence, but all will have a long-term upward direction. After a long while, if your stock didn't hit $0, it never will. It is almost a mathematical certainty. In fact, it will have already risen above $300 per share and will never look back. After some time, every stock will be above $1000. After some more time passes, every stock will be above $5000, then $10,000. All 99 stock lines will keep

going higher and higher on the graph with a lot of peaks and valleys along this upward momentum track. The simplistic understanding of this fact makes even most professional players believe that 300 big bets will insure them a 99% chance of never going broke.

But there's more to this story. What if one day during this overall upward trend, your company decided to do something dramatically different from the rest of the stocks? It decided when it hit $2500 that it would pay out a cash dividend. All of a sudden, your stock is worth $300 again. All your competitors' stocks are so much higher in value than yours, that they will never hit $0. It's basically guaranteed by the poker gods themselves. But now you are at risk again. It is just as if you are going public again on January 1 for the first time. You have a 1% chance of going broke <u>again</u>.

Do you understand the analogy? Try reading it again if necessary. You must understand that every time you take money away from your bankroll and reduce it back to the exact amount that the mathematical calculation figured you'd need in the first place, you are putting yourself at your bankroll's mathematical risk of ruin <u>again</u>. If you keep playing at the same limits, not dropping down when things head south, you will most probably go broke (did you hear me? PROBABLY GO BROKE!) sometime during your career, even if every time you take money out of your bankroll you only do so when you can still leave 300 big bets still in it. This is something most poker pundits never mention. Not because they are hiding the truth from you. It's because they don't understand this mathematical concept themselves.

But don't fear. As you'll learn later in this chapter, there are strategies to practically eliminate this risk of going broke if you are capable of consistently playing winning poker. I'm not referring to "winning according to your short-term results" poker. I'm referring to "skillful enough to expect to win in the long-term" poker.

A note about the stock example: If you have a pool of one hundred players (or stocks) each with an individual and independent 1% chance of going broke, it will not always occur that precisely 1 does go broke. Sometimes 2, 3, or more will broke. Other times none of them will go broke. It is just that on average, 1 will go broke.

Bankroll Myth #5
"I've Lost 100 Big Bets, But Because I Started Out With 300, I Still Just Have A 1% Chance Of Going Broke"

To illustrate this point, let's go back to the stock example. When the 100 different stocks all went public at $300 each, they each had a 1% chance of going bust. But let's look a little closer at this 1% chance. If your stock goes to $200 right off the bat while another stock goes to $400, do you think you both still have the same 1% chance of going broke? Of course not. Your chance is now more than 1% and his is less. The lower your stock goes below $300, the higher your chance of going broke. In other words, the higher the chance of being that unlucky stock that hits zero. The higher your stock goes above $300, the lower your chance of going broke, or in other words, the higher your chance that the unlucky stock is going to be anyone but you. In fact, if it goes high enough, your chance of going broke will be, for all intents and purposes, zero.

The reason this concept is so often misunderstood is related to a common gambling fallacy. People believe that certain chance outcomes are dependent on previous outcomes. When they flip a coin, they believe that if tails has just come up six times in a row, the chance of it coming up a seventh time is less than the chance of heads. Why? Because they know it is rare for a coin to come up tails seven times in a row. But that is if you are considering the chances of that happening before the first flip. Once you get to the point right before the 7th flip, the coin has no memory of what it did before. You have exactly a 50-50 chance of it coming up heads or tails on this 7th flip.

This is the same with your bankroll. After you've lost 100 big bets, the cards do not remember this. They are poised to be dealt the same way they always are. Completely random and unknowable. So it doesn't matter if you've already lost 100 big bets. If you want your chance of going broke to only be 1%, you have to give your bankroll an outside infusion so that it is the full 300 big bets again. If you don't, you have a far greater chance of going broke than just 1%.

Bankroll Equation Limitation #1
Factoring Your Average Hourly Rate Into The Equation

Extremely interesting and practical mathematical analysis has been done by Malmuth and Sklansky into the short term effect of luck on your hourly earnings results. They have used mathematical formulas to demonstrate that the fluctuations caused by luck can be quite extreme for a much longer time than most players would suspect. So your average hourly rate, which you have calculated from your recorded playing records, can be quite inaccurate as a true gauge of your playing ability because it can take many years before you can trust these numbers as an accurate reflection of your ability and not just due to lucky or unlucky fluctuations.

This fact has practical implications for the accuracy of any bankroll formula. These bankroll formulas require you to input your average hourly rate into the equation. But the formulas I referred to in the previous paragraph have shown how inaccurate these hourly rates can really be![22] In the computer world, they refer to this as "garbage in, garbage out."

Bankroll Equation Limitation #2
Factoring Your Standard Deviation Into The Equation

Bankroll equations also require you to know the fluctuation rate of your results. This can be done through a mathematical figure known as standard deviation that you can learn how to extract from your win and loss records. But again, this figure needs a lot of time to insure its own accuracy just as your hourly winning rate does. Maybe it doesn't need as long as hourly rates do, but now you are adding another inaccurate factor into the bankroll calculation equation along with your hourly rate, compounding the possible inaccuracy.

[22] Unless they were compiled from many years of playing, but as I will soon show you, even then they might not be very accurate.

Bankroll Equation Limitation #3
Your Past Play Must Have Been Consistent

Let's assume that you have played for years and years and attained an average hourly rate and standard deviation that has basically shaken all of the luck factor out of it. You can trust that this really represents quite accurately your average over the past years of play. But wait a second. You still have a big problem. Maybe your playing ability today has changed quite a bit from your average playing ability over those years. Hopefully, it has improved. Maybe you are an "A" player now, but you are basing your bankroll calculations on some years that included "C" and "B" level play. That's not right. Conversely, you could have developed some bad habits over the years. Maybe you heard the advice that great players can profitably play more starting hands. Although this is true, *you* don't know how to play them properly. So your game has actually gotten worse over the years. You are basing your bankroll on your stellar past play when your current play is only mediocre.

Likewise, your fluctuation rate may change over time as your playing style changes. So you could be inputting a figure that fairly accurately represents your past, but not your present. Another reason that bankroll equations will not be perfectly accurate.

I recently read a book by a very popular poker author where he simply stated that if you have lost 300 big bets, you know for a fact that you are a losing player. That's just flat-out wrong! First of all, as previously mentioned, Bankroll Myths #1, #2, and #3 could all explain reasons why a winning player could lose 300 big bets over some span of time. But now you've just learned another reason. Maybe you were a losing player over the time you lost those first 200 big bets. But for the last 100 big bets, you have learned a lot from that playing experience. You have plugged the leaks in your game and are now playing winning poker. Unfortunately, bad luck hits and costs you those last 100 big bets. It's not hard for a great player to lose 100 big bets because of bad luck. Losing those 100 big bets <u>since</u> you fixed your game certainly doesn't prove you are *now* a losing player.

Bankroll Equation Limitation #4
Your Past Competition And Playing Conditions Must Have Been Consistent

For the sake of analysis, let's assume that you played at the same consistent level for your entire playing history. Even so, your competitors may not have. Maybe they've improved. Your bankroll calculation is based on the average way they played in the past. Not how they play now. Or maybe your card room management changed. They've had a certain rake amount for a long time, but just recently upped it. Your bankroll numbers are mainly based on the old rake. Or they had a dispute with their dealers and recently decided to fire many of the old guard for new, cheaper, younger dealers. Now you are getting dealt less hands per hour. Maybe the local economy has recently changed and the pool of recreational players don't have as much discretionary income. There are a number of other little changes that can impact your profitability but will never factor into bankroll calculations that only measure the entire span of time in the past with consistent weighting.

Bankroll Equation Limitation #5
You Must Play The Same Way In The Future

Limitation #3 referred to the fact that your current playing ability may not match your past. Limitation #5 refers to the fact that your future playing ability may change too. So even if your skills have been fairly consistent over your playing history enabling a "valid" bankroll computation, it might not accurately match your future caliber of play.

Let's get real for a second. The only time the issue of having an adequate bankroll really matters is when you are going through a losing streak. It is rare for a losing streak to not affect the caliber of someone's play in even the slightest degree. Even most professionals whom I highly respect, who pride themselves on always maintaining a very cool head while playing, are probably affected to some extent by prolonged losing. They probably play at an "A+" level while winning, at an "A" level when breaking even, and at an "A-" level when losing.

If they are ever down 200 big bets or more, they may drop down to "B+" or even worse. Still good enough to bounce back eventually with a large enough bankroll. But the bankroll equation has figured out bankroll requirements based on their average "A" level of play. And that is for a pretty disciplined player. Lesser players might really decline in their level of skillful play when in the later stages of a bad luck run.

Bankroll Equation Limitation #6
Your Competition And Playing Conditions Must Stay The Same In The Future

Same basic concept as in Limitation #5 except that you now apply it to your competition and playing conditions.

Recommended Bankroll Strategy For Cash Games

First, you will learn a three-part bankroll strategy. It is recommended for all players regardless of your playing ability or experience, although you will later learn some reasons why certain players will need to make certain adjustments. In theory, bankroll strategies are supposed to insure that you never go broke. But this obviously can't apply to everyone. If you are a losing player, for example, no bankroll is going to big enough. If you play long enough, you will always lose it all.

What if you don't know for sure if you are winning player or not? Remember that short term luck can cause winning players to sometimes have losing results, or vice versa. This also presents an interesting problem. You may be a winning player, in which case a bankroll strategy would be helpful. But you may not be, in which case the strategy doesn't really matter. That's why, after you learn the strategy, you will learn the distinction between the "proven" winning player and the "non-proven" player, and what it takes to become a proven winner. Only once you've become a proven winner, can you reasonably guarantee you won't ever go broke with a proper bankroll strategy.

As you now have learned, using mathematical formulas to calculate your required bankroll may seem good on paper, but can often fail in

real world practical application. However, they do have some value in that they produce a ballpark figure that we can use as a basis point. This brings us back full-circle to the 300 big bets per hour rule of thumb which will become a straddling point for these strategies.

There are three parts to this strategy:
1. Moving Up
2. Dropping Down
3. Taking Money Out

First, you will learn the basic tenets of these strategies. Then you will learn some additional bankroll facts that may change how you implement these strategies depending on your particular situation or goals.

Moving Up

This part of the strategy refers to how much money you should have before you move up in limits. Most poker pundits recommend that you start with 300 big bets for a particular limit. I disagree. If you read the previous topics on myths and limitations, you know why. Although there is no perfectly accurate number that applies to everyone, and you will adjust for yourself according to the "Bankroll Facts" that you will read about soon, here's my rule of thumb. You move up in limits when you have 400 big bets for the limit you are going to be moving to. So if you are currently playing $20-40, but want to play $30-60, wait until you have $24,000.

Moving Up Warning

It is possible that you can move up in limits and expect to make less than what you previously made. For example, maybe at $20-40, you can win $35 per hour in the long term. At $30-60, however, you can only win $30 per hour in the long run. The caliber of play is just too strong for you and your playing style doesn't adjust properly. You try to study more and keep gaining playing experience, but just can't improve. This can happen for different people at different levels. There is no shame in settling in at a certain level, even for the rest of your career, if you can't make any more at higher limits. It's really no different than professional sports. Some baseball players just can't hit

any better than .300 no matter how hard they try. Hey, you can still make a lot of money hitting .300 in baseball.

Dropping Down

Once you graduate to that higher level, you'd like to give it a long enough chance before you have to drop back down. Starting with 400 big bets will give you that chance. But when should you put your tail between your legs and go back down? I'll give you two options. Option #1 is if you think that you are not outclassed at this (let's say $30-60) level, but just must be having bad luck. Be honest with yourself and realize that it is a normal human inclination to blame bad luck rather than your own flawed play. But if this is truly your best assessment, you can play until you have 200 big bets at your current limit ($12,000). Once you get down to just 200 big bets, you must drop down to half the stakes. You'll be all the way back to playing $15-30 in this example.

Option #2 is if you worry that maybe you *are* a little outclassed at this level. Maybe your skills are not yet honed enough for $30-60 play. In this case, play until you are down to 400 big bets of the next lowest level. In this case, the next lowest level would be the $20-40. So you started the $30-60 level with $24,000. When you are down to $16,000, go back to the $20-40 games until you build up your bankroll again along with the additional playing experience and book study.

If there isn't a level that is exactly half the size of the current one you are playing, then forget about Option #1, and just utilize Option #2.

Dropping Down Warning

Most poker players, even many professionals, suffer from a potentially bankroll crippling disorder. Once they have climbed up the ladder to a certain level of table stakes, they cannot bear to step back down a rung. There is absolutely no shame in this. The shame is if you are too stubborn to take the step down and end up going broke because of your stubbornness. By the way, anyone who is really in the know regarding bankroll management will realize that dropping down in limits could have nothing to do with your playing ability, but just be due to bad luck.

Taking Money Out

At some point, unless you have unlimited money for living expenses set aside, you will have to take some money out of your bankroll to live off of. Anytime you have more than 400 big bets for the limit that you are playing at, you can take out the excess to spend or save or do whatever you want with it. I don't care. It's your money.

There is a good reason, though, to keep it in your bankroll if you don't currently need it for living expenses. This will enable you to move up to the next limit that much faster. As long as your playing skills keep improving in step, you will probably make more money at the next higher level. Hey, you can basically give yourself a raise as opposed to most of the working class who have to wait for their bosses or companies to give them a raise. Damn, I love poker!

Proven Winning Players

You may think you're a good player. You may have a history of wins. But how do you know that you really are a winner and not just lucky? Many players have thought they were winners because they got off to a fast start. Then when they start to lose, they figure it is just temporary bad luck. Then when they go broke, they can't figure out what happened. I'll tell you what happened. They weren't really proven winners in the first place.

How To Prove You Are A Winner – Method #1

Mathematical formulas can measure how much of your past results are definitely due to skill instead of possibly just luck. While these formulas are extremely helpful in some ways, like bankroll formulas, they do have some limitations, although not as many as bankroll equations. The bigger drawback to these formulas will be detailed later. For practical application, you only need ballpark ideas of what these formulas demonstrate. The following ballpark figures were derived from a formula in *Poker, Gaming & Life* by David Sklansky. – A book I highly recommend for numerous reasons.

If you have been playing $10-20 Texas hold 'em, what kind of playing results would you need to have in order to prove that you are

almost certainly in the ballpark of 1 big bet per hour caliber play ($20 per hour) at this limit? Any of the following would prove it:

- Average $40 per hour for the past 500 hours
- Average $35 per hour for the past 1000 hours
- Average $30 per hour for the past 2000 hours
- Average $25 per hour for the past 4000 hours

And, again, these just prove that you are in the ballpark of a $20 per hour player. You may just be a $16 to $18 per hour player, even with these seemingly very long-term results.

Also realize that for practical purposes, if you have been playing $5-10, just cut these dollar figures in half to apply it to your situation, or double them if you've been playing $20-40.

Things Worth Noticing

You should come to a few important conclusions from this information. Let's look at the fact that you need to earn $30 per hour for the past 2000 hours to prove you are in the ballpark of $20 per hour. In other words, after 2000 hours of play, 1 small bet worth of your results could be mere luck. In this case, you would be extremely fortunate to win $30 per hour for 2000 hours because you were only really expected to earn $20. If you did in fact just earn the $20 per hour as expected, you would be left wondering if you were a $10, $20, or maybe even a $30 per hour player. The only thing you could prove is that you were a $10 per hour player. And what if you were very unlucky over those 2000 hours and only averaged $10 per hour. You would not know that you were, in fact, a $20 per hour player. You might worry that you were just a break even player because that is actually all that you would have yet mathematically proved.

What if you were just playing on the side for 10 hours a week while you kept a full-time job? What if you wanted to know to a great certainty that you were capable of playing at least $20 per hour caliber poker before you quit your job. This seems like a reasonable request to me. But think about it. If you run unlucky, you might be stuck playing for well over a decade on the side before you could be sure enough to quit your day job. Wow! It seems crazy, but it's true.

This is why this method, although quite sound as far as accuracy goes, is rather impractical for making life and poker playing decisions most of the time.

Do You Just Have To Dive In?

So what have most professional poker players done about this? It's simple. They have thrown caution to the wind and just gone for it. They have quit their day jobs, and probably unknowingly, basically took a big gamble that they had what it takes. Some may not have had it, and only discovered this sad fact after suffering disappointing results. Others probably did, in fact, have it, or they just improved their abilities on the job. They either had large enough bankrolls to withstand the greater downside fluctuations that lower than 1 big bet per hour players can suffer, or they got lucky and never had a bad luck streak until they had fattened up their bankrolls.

All of this is just not good enough for me. That is why I have devised another method to proving for yourself if you have what it takes to expect to earn in the 1 big bet per hour ballpark.

How To Prove You Are A Winning Player – Method #2 (The Blade Method)

This is not intended as a replacement for method #1, but only as a compliment. It will help to shorten the very long time required to prove your results using method #1.

Maybe it is the fact that I have a Bachelor's degree in Sociology along with a Master's degree in Business Administration that has led me to want to combine a qualitative method to a quantitative one.

Let's say you've been winning $20 an hour in a $10-20 game over 500 hours. As you have learned, you could actually just be a break-even player (or maybe even a slight loser), who has just been getting lucky for the past 500 hours. Now imagine that we had a poker research school. We filled a classroom with 100 players who have all averaged $20 per hour in $10-20 Texas hold 'em games for 500 hours of play, each with identical fluctuation rates. How could we better sort out who really are the $20 an hour (or possibly more) caliber players and who are the short-term lucky ones?

I'd simply give them a poker quiz. Of course, I'd hook them up to lie detectors first. Here's what I'd ask:

1. Have you read *The Theory Of Poker* by David Sklansky?
2. Have you read *Texas Hold 'Em For Advanced Players* by Sklansky and Malmuth?
3. Could I give you a pop quiz question from any page of these books and expect you to give me the correct answer almost every time?
4. Have you memorized the starting hand recommendations of Sklansky & Malmuth?
5. Do you always follow them or do you stray because you lack self-control? (Of course, there are situational exceptions but you better have a good reason for those times you stray, and these reasons cannot include some unproven notion you have.)
6. Have you read *Middle Limit Poker* by Bob Ciaffone and Jim Brier?
7. Can you give the answer for each of their hand quizzes without looking at the answer first? (You are allowed to occasionally give a different answer than what they have given because they are not necessarily always right, but you had better have a well thought out reason steeped in poker theory for why you differ.)
8. Do you have a very firm handle on your emotions at the table as opposed to getting upset at bad beats and finding yourself not always playing the way you know you are supposed to play? (*If my book, Professional Poker 2: The Mental Game, is out by the time you read this, then you should read it first before you answer "yes" to this question.*)
9. Do you spend a significant time away from the table thinking through proper playing strategy?
10. Do you take good care of yourself so that when you play you are well rested, alert, and in a positive state of mind?

After they all take this quiz, we'd total up their scores and give them grades.

If you know anything about statistics and you understand the profit value of the poker strategy found in the aforementioned books, you will realize that there will be a strong statistical correlation between the test grades and these players' future results. It would take a large study over a significant period of time to figure out the precise mathematical weight to give to these test scores.

But since all these bankroll related formulas have their flaws, why not join the club with my formula as well. Here is my educated guesstimate of what this method could add to method #1. If you answered "yes" to all the quiz questions and you are being totally honest with yourself, then you can cut the previously listed times from method #1 in at least half and maybe even to one fourth.

Method #1 & Method #2 – Combined Results

Remember, you must answer every single quiz question in The Blade Method correctly to apply the following numbers to a $10-20 game.

You are in at least the 1 big bet per hour ballpark if you have:

- Averaged $40 per hour for the past 125 to 250 hours*
- Averaged $35 per hour for the past 250 to 500 hours
- Averaged $30 per hour for the past 500 to 1000 hours
- Averaged $25 per hour for the past 1000 to 2000 hours

You are in at least the ½ big bet per hour ballpark if you have:

- Averaged $30 per hour for the past 125 to 250 hours
- Averaged $25 per hour for the past 250 to 500 hours
- Averaged $20 per hour for the past 500 to 1000 hours
- Averaged $15 per hour for the past 1000 to 2000 hours

* The "125" hour figure applies to my more confident assessment of how powerful Method #2 (The Blade Method) is. The "250" hour figure applies to my more cautious assessment. Therefore, if you are a little more of a risk taker, you can still feel pretty secure going with the lower numbers (125 in this example), but if you want to play it extremely safe, I'd recommend the higher numbers.

Adjusting For Online Play

These hourly figures were derived for live play. If you play online, you will be dealt more hands per hour and thus can gauge your true playing capabilities sooner. So you can cut these hourly figures in half. If you regularly play two tables at a time, you can divide these hours by four. And if you 4-table, you can divide by 8.

Cruel Power Of Luck

As you've probably noticed from all these figures, luck plays a large part in determining how long it will take you before you can prove you are a 1 big bet per hour expectation player. If you are very lucky from the start, you can prove to yourself in a relatively short amount of time that you are a solid winner. If you get unlucky from the start, however, it will take you much longer. There is almost no practical way for you to get around this cruel effect that luck has on your ability to prove yourself as a winner.

Theoretically, you could make a judgment on how much bad luck you were having. For example, if you kept track of the odds of every drawing hand you ever held and then how often you completed those hands, you could determine, at least for that one portion of your game, whether or not you've been lucky or unlucky. If you've had 250 hours of very bad luck regarding your straight and flush draws, yet you still averaged $20 per hour, you'd know your chances were much greater of being a winning player vs. someone earning $20 per hour who had enjoyed drawing luck much better than average. You could also keep track of how many pocket aces, kings, and queens you were dealt vs. the total number of hands dealt and determine if you were having good, average, or bad luck in this regard. Analysis like this or of any other measurable parameters would be valid in evaluating your luck to at least some significant degree.

Although theoretically valid, such analysis is extremely impractical. Self evaluation of your luck would be so off the charts in terms of observer (you) bias or recording error that I couldn't recommend you making any adjustments based on it. You may disagree and decide to anyway. That's up to you. Just whatever you do, don't stray *too far* from the hours I recommend you need to prove yourself according to the combined results of method #1 and #2.

Bankroll Facts

Now that you have learned proper bankroll strategy, along with the best practical method for determining where you stand in terms of your playing ability, you are now ready to make adjustments to that strategy depending on your ability and goals.

Bankroll Fact # 1
If You Aren't Certain You Can Play Very Well, You Need More

The recommended bankroll strategy assumes that you are in the 1 big bet per hour ballpark. If this is not you, you need more. Maybe according to method #1 or method #1 & #2 combined, you are only certain of being a ½ big bet per hour player. Then you need 800 big bets (not 400) for the level you are moving up to. And you must drop down in half when you reach 400 big bets. If you are a ¼ big bet per hour player, then double these numbers once more.

Bankroll Fact # 2
Risk Tolerant Players Can Play With Less

If you want to take some risk, you can move up when you have 300 big bets and drop down to half the stakes when you get down to 150 big bets. This isn't actually that risky if you truly are a 1 big bet per hour caliber player. The drop down strategy actually reduces your roughly 1% chance of going broke to much less than that. But remember the risks involved. How sure can you be that you are a 1 big bet per hour player? How sure can you be that your fluctuations aren't greater than the "typical" pro? How sure are you that you will always play your "A" game, even during prolonged losing streaks? How sure can you be that your competition won't get any better? With all these questions, why risk your career lifeblood? But that's just me. You might choose differently for yourself. As long as I know that you are making your decision with both eyes wide open, I can totally respect any decision you make regarding the level of risk that you are comfortable with. It's your life.

If you are an even bigger risk taker, particularly if you aren't worried too much about having to get a real job if you go broke, you can set your bankroll as dangerously low as you want. I just can't endorse it.

Also, if you are playing low limits and you have a job that gives you enough discretionary income, you may decide that you want to move up the ladder much faster than I recommend. You may quickly jump from $2-4 to $3-6 to $4-8, maybe all the way to $10-20 without the number of big bets I've recommended that you have in your bankroll

first before you make each step. If you can afford the risk and don't mind doing it, I can't argue with you one bit. In fact, it's really the only way to move up the ladder in a shorter amount of time unless you get very lucky and can both prove yourself and quickly expand your bankroll to more rapidly fund your upward moves. I'm just a big believer in getting your playing experience in with a small amount of cost to you. I strongly suggest that you don't think about moving up any farther than that without first proving yourself. You could really be throwing your money away.

Here's a true fact that I hope you don't dwell on too much. Many top earning pros who play regularly in some of the highest limit games did not follow conservative bankroll recommendations on their way up. Although now, they may have accumulated so much money in savings that they do, in fact, have an adequately sized bankroll to tap into. How did they avoid going broke on the way up? They were lucky, or more accurately put, they were never very unlucky. Many other players who had identical playing skills and similarly risky bankroll strategies suffered a bad luck streak somewhere along the way and went broke. You never hear their names. And they may erroneously believe that they weren't good enough. But they were! They just didn't have a proper bankroll strategy.

Bankroll Fact # 3
The Bigger Your Bankroll, The Fewer Risks You Should Take

You must be even more conservative as you move up to $40-80 and higher. There are a couple of reasons for this. One is that it is virtually impossible to make 1 big bet per hour over the long run at these levels as the competition is too stiff. As you go higher, you may start to need 500, 600, or even many more big bets. Another reason you need to be more conservative is because a large bankroll is much harder to regain than a small bankroll. If you just lose a couple of thousand dollars, you can probably get another job, save up or play low limits, and get that money back. If you lose a bankroll in the tens of thousands or even hundreds of thousands because you were playing in too high of limits, that is a real tragedy. It may take you years or even decades to save up that kind of money again. It has been said that rich people worry about money much more than poor

people do. In terms of poker bankroll strategy, this is probably not such a bad idea.

Bankroll Fact #4
You Can Never Know Exactly How Much You Can Expect To Make Per Hour

This is a simple way to encapsulate the practical consequence of some of the previously mentioned "bankroll equation limitations." Because everything in your poker career is always in a state of flux to at least some degree, you can't know your precise hourly expectation. This is one of the most important reasons why a bankroll strategy *must* have a drop down component to it to be practical.

Bankroll Advice For Beginners

There are two routes that beginning players can take. Which route you decide on depends on how much money you are willing to lose to learn the game.

Beginner Route #1

This is the most popular route. You just dive right into playing. I recommend that you start at the lowest limit available to you, probably $1-2, $2-4, or $3-6. As you play, you will concurrently be studying the best poker playing strategy books available which I will list for you later in this book. If you play and study with a high level of determination, you should lose $1,000 to $5,000 at most before you start playing 1 big bet per hour caliber poker for the average low limit game. With some playing time under your belt, you can verify your ability using the previously mentioned methods. Once you are confident you are up to this standard of play, you can follow the three-part bankroll strategy described earlier. (Or if you don't mind risking some additional money, possibly because you currently have a decent job and can afford the financial risk, you can promote yourself up the low limit ladder in a quicker, though not foolproof, manner.) The $1,000 to $5,000 mentioned here does not include the three-part bankroll strategy. Basically, it is the money that you might lose before you become a winning player. So you could lose $5,000 (usually slow learners with some bad luck on top of that) before you

became a 1 big bet per hour caliber player. At that point, you would still need the previously discussed bankroll requirements, which for a $3-6 player (for example) would be $2,400. So your worst case scenario would be risking $7,400, though the vast majority of you should never lose that much because, again, to do so would require you to be a very slow learner and very unlucky.

The reason that there is such a spread of worst case scenarios from $1,000 to $5,000 (plus the bankroll requirements) primarily depends on you. First, there is a big difference between starting at $1-2 vs. $3-6. If you start lower while you are in your learning phase, obviously, you risk less. Second, it depends on the ratio of book study to playing that you decide to do. If you play a little, then study a lot, then play a little more, then study a lot more, you will risk much less money. On the other hand, if you play a lot, then study a little, then play a lot, then study a little, you will risk much more. Third, some players just have higher intelligence and self-control ability than others. If you are naturally disciplined and quite bright, you will risk less money and take less time to rise to a high winning standard of play.

Of course this very worst case scenario amount of $5,000 (plus your regular bankroll risk amounts after that) isn't etched in stone. You may be incapable of playing winning poker because you refuse to do everything I recommend in this book. You don't study the best poker strategy. You don't learn how to control your emotions at the table leaving you susceptible to frequent bouts of tilt. You may have such a low IQ that you just can't remember and apply proper playing strategy even though you study it as hard as you can. If this is you, you must recognize this fact and give up on your poker dreams. It is not for you.

Beginner Route #2

This route may take a little longer to learn winning poker play, but it will risk much less money. You could probably get to the same level of expertise as in route #1 while risking only $500 to $1,000 during your learning phase. In this route, you will not play for money for quite a while, unless you play at penny limit internet games. You will instead study books exclusively initially. You will memorize starting hand strategy until you have them all down pat.

You will study countless sample hands, imagining yourself making playing decisions. You will study and understand the many poker theories and playing concepts before you even sit down at a table. You may even buy one of the better poker playing software programs to get some playing experience without risking any money. If you were extremely studious and bright, you could probably sit down at a low limit table and hit the ground running, playing 1 big bet per hour caliber poker from the very first hand you were dealt. In this case, you wouldn't be risking $500 to $1,000, you'd be risking zero (except for your bankroll requirements). If you could be confident that you were in fact already this good, you could jump straight to the three-part bankroll strategy. Of course, this is impossible as you would need some time to "prove" to yourself that you are a 1 big bet per hour player, but you get my point.

The reason I say that this route takes longer than route #1 is because when you don't have real world playing experiences to compliment your book study, playing lessons usually take longer to sink in. Also, if you tried to jump right up to $10-20 or $20-40 games with just book or even computer software experience, it would be extremely unlikely that you could hit the ground running. There could be exceptions, or maybe you could play break-even or slightly better caliber poker, but probably not 1 big bet per hour expectation poker.

Quitting Your Day Job

Before you quit your day job to play poker for a living, I recommend that you complete the following three steps:

Step #1 – Prove Yourself

You must first establish yourself as a proven 1 big bet per hour ballpark caliber player at the minimum limit you need to get by. So if you need at least $16 to $18 per hour, you need to be a proven winner at $10-20. If you need at least $32 to $36 per hour, you need to prove yourself as a 1 big bet per hour ballpark player at $20-40.

Step #2 – Save Appropriate Bankroll

At minimum, you need 400 big bets for the limit that you intend to begin at. If you are more conservative, 500 or 600 big bets would not

be unreasonable. This would enable you to improve your play without too much risk if for some reason (probably a less than perfectly honest calculation of your playing ability) you didn't play quite up to the standard you had assumed for yourself. In fairness to you, you may have just not realized how you'd handle the pressure once playing without a financial safety net. This is really unknowable until you've walked out on the tightrope.

Step #3 – Save Required Living Expenses

There are a few things you'll have to consider in order to determine your living expense needs. What is the minimum you need per month for living expenses? Only you can answer this for yourself. Do a serious budget on what you spend each month and come up with a number.

How many months worth of living expenses do you need? To figure this out, you need to examine the numbers from Method #1 (not the method #2 numbers as these do not apply here). If you are a ballpark 1 big bet per hour caliber player, you will always be winning money by your sixth month of 40 hour per week play. But you may be earning very small amounts. Maybe only an overall average of ¼ big bet per hour after 1000 hours (six months), only 1 small bet per hour over 2000 hours (1 year), and only ¾ of a big bet after 4000 hours (2 years).

So if you were going to play $10-20 initially, but really needed to count on that $16-18 an hour (the low end of the 1 big bet ballpark) to live on after your living expenses ran out, you should save up over 1 year of living expenses before you quit your day job. This is on top of your bankroll number. Over these first two years, you should be able to move up to $15-30 and maybe a level or two higher depending on your luck. If you are properly dedicated, you should be able to count on your playing ability only improving over this time. Playing well at these higher limits will start to really give you some breathing room.

The Ongoing Need For Saved Living Expenses

But don't think that once you passed the two year mark, you miraculously won't need saved living expenses anymore.

A bad streak could hit at anytime and you are never allowed to touch your bankroll unless it exceeds 400 big bets for the limit you are currently playing. So as you move up in limits and the certainty of your 1 big bet per hour caliber play is not yet proven at these higher limits, you should actually try to squirrel away 1.5 to 2 years worth of living expenses. Hopefully you will never need it. Fine, no harm done. You've just added more money to your retirement savings so that you can suntan on some tropical beach that much earlier.

Your Poker Dreams

How long are you willing to go before you give up on your poker career dreams? This is one more thing to consider. If you follow every recommendation in this book from educating yourself as a player (including mental control) to bankroll and living expense management, you should have every confidence that all these money matters will work out exactly as designed. You should never go broke and will have a poker career as long as you want.

That being said, as much as I recommend you do so, you may not follow my advice to a tee for whatever reason. Maybe you think you know better than I do about how to play poker and don't need such and such book or this and that strategy. Later in the book I recommend that you spend a lot of time and effort working on the mental and emotional control needed to be a successful player. Maybe you ignore my advice and disregard this critical aspect of your game. Maybe you play at higher limits than I recommend for your current bankroll. Any of these actions on your part may cause you to lose more money than I suggest is possible for my obedient students, even though you were otherwise a very promising player, maybe even a winning player. Also, you may be led astray by some other poker instructor's advice on how to achieve your desired poker career. Maybe this instructor blows some smoke up your you know what about how easy it is to play winning poker. How do you know which of us is right? Maybe you follow his advice and things don't go so well. I understand. I'm not offended. If by chance, you have some more money you can tap into, you still have a chance to right your ship's course and steer it back according to the path that I recommend. I hope you will now see the error of your ways and follow my advice more closely from now on. Having this extra money is really the only way you can buy yourself more time to work

out your poker problems (i.e., your stubborn refusal to follow my advice). Otherwise, you will have to go back and get a real job and start saving up again so that you can follow my advice properly the next time you give poker a shot.

My strong recommendation, however, and I know this may sound cold, is that you instead just give up on your poker career dreams. You may have some major self-defeating problems regarding poker (possibly a compulsive gambling problem) that are not likely to get solved by throwing more time and money at them. Go get that real job and, at most, play poker as a side hobby with just a small amount of your discretionary income. It's probably your smartest bet.

No-Limit Players

Your bankroll considerations might seem different than for a limit player. First of all, your session fluctuations will be much, much greater than for limit players. On the other hand, your hourly earnings should be much greater in proportion to the blinds than in limit. These will offset each other to a significant degree. The difficulty in assessing no-limit bankrolls is that the makeup of your opponents can vary wildly, and correspondingly so can your results. But with all the bankroll theory lessons you have learned so far, you can make very informed decisions for yourself.

If you play in the most popular version of no-limit as it is played today, which means a buy-in cap of 100 times the big blind, then 15 times the max buy-in amount is a good starting point for *experts*. But remember that very few players are actually experts, despite their inflated self-assessments. If you consider yourself merely "great," go with 20 times. Good to very good players should start with 30 times. As with limit, dropping down when you start losing is vitally important. You *must* drop down to half the stakes whenever your bankroll drops in half. To play it safe, dropping down once you've lost just a third is wise. If you are losing half your bankroll more than once a year, you are almost certainly playing at too high of stakes and are not truly the caliber player you think you are. Or you are playing with too many other great players. Either way, you are playing too high for your current bankroll. If you play in games where you and your opponents normally buy in for 200 x BB(big blind), then double your bankroll. Triple it if you regularly play for 300 x BB stacks, etc.

Another thing to keep in mind is that the availability and popularity of no-limit cash games is relatively new. The divide between the skill level of a great player vs. his common opponent is fairly large today. It could shrink a little in the future. If you notice this happening, be smart and pad your bankroll a bit more.

Bankroll For Tournaments

David Sklansky has done some groundbreaking tournament bankroll analysis in his book, *Poker, Gaming & Life*. This is some of what he discovered. I warn you ahead of time, it's a bit mind-blowing.

If you are a highly skilled tournament player who plays well enough to expect to win twice your buy-in amount per tournament *over the long-run*, this is what you can expect if you play in typically payout-structured $1,000 buy-in tournaments:

- You need a $55,000 bankroll just to have a 95% chance of never going broke.
- You have a 5% chance of never breaking even until after your 175th tournament.

If you are a skilled tournament player of such caliber that you can expect to win one and a half times your buy-in per $1000 tournament over the long-run (in other words, you are very good, but just not quite as skillful as the previously mentioned player), here's your story:

- You need a $130,000 bankroll just to have a 95% chance of never going broke.
- You have a 6% chance of not breaking even until after 1000 tournaments!

You might want to get a band-aid for your chin as your jaw probably just hit the ground. But brace yourself, because it gets worse. Sklansky did this analysis assuming 200 entrants on average per tournament. The majority of tournaments today have much larger fields than that. That means your fluctuations can also be much larger. It's quite possible that you could never break even in your lifetime despite being a "winning" player.

Recommended Bankroll For Tournaments

I will give you a bankroll system for tournaments, but realize that this is nowhere near as rock-solid and powerful of a system as the one for cash games. You will soon learn why.

Moving Up

You should start with 100 times the buy-in amount for the tournament level you are playing. So if you want to play in $100 buy-in tournaments, you should have a $10,000 bankroll. Don't worry about factoring in the fees as these are all ballpark recommendations anyway. When you increase your bankroll to 100 times the next level of buy-ins, you can move up. So you would need $20,000 to play in $200 buy-in tourneys.

Dropping Down

Whenever you lose half your bankroll, drop down to half the stakes. As you'll notice, this works just like the three-part cash game bankroll strategy.

Taking Money Out

Take money out anytime your bankroll exceeds 100 buy-ins for the tournaments you are playing.

Prove You Are A Winning Tournament Player

In the cash game strategy, you learned a couple of methods to prove that you were a certain caliber of winning player. This is necessary because without this assurance, you couldn't be confident that the bankroll strategy would work. In tournaments, unfortunately, there isn't a very practical way to do this. This is the major flaw in tournament bankroll strategy. Actually, accurate mathematical formulas could be derived to prove the accuracy of your results, the problem is that they would take an extremely long time to play out. This is because the fluctuations are just too great in tournaments. Having to wait so long for the proof that you are a winning tournament player makes such proving methods impractical.

You can't wait forever to make playing (and basically career) decisions. Your life would pass you by.

What Are You To Do?

To be on the safer (but not safe) side, you should use Method #2 (The Blade Method) to give you at least an indication of greater likelihood that you are a winning tournament player. Just add the following three questions to the previous quiz:

2(a) Have you read *Pot-Limit and No-Limit Poker* by Reuben & Ciaffone?

2(b) Have you read *Tournament Poker For Advanced Players* by Sklansky?

2(c) Have you experimented extensively with heads up matches between many different hands on either a poker software program or Cardplayer.com so that you know the winning percentage chances in all-in situations?

If you answer yes to all the previous list of questions plus these three new ones, you have taken the first step toward proving yourself as a winning tournament player. The second thing you can do is get some significant tournament experience (at least 25 tourneys, but hopefully more) under your belt. That will take you even closer to proving yourself as a tournament winning player. You should first gain your experience at very low limit tournaments so you don't risk too much money. But eventually you will have to take it up a notch for it to be very meaningful. The better your results, the more likely it is that you are a winning player. But results from 25 or so tournaments don't prove much unless your results are astoundingly terrific or shockingly horrible. If you have many more tournaments under your belt than just 25, with overall winning results, you will just increase the likelihood more and more that you are, in fact, a winning tournament player. The third thing you can do to help prove that you are a winning tournament player is to become a *proven* 1 big bet per hour (or better) caliber cash game player at middle limits or above. Although it is possible that you could be a winning cash game player and still not be a winning tournament player, your odds of tournament success are significantly increased by your winning pedigree.

Fulfilling these three requirements (especially if you've had some positive results from your 25+ tournaments played so far) should give you likely confirmation that you are a significant enough winning tournament player that combined with a "100 times the buy-in" three-part bankroll strategy (which greatly benefits from the drop down component) will give you a better than 95% chance of never going broke playing tournaments. I wish I could give you better assurance than that, but I can't.[23] If you knew for sure that you were a twice the buy-in caliber player, I could flat-out guarantee to an even higher percentage likelihood (over 99%) that you would never go broke.[24] But, as previously mentioned, you can't figure out if you are for sure a twice the buy-in caliber player in a short enough time frame to be practically useful.

I'm Sorry But You Need To Have A Large Bankroll

Realize that the three confirming requirements for proving you are a winning tournament player only help to better confirm that you are, in fact, such a player. They do not in any way mean that you will have fewer possible fluctuations than what Sklansky points out are possible for a 1.5 or 2 times the buy-in expectation tournament player. That's why you still need such a very large bankroll. If you are a 3, 4, or even 5 times the buy-in caliber player, the size of your required bankroll could be significantly reduced. Unfortunately, you won't know if this is really the case. (You could always get down on your knees and pray for a sign from the poker gods that you were, in fact, a 4 or 5 times the buy-in expectation player, so that you could plan your tournament bankroll accordingly. I usually ask for this sign to be in the form of a swimsuit supermodel knocking on my door. Unfortunately, the poker gods haven't answered my prayers yet. Maybe they'll answer yours.)

I want to reiterate that I'm not claiming that your history of tournament results mean nothing at all. Certainly, the more you have

[23] As is, this assessment is not based on irrefutable statistical substantiation, but rather my expert analysis of the combined power of these three important factors.

[24] Unless you were regularly playing in tournaments with unusually high numbers of entrants or unusually concentrated payout structures, as this increases your risk of going broke.

been winning (or losing), the greater the likelihood that you are, in fact, playing winning (or losing) tournament poker. And the longer you've been playing and winning, the better. It just can't be weighted very heavily unless you've been playing for an extremely long time, or unless you have just been crushing, and I mean crushing, the tournaments for a reasonable amount of time.

Let's Get Real

How many people have this amount of money to more safely play in high priced tournaments? And how many people have the amount of money that could pay for their living expenses if they didn't start seeing a profit for years or even a decade. (Remember that, according to Sklansky, 6% of all "1.5 times the buy-in" caliber players will be in the red until after 1000 tournaments!) If you aren't a trust fund baby or a retired dot-com millionaire, you will probably be forced to gamble if you want to play in tournaments with $1000 or more buy-ins. Even smaller tournaments might not be affordable for many players.

There are a couple of other options to explore:

Tournament Option #1
Get Staked

This is the best option because you don't have to risk any money except your living expenses. It is also a great investment for a very wealthy person who can afford high expectation yet high volatility investments *if* he really believes in the winning skills of the player he is staking. If I ran a hedge fund and I could stake Howard Lederer or Daniel Negreanu, I'd do it in a heartbeat. An entire chapter is devoted to this topic later in this section.

Tournament Option #2
Play In Cash Games And Take Stabs At Tournaments

If you can't get staked, and it is very difficult for most unknown players to find a backer, this is what I would recommend for players who want to play in larger tournaments. You just play in your normal

cash games. Whenever your bankroll success allows you to take money out, if you have enough to cover living expenses and retirement savings, you can spend the rest on tournaments. Maybe you'll get lucky and make a big score right away. If so, you may have a large enough bankroll to play tournaments from now on. Take into account your need for living expenses over long periods of being underwater if you do hit the tournament trail. More likely, you won't have enough to play tournaments exclusively, but you will have enough to enter many more. Then, if your tournament cash-outs begin to snowball, you could become a top tournament-only pro.

Tournament Option #3
Play Satellites

This is similar to option #2, except that instead of taking stabs at tournaments, you take stabs at satellites that will get you into the tournaments. It's a way of taking a stab when you don't have the full buy-in amount. These satellites are covered in detail in the upcoming chapter, "Ways For Risk Takers To Jumpstart Their Poker Careers."

Tournament Option #4
Tell Mark Blade To Take A Hike

You could always throw caution to the wind and just start entering tournaments with whatever bankroll you have. I can't endorse this option, as there is considerable risk of going broke because your bankroll and/or living expenses can easily get eaten away during bad luck stretches. Having stated that, I must admit that many top tournament pros did, in fact, do just this and they've never looked back. They avoided going broke because they got lucky, or more accurately, they didn't get unlucky. This same concept was earlier mentioned regarding cash game players.

If you do choose this option, and I'm sure many of you will, please be careful. Play lower limit tournaments if possible. Play satellites. Don't get comfortable because you have 55 buy-ins. Remember this is for players who have proven themselves to be capable of cashing out twice the buy-in on average, and it still has a 5% risk of going broke. You haven't proven this. And also remember from Bankroll Myth #4 that this 5% figure only applies if you never take money out

of your bankroll ever. Also, if you have more than 200 entrants in your tournaments, this 55 buy-in number doesn't apply either. It's too low.

Ways To Reduce Your Risk

Besides getting staked and playing satellites, you can reduce your potential downside in other ways. You can share pieces of your action with other players who you believe play as well, or even better than you. This is covered more in the upcoming chapter on getting staked.

The best way to reduce your risk is to become the absolute best player you can before even sitting down. Read books on tournaments and whatever game you want to play like No-Limit Texas hold 'em. Tape every televised tournament and hone your strategy vicariously by observing what other players do both right and wrong. Learn how hands match up with computer software or on the Cardplayer.com website. All of this will be covered in greater detail in a later section of the book.

Tournament Living Expenses

I've already touched on this, but it's very important to fully consider. The brutal nature of tournament play is that your enormous bankroll needs are compounded by very large living expense needs. Airfare, hotels, eating out, and transportation are all additional expenses above and beyond your home-base expenses. If you played enough out of town tournaments, I guess you could sell your house or give up your apartment to save some money, but I wouldn't recommend it. Living out of a suitcase without any time off between can really become a grind.

Do the math on a budget for these travel expenses to make a better informed decision of whether the tournament trail is for you.

FINAL CONSIDERATIONS FOR ALL
ASPIRING PRO POKER PLAYERS

For aspiring cash and tournament pros, there are a couple more considerations before we close this bankroll chapter. I bet you thought you'd never get here. Seriously, if you had the perseverance to read this chapter in its entirety, I really like your chances of successfully playing poker for a living. That's some serious dedication!

How Good Is Your Current Job?

Taking a shot at going full-time with your poker career is a much less risky proposition if you aren't giving up anything great. Say you don't follow my every word to perfectly prepare yourself both in terms of playing skill and bankroll. If you go for it and fail, so what?[25] If you don't blow a lot of money in the process, it's not that big a deal. Especially if you are young, you can dust yourself off, go back and get a real job, gain some maturity and really do it right the next time.

If you have a good paying job, however, even if you don't love it or even like it, be very cautious before you jump into playing full-time poker. Maybe after a while, you won't like this one either. Then you'll be kicking yourself, especially if you can't easily get back onto your previous career track.

At least make sure you are absolutely prepared so you don't fail if you do make the move.

Do You Have A Family That Relies On You?

Now I'm going to take my note of caution… AND SCREAM IT RIGHT INTO YOUR EAR!!!!

[25] I know I'm contradicting the tone of my previous admonishments in this regard. In this case, I'm making an exception because I'm referring only to the specific smaller segment of usually younger readers, who wouldn't be giving up much to take a haphazard stab at a poker career.

You <u>must</u> take all the necessary preparation steps. You <u>must</u> have the required bankroll and living expenses saved. You <u>must</u> prove yourself a winner during your transition time to pro poker while you still have a job that pays your bills. You <u>must</u> also have an immediate back-up plan if, for whatever reason, things don't work out for you and you need to earn a living again.

Poker can be a great side job. In fact, for most players, that's what I'd recommend.

Chapter 14
Can You Control Wins & Losses
Through Money Management?

First, let's define what "money management" is. It is the notion that you can improve your results if you have a predetermined formula for stopping your play after you have won or lost a certain amount. It is probably one of the most common misconceptions for the aspiring pro.

So what's the answer to the question? – Can you control your wins and losses through money management?

A RESOUNDING NO!!!....

With a few qualified yeses.

Before the entire poker establishment pounces on me for the blasphemy of stating that there is something to be said for money management techniques, please read on. I'll start with the obvious.

Why Money Management Does Not Work

It's amazing to me how many smart people are erroneously seduced by this notion. If you're smart and you think the idea of quitting while you're ahead by some certain amount or quitting when you're down by some certain amount makes sense, you're wrong. Plain and simple. But don't feel bad. You're certainly not alone in your mistaken notion. Let's analyze this two ways.

Smack Some Sense Into You About Money Management - Attempt #1

You've probably entertained this notion of money management because of something like this. On June 11, you walked into a casino and played poker. After 3 hours and 45 minutes, you were up $500. If you had just walked away at precisely that moment, you'd still have that money. But instead, you kept playing and ended up down $1245. So you thought to yourself, "Eureka! From now on, I'm always going

to quit when I'm ahead by $500." Sounds good. I'm following you so far. But let's see how this really plays out.

Assume that you normally would play 8 hours a day, 5 days a week, except that you will now cut your days short whenever you reach that magic $500 mark. You will have three types of results.

Result Category #1

Some days your plan actually works. Some days you were destined to lose that day. Or you were going to break even or just make between $1 and $499. But instead, you hit that $500 mark and quit. That worked out great! You really saved some money on those days. Congratulations! Maybe you're smarter than I realized.

Result Category #2

Uh-oh. Wait a second. Other days your plan doesn't work out so well. You stopped playing at $500, but little did you know that you were destined to make more than $500 that day. You were going to make $501 or $753 or maybe even $2215. Those days it didn't work out so well, did it? It actually cost you a lot of money. Hmmm.

Result Category #3

These are the days when you were going to lose, break even, or make between $1 and $499. But on these days, at no point during the day would you ever hit the magic $500 number. So these days are irrelevant. You would play the full 8 hours whether you had your money management system or not.

Money Management Put To The Test

So we're only really debating Category #1 and #2. Let's look at these days, and let's zoom in on the precise time that you hit your $500 mark. Remember, you came up with your "Eureka Plan" on June 11. Now it's June 12 and you're putting it into effect for the first time.

Sure enough, 4 hours and 22 minutes into your playing on June 12, you accumulate your desired $500. Freeze time and let us think about

this. Is today a Category #1 day? Will you save yourself money by walking away right now? Or maybe it's a Category #2 day? If it is, and you got up now, you would be missing out on a lot of money. So how do you know what kind of day it's going to be?

You don't! And therein lies the rub for money management. You have no idea if you are destined to win or lose from that $500 point on.

Wait a second. I just lied. You do have an idea. You are a winning player. You play better than your competition. You average 1 big bet per hour. If you stay and play on, you can expect to make your 1 big bet per hour *on average* for every additional hour that you sit there at the table. Sure, it won't be guaranteed for any particular hour or short stretch of hours, but in the long run, that is what you will earn.

So money management strategies really just cost you money because they prevent you from putting more hours in at the table which would put more dollars into your pocket.

What About Stop-Loss Strategies?

They work exactly the same way as the "stop-win" strategy that I just debunked. Think about it and you will see that you will have the exact same three result categories except they will be flip-flopped. And when you get to that decision making moment when you're *down* $500, you still won't know if you are more likely cutting off future losses or future gains. Whoops – I lied again. You do know what's more likely from that point on – Gains.

Moral Of The Story

Keep playing whenever you have an advantage over your competition.

Smack Some Sense Into You About Money Management - Attempt #2

If you solidly get the idea now that money management techniques are futile, you can skip to the next topic if you want. Otherwise read on.

Here's another way to look at money management strategies. What it all boils down to is that you are picking a specific time to stop playing. You are picking this time because during one particular session, which you define as a day at the casino, you hit some predetermined winning or losing amount number and hit the eject button on your poker seat. Let's say that this happens when you lose $500 at 8:17pm on April 6.

Then what happens? You walk out of the casino and go home. You put your wallet on your bedside table, put on your pajamas, and climb into bed and go to sleep. You wake up, take a shower, have breakfast, grab your wallet and hop back in your car.

You go to the casino, plop yourself down at a table and start playing again.

This is your new session on the glorious new day of April 7. You are going to start your counting from zero again and wait until you win or lose your predetermined $500. But wait a second. What if on April 6 at 8:17pm you had walked out of the casino, walked over to your car, kissed the hood ornament for good luck, and then walked right back into the casino? What if you called that your "new session?" Hey, that could save you on some gas money too! You could just start from zero then and decide to leave when you won or lost $500 from that point on.

Don't you see that that is what money management techniques are really all about? Once you're really evolved, you wouldn't even have to get up out of your seat and go to kiss your car hood ornament. You could just do what I do. Every time I win or lose $500, I just stand up, kiss the nearest waitress on the lips, plop myself back down, and start my new count again from zero.

C'mon. You're a professional poker player now. Leave the money management nonsense to the novices.

Why Money Management May Work For You In Some Cases

Now you must really think I'm sadistic and just enjoy messing with your head. Let me explain. There are some actual practical reasons why you may want to walk away from a table after you have been winning or losing a certain amount. I wouldn't exactly define these as "money management" techniques, but I couldn't really argue with someone who did. So here they are:

Psychological Walloping

Most players, probably you included, cannot play their best after losing a lot of money. The amount differs for each player. For you it may be $100, $500, $1000, or something more. My first advice would be that you should figure out a way to deal with this better. The later section in this book on mental and emotional tips should definitely help.[26] You cannot possibly become a successful pro if you start reeling every time you are down $100. You could, however, still have a successful career despite the fact that a $1000 loss triggers you to start playing badly.

How so? Simple. You just tell yourself to walk away from the table any time you are down $1000. You might be thinking from the lessons you just learned earlier, "But won't this cost me money?" Yes, it will. Those additional playing hours that you miss out on means less money in the long run. But if you start playing badly, it could cost you even more than that. There is no shame in recognizing that no matter how hard you try, you just cannot handle huge losses well. Maybe you'll have to play an extra couple of days each month to make up for these lost hours. Fine. It's better than blowing off your month's worth of profits because you go on tilt.

[26] Along with my upcoming book, *Professional Poker 2: The Mental Game.*

Remember, the key to winning at poker is playing better than your competition. If you are not playing better, for whatever reason, always walk away.

Psychological Walloping #2

The previous topic mentioned a reason why you might want to employ a stop-loss for psychological reasons. There is also a reason to utilize a stop-win. If you have a very long losing streak, such as many days or weeks, you may not be able to handle this. You could start to believe that a rain cloud is parked over your head like Jim Carrey in the Truman Show. In this situation, you may want to quit the next time you are ahead. Sure, this could cost you money, but playing with extreme psychological baggage can cost you even more. This one recorded win ("Wow, I'm not doomed after all. I actually had a winning session!") may be all you need to get yourself out of your mental funk.

Your Table Image Is Shot

This is one reason that I personally employ as a basis to switch tables when I'm losing. Although I don't have a perfectly set number that triggers my move.

An often overlooked force at the table is how winning or losing can affect your future winning or losing. I'm not talking about lucky or unlucky streaks. I don't believe in that and you shouldn't either. I'm talking about your table image. When you have been winning a lot, it can have a powerful psychological impact on your opponents' perceptions.

For example, if you sit down at a table and, because of mere crazy coincidence, happen to get dealt 10 full houses in a row, people will play differently against you. If on hand #11, the board pairs on the river and you make a raise while saying, "sorry guys," just watch what happens. Everyone will fold their straights and flushes screaming, "I can't believe this crap!" Meanwhile, you didn't have a thing. Of course, this is an exaggerated example, but it is a very true psychological effect. When winning with a lot of shown strong hands, you can bluff more profitably as people fear you.

People won't raise or value bet[27] against you when they should because they fear you always seem to have a strong hand. This is an extremely profitable situation.

Now the flip side. When you sit down and by chance just happen to be dealt weak hands again and again, people notice. Maybe you bet your flush and straight draws a few times, but they never get there. Even non-observant players begin to sense that you never have a winning hand. This alters the way they play against you. Forget about bluffing. That powerful and very profitable weapon is now rendered useless for you. Nobody fears you. You also can't thin out a crowd when you'd like with your bets. And something really weird can happen. Bad players can start to play almost perfect poker against you. It may seem like an odd idea but imagine some of your typical bad players. They are too passive. They don't bet or raise their hands when they should and they rarely make opportune bluffs. But now, because you are seen in their eyes as so non-threatening, they are emboldened to bet, raise, and bluff more. In fact, they might stumble upon near perfect strategic frequency for these plays.

There is one upside to your table image as a loser. When you do bet or raise with winning hands, you will get a few more calls than normal. But this pales in comparison to all the other downsides. So for this reason, when you are losing, and the competition isn't particularly attractive enough to keep playing against, leave the table. You may be in a negative expectation situation or at least your prospects are not as good as at another table where you can present a fresh table image.

When You're Losing Big, Others Are Winning

This is another reason that I may consider making a table change after losing for a while. Although again, like in the previous topic, I do not have a preset number that prompts my move.

It is no secret that the vast majority of players play better when they are winning than when they are losing.

[27] Value bet means a bet that is made when the bettor believes he has the best hand and wants the potential caller(s) to call in order to get full value for his hand.

When they are losing, they often go on tilt and really start blowing off their chips to you. So the following relationship should be obvious. If you are winning big, many of your opponents are losing. They play worse and your winning snowballs. On the flip side, if you are losing big, many of your opponents are winning.[28] They may start playing their "A" game. Now, even if you are a great player, your profit margin may become quite small at this table. You would be better off starting from scratch at another table where your chances of playing against winning or losing players are unknown but probably closer to your average playing conditions.

You Don't Realize That You Are Outclassed Or Cheated

As a professional poker player, you should be able to size up your competition by the way they play. But maybe for some reason your radar is off some day. Maybe you're at a table of all world class players who you have misjudged as bad players. One way to ensure that you don't get stuck at a table like this for too long is to set a stop-loss amount. I'm not a big believer in this because you should be able to judge if a table is good or not through your own observation, but I must admit that this is a "valid" reason to employ this "money management" technique.

A more difficult to recognize situation that could be occurring is that you are being cheated. (Side note: I don't worry about cheats too often for a few reasons. One is that I don't think it's very prevalent. The other is that even when it is, I can still usually beat the cheats despite their added advantage. Obviously if the cheating involved somehow dealing fixed hands, I would be doomed to lose.) It is possible that the reason you are losing so much is because you are against a team or teams of cheats who are colluding against you. Having a stop-loss amount would prevent you from ever playing in one of these games for too long.

[28] Mason Malmuth has also mentioned this idea in Gambling Theory And Other Topics.

When You Are A Losing Player

If you are a losing player, which most poker players are, forget about everything I've said about money management. Money management is your savior. It is your knight in shining armor whisking you away from danger. Any convoluted system you come up with that convinces you to stop playing sooner than you would otherwise will save you a lot of money in the long run. In fact, I've got the most profitable money management system ever invented for a poorly skilled player. Every time you are playing and you win $1, get up and go home. Do likewise whenever down $1. That's it. Class dismissed.

When You Are A Break-Even Player

What about the break-even or near break-even player? This is an interesting case. A break-even player sometimes plays in games that are profitable in the long-term because the caliber of competition is below average. Other times, he plays in games that are unprofitable in the long-run because the competition is above average. Stop-loss techniques (not stop-win) could theoretically actually help him to automatically self-select his way out of those unprofitable tables and play longer in those winning tables.[29] And this doesn't just affect the break even player. (I just figured that you might see this point more clearly with him as an example.) A self-selection process could also steer a winning player toward the most profitable tables, and steer a losing player away from the most damaging ones.

You shouldn't concern yourself too much with the possible merits of such a plan though, as they are not practical in real world application. Even losing players should have a much more accurate assessment of whether or not tables are potentially more or less profitable through their own brain power than with money management techniques. And as a skilled player, your assessment powers should be even more powerful. Money management techniques would give you a better than random coin-flip guess, but not that much better, especially since the frequent turnover of opponents doesn't give the power of mathematics much time to sort things out in a meaningful way.

[29] I say "theoretically" because as I will mention in the later chapter on "Dealing With Bad Days," some particular losing patterns in certain games could indicate favorable situations.

If You Die Tomorrow

There is one more valid reason for money management techniques. If you know you are going to die tomorrow or you plan on quitting poker forever after this session, then yes, walking away after losing $500 will insure that that's all you lose. And leaving after winning $500 will guarantee you will still have that $500. You can clutch it tightly in your hand as you lie in your casket with a big smile on your face, looking down at me from heaven saying, "See Mark Blade, you're not so smart after all."

♦ ♣ ♥ ♠

Chapter 15
Ways For Risk Takers To
Jumpstart Their Poker Careers

So you have a small bankroll and an even smaller amount of patience. Are there any ways to jump into the big leagues, or at least bigger leagues, than the slower, gradual ascent that I highly recommend?

Yes. But they require substantial risk of going broke. For some of you, this may be acceptable. Maybe you want to take a quick shot at a poker career, but don't care that much if it doesn't work out. You are willing to risk all the money that you've saved up for this poker attempt and go back to the regular working world with your pockets empty, but head still held high. Who am I to tell you how you should spend your money?

All I'm saying is that there is a way to safely play your way up the poker ladder without ever falling off. For those who don't fear a fall, here are your options:

Tournament Satellites

Let's say that you want to enter a major $10,000 buy-in tournament. You can win this entry fee by playing in a smaller tournament, sometimes as small as just one table, where the prize or prizes are these $10,000 buy-ins. This is called a satellite.

In one sense, you might argue that tournament satellites reduce your risk. This seems to make sense because you could win the $10,000 buy-in with much less money than the full $10,000. Maybe as little as $10 to $50 if you entered certain super-satellites. That's what Chris Moneymaker did to win entry into the 2003 World Series Of Poker, which he went on to win for a payday of $2,500,000. Not too bad. He risked $40 and won millions! On the surface, that seems like satellites reduce your risk. But that assumes that you win your satellite. This is far from a sure thing. And that's where the risk comes in. Satellites are long-shots. The lower the entry price, the greater the long-shot odds.

If you want to enter a tournament that costs $10,000 to enter, the <u>guaranteed</u> lowest priced way to enter is to pay the full $10,000. Entering satellites may get you in cheaper or it may end up costing you even more money. Even if you enter a $1000 buy-in (plus fees) one table satellite to win your $10,000 entry, you may win on your first try. But it might also take you 20, 30, or even more tries. That's risky! The same thing can happen with a $40 satellite. If you were unlucky, you could play 500 or more of these before you won one. Now you've spent $20,000+ to enter the $10,000 tournament. And look at all the time you wasted to earn that entry. That's not just financially risky; it's also a risk of your valuable time. It might be more worth it for you to just take a stab at winning your entry fee by playing in a $30-60 cash game for a month instead.

For You, It Might Be Worth The Risk

Let's say you only have $5,000 and you have your heart set on entering the big one. You don't have the patience or desire to spend hours and hours playing in small cash games or very small tournaments to earn your entry fee in a safe way that doesn't wipe out your entire bankroll. Fine. Play in some $1000 one-table satellites. Cross your fingers and hope you win your entry into the main tournament within your first five tries.[30] Or if you only have $500, play in two $250 super satellites or ten $50 ones.[31] Just realize that you have considerable risk of never even getting in. And, of course, I haven't even mentioned yet the enormous risk that you will not finish in any of the money positions even if you do get into the main tournament. When that happens, your poker career is over. At least until you get a job and earn some more poker money.

Even when you have a bankroll around $50,000, satellites are a good option if you have your heart set on trying to make a lot of money by playing in big tournaments, but aren't willing to play in cash games or much smaller tournaments to build up the required bankroll. Realize, of course, that $50,000 is not nearly enough money to safely

[30] Actually, when you add in the fees, you would only be able to play in four, not five, but you get my point.
[31] Some specific entrance amounts like $250 exactly may not be commonly found, but satellites in the ballpark range of just about every amount from tens of dollars up to a thousand are frequently available.

play $10,000 buy-in tournaments without risking going broke, even when utilizing satellites. With this much money you could guarantee your entry into 5 of these big tournaments by buying in directly, but there is no guarantee that you would cash in any of them. Playing in satellites will likely enable you to play in more than 5 tournaments. Probably about 6 or 7 most of the time if you are a winning player.[32] Even though you are risking getting into just 4, 3, 2, 1, or even no tournaments, your overall expected return after all the satellites and big tournaments are played is greater with your $50,000 than if you had just bought straight into the big tournaments directly. This is because on average you will be playing in more than 5 big ones.

So, on a short bankroll, as a risk taker, besides factoring in the overall expected return on your investment, you may want to decide if you will be extremely sad if you never even get up to the plate to play in these $10,000 entry tourneys. If so, avoid satellites. If you will only be sad if you never hit a home run, then play satellites. Either way you are in no way guaranteed of ever hitting that home run because of your short bankroll, but playing satellites will at least give you a better chance at it if you are a winning caliber player.

How Pros Should View Satellites

Pros with comfortably large bankrolls shouldn't ever even think of satellites in terms of being a cheap way to gain entry into a tournament. You should only consider them in one of two ways.

The main way you should think of them is as a separate, independent poker playing investment option. Just as you consider how much money you will make per hour in a $20-40 game or a $500 buy-in tournament, you should think about how much per hour you will make playing in a satellite or satellites. You might do the math and decide that you can make more in cash games. If so, how is this satellite helping you in the long run to earn main tournament buy-in money? You could more efficiently earn this entry money in the cash games. In making your decision, don't forget to factor in if there will be a lot of downtime until the next satellite if you get knocked out of this one quickly. Remember, in poker, like in many other jobs, time is money.

[32] Of course your probabilities correspond with your satellite playing ability.

Many pros, especially tournament experts find that satellites are more profitable to them. When a tournament is in town, they may only play in the satellites, every day, hour after hour. Most satellites pay you off in special chips that can only be used for tournament buy-ins. However, these chips are usually transferable so you can sell these chips to players who were going to spend cash directly for their tournament buy-ins. Some players may ask for a small fee for this exchange, but if you're friendly enough, you can usually find people who will exchange cash for these chips without a service fee. It's not like it's costing them anything. It's really no different than asking someone to give you four quarters for your dollar so you can use a pay phone. Look for players in line for the tournament buy-in desk. Tell them that if they do this simple favor for you, they will be rewarded in tournament-winning karma. It usually works. Superstitious gamblers love any break they think they can get.

Satellites As Tournament Practice

Another way that you might want to evaluate satellites is as practice for tournaments. They are great practice for some of the final table situations like short-handed or heads-up play that you might not get regularly in cash games. Even if you don't make as much per hour in a satellite, this practice benefit might still make it worthwhile to you. Also, as with other forms of poker, you may particularly enjoy it so much that you don't care if it means a cut in pay for you.

Playing Above Your Head

Another risky way to jumpstart your career is playing above your head. For example, your poker bankroll may only be $8000. This may be enough for $10-20 if you are a 1 big bet per hour caliber player. But what if you just stepped right up to $20-40? You actually would have a pretty good chance of not going broke right away. You will more times than not get your bankroll up to $16,000 rather than go broke. But this assumes that you do not keep spending any of your bankroll until you get it over $16,000. If you always keep it at just $8,000, spending everything you earn above that, it will just be a matter of time before you go broke. You will usually lose 200 big bets over some span of time, sooner or later. So you are playing with fire. But if you only play over your head initially, you can cross your

fingers and hope that bad luck doesn't strike you early out of the box. You will usually get your bankroll up to a safe enough level where you can then breathe a sigh of relief and follow my recommended bankroll numbers and strategy for the rest of your career.

I can't recommend this initial risky leap in good faith because I would like to know that if you are reading this book and are determined to have a professional playing career that you *will* have it. But I also can't honestly deny that many, alright who am I kidding, *most* successful pros have jumpstarted their career in just this way and have never looked back.

Getting Staked – *Not Risky*

This is a way to jumpstart your career without risk. If you can find someone who believes in your potential, they can bankroll you. This presents absolutely no financial risk to you, unless you consider limiting your upside as a risk. Of course, your backer is taking on a lot of risk. Read more about this in the upcoming chapter in this book on "Staking And Getting Staked."

Chapter 16
Loaning Money

When should you lend money to another poker player? My answer is pretty simple. Never.[33] If someone asks me, I tell them the truth. "Listen, it's nothing personal. I just have a policy that I live by. I never borrow money for poker and I never loan it out either."

There are two good reasons for this. One is that poker players are notorious for borrowing money and never returning it. I've heard many loans-gone-bad stories like one where a guy played regularly for years against a nice old lady. Then one day she claimed to have forgotten to bring her wallet. She borrowed a grand and was never seen of again. If you lend money at the poker table and never have it returned, don't come crying to me. I warned you.

Another reason to not lend money is because you are usually helping a losing player to dig himself into a deeper hole. Even if he pays you back, it could be money that he got from a credit card cash advance or a family member he will stiff later. Or often it's just money that he shouldn't be wasting on poker in the first place. Usually if he's borrowing money, it is because he already lost everything he brought with him that day. Even winning players who are in this position are often having horrible bad luck days that are likely to affect their playing skills. You could be doing him a big favor by making him go home for the day and shake it off.

[33] This is not to be confused with "staking" which is perfectly acceptable in many situations. It will be covered in the next chapter.

♦ ♣ ♥ ♠

Chapter 17
Staking And Getting Staked

Staking is when one person puts up either all the money or some of the money so that another player can play poker. This is nothing like loaning because the person staking the player owns a piece of the profits.

Cash Game Staking

In cash games, a backer would normally provide your bankroll in exchange for a percentage of your profits. Possibly around 50%, but it's completely negotiable between you and the backer. Let's say you are just getting started and have a friend or relative who believes in you. You could play $20-40 games, for example, and, if you could win on average $40/hour, you would keep $20 and your backer would get $20. You might decide to just total up your results every month and split any profits.

You must have a very trusting backer for cash games because it would be easy for you as a player to hide some of your winnings if your backer wasn't with you every day. Of course, if you didn't produce results, your backer could pull the plug at any time which would destroy your lifeline, unless you had a commitment that this staking relationship would last for a specified duration, such as 30 or 60 days. This duration concept will be covered more thoroughly in the upcoming discussion of tournament staking.

By the way, if you were considering a duration commitment for cash game staking, here are a couple practical reasons why you may want to reconsider. If the player is still losing toward the end of the commitment, he's going to want to play every day for as many hours as he can keep himself awake, which is a recipe for disastrous results. You could somewhat protect against this by having a pre-set maximum allowable downside. But still the player has an incentive to play a high risk/possible high reward style of play just to have a chance at winning some money, even if it greatly increases his chances of bottoming out. So maybe, in an effort to eliminate this inherent problem, you decide to just commit to a certain amount of *hours* of play. But now the player, especially if he's losing, will want to

save his remaining backed hours for just weekend nights which are usually the most profitable. This is not very productive, though, for a player to only play 10 to 20 hours a week. Also, if the player isn't watched like a hawk, he'll be tempted to play more hours than what he will claim to the backer. So cash game staking is usually best arranged where the backer can cut off his funding at any point. It is up to the backer if he wants to extend the player the same privilege.

As a player, you might also just convince a backer to bankroll you for one night's play at a higher stakes table. Maybe a friend will invest up to $1000 for you to play in a $30-60 or $40-80 game. If you lose it all, your friend is out $1000. If you win, you split the profits in whatever percentage you agree to.

Cash Game Staking Not Recommended

I do not highly recommend cash game staking. If you are a winning player, you should be able to smartly move yourself up the stakes ladder with your own bankroll. If you are just starting out, you shouldn't be jumping right into the middle limits anyway. You should be getting your experience at the lower limits and proving yourself first. Why put anyone's money at risk, even if it's not your own, when you haven't proven yourself to be a winning player yet? Also, if you have a bad streak, it is very easy for your backer to get suspicious that you are stealing from him. This puts you in an uncomfortable position.

As for you being the backer, I'd be extremely suspicious of someone who couldn't afford to pay his own way in cash games. Of course, it is possible for a winning player to have gone broke just because he didn't have an adequately sized bankroll to begin with, or maybe he spent his winnings on a car or a house down payment. There are a lot of theoretically valid scenarios for why a winning caliber player could be broke. Also, he might not be broke, but just can't afford the very high stakes he'd like to play, such as a winning $20-40 player who has his eyes set on a $100-200 game. But even considering all these valid possibilities, it is just much more likely that this "horse" you are considering staking is simply a losing player, as you will soon discover when he loses all your invested money as well.

Tournament Staking

Much more common is tournament staking. As you've learned, buy-ins can be so high and fluctuations so great that many, if not most, winning players simply cannot amass a big enough bankroll to safely stake themselves in big tournaments without a huge risk of going broke. There are three common types of tournament staking. One is where you have a backer who pays all of your entrance fees and possibly travel and living expenses too. The second type is where you sell portions of your entrance fee at a premium. The third is where you sell portions of your action with no premium.

Category #1 – Total Backing

A typical example of this arrangement is if you had a backer who paid your $10,000 entry into the World Series Of Poker. If you win anything, you split it with him. Usually, the net profits. By "net" I mean that you split the cash-out amount only after the entrance fee has been subtracted out and returned to the backer first. So if you cashed out $20,000, you would take home $5,000, not $10,000. Of course, all this is negotiable. Travel and living expenses may or may not be included depending on your arrangement. You might convince your backer to give you 50% of the *gross* cash out (in other words, if the cash-out is $20,000, you get $10,000 and the backer gets $10,000, meaning that the backer neither wins nor loses any money in this particular situation). However, it is much harder to convince a backer to give you a gross split, at least not at a 50-50 percentage split. But maybe you could convince your rich uncle to do so, or maybe he'll give you 60% of the *net* profits. Anything is possible. It all depends on how persuasive you are and how desperate your backer is to bet on you. If you want to play in a particular tournament and can't afford to otherwise, you'll have to accept any deal you can get. Even giving up 90% of the net profit to your backer isn't out of the question. Hey, 10% of the profit is better than nothing if you couldn't afford to play otherwise.

Tournament Taxes

For tax purposes, you will either have to ask the tournament organizers to issue separate W2-G tax forms for you and your backer

(or backers) according to those assigned percentages or else you can issue tax form 1099's to your backer(s) after the tournament, similar to how many independent business people do for any number of business arrangements. If you really want to be prepared, fill out IRS tax form 5754 ahead of time detailing your arrangement. If you give this filled out form to the tournament operators when you win, they will hopefully cooperate with filling out separate W2-G's, if they wouldn't have otherwise. Consult a good accountant to handle this. It's prudent to always have a professional handle tax issues rather than yourself.

For more info on all gambling related tax issues, get The Tax Guide For Gamblers by Roger C. Roche and Yolanda Roche. (I have posted links on where to get this at my website, MarkBlade.com)

Backers can pay for your tournaments on a one-at-a-time basis, starting with a clean slate before each tournament. This enables either of you to walk away from your relationship any time you want. Or you can have a longer term agreement for a predetermined amount of tournaments or money. For example, you and your backer could agree that he will fund, let's say, your next $100,000 in tourneys. This has interesting risks and rewards for both of you.

Long Term Commitment Upsides

The upside to you is that you will know you have funding for the next ten $10,000 buy-in tournaments or the next hundred $1,000 ones.[34] This is nice for you because if you get off to a slow start, you won't have to worry about having to keep convincing your backer that you are a wise investment for him. But why would a backer ever agree to such a long commitment? Wouldn't he want to stop backing you whenever he started to feel that you weren't a wise investment? Actually, there is very good reason for him to commit to a predetermined long-lasting commitment. Let's say that on your first tournament, you win $2 million. You could pay your backer his share and then kiss him goodbye. The backer would be extremely disappointed because his prize-winning horse has now left his stables. And the backer believed that you were a 2, 3, 4, 5 (or maybe

[34] For the sake of simplicity, I'm not mentioning the tournament fees which would also be included in your calculations.

even more) times the buy-in expectation player. So every time he bankrolled you for a $10,000 tourney, he was expecting a profit of $5,000 (for himself which is his cut of the total $10,000 in expected profits if you were, in fact, a "2 x the buy-in" caliber player) or $20,000+ (if you were in fact a 5 x the buy-in or better player). Even though his investment in you is highly volatile fluctuation-wise, he can easily afford that fluctuation risk in return for such an incredible average ROI (return on investment).

It is just like the situation with the investors for the famous MIT blackjack card-counting ring. These winning blackjack players needed financial backing to get started in the first place because they didn't personally have big enough bankrolls to withstand the fluctuations of big bet blackjack. After a while though, with their cuts of the profits, these players could fund themselves. They didn't need their investors anymore. But their investors would have loved to have had them under a long term agreement so that they could keep profiting from their winning play. And, in some respects, it would only be fair as the only reason these MIT students had the opportunity to win so much money in the first place is because of these smart investors' willingness to bankroll them.

Long-Term Commitment Downsides

Then again, there are the obvious downsides to a long-term commitment for each party. If you are the player and you do win a lot of money right off the bat, you may wish you could just bankroll yourself from now on so that you could keep all the future upside potential for yourself. The backer, if he loses faith in your playing ability for any reason, will wish that he had never made a long-term commitment because he would rather back out now and cut his losses. So which way is better? It all depends on what you and your backer value. As with almost all investments, it basically all boils down to risk vs. reward propositions.

Should You Have A "Carryover?"

So let's say you find a backer and you decide to have a long-term commitment which, if you do, I recommend you get in writing. There is another issue to discuss. Should you have a "carryover" component to your agreement? What this means is that you do not

treat each tournament independently when calculating your profit distributions or "cuts." Instead, you will carryover any previous losses into your cost basis, usually until you are in the black. Here's an example of how such an arrangement works with a carryover and a 50-50 net split:

Tournament #1 - $10,000 buy-in. $0 Cash out.
Tournament #2 - $10,000 buy-in. $0 Cash out.
Tournament #3 - $10,000 buy-in. $25,000 Cash out.
At this point, you are still $5,000 in the hole so you (the player) get nothing yet.
Tournament #4 - $10,000 buy-in. $45,000 Cash out.
Now you have a $30,000 overall profit. So now you each take your cuts. You take your $15,000 and permanently bank it. Your backer takes the other $15,000. And you now start all the calculations from scratch again. So if you don't turn a profit here in tournament #5, then the $10,000 buy-in will carryover to Tournament #6, and again and again until you are in the black *again*.

So which one of these arrangements is better, both for the backer and the player? You probably already have a good guess at the answer, figuring that the arrangement <u>with the carryover</u> is better for the backer, while the one <u>with *no* carryover</u> it is better for the player. But that's just the simple way of looking at this.

Actually, the best arrangement for *both* parties is the one with *no* carryover. Let me explain. First, I am going to give you some practical reasons. After that, I will get into the numbers.

Why "No Carryover" Is Better

Taxes: Having a carryover can complicate things in various ways when it comes time to report your (and your backer's) winnings to the IRS. Most arrangements work around this problem by coming up with some agreement as to how the tax basis is going to be figured out, which can be quite unfair to either party depending on the situation. The cleanest way is to have no carryover. Then, every year the backer is entitled to the entire cost basis of the tournament entry fees (for gambling loss deduction purposes) which is fair as he did put up the money. He can use this to offset whatever gambling profits he may realize that year, especially if he's had a profitable year

staking other players or via his own play. He bore the risk. Why shouldn't he get all the tax breaks he can get? Whatever you take home that year is all gambling profit to you with your only gambling deductions being your professional expenses (such as travel and food expenses which will be sizeable) if you are filing as a professional gambler. If you have other gambling losses on the side, outside of this arrangement, you can, of course, still claim those. If you think that dealing with taxes as I recommend somehow benefits the backer more than it does you, just bake that into your negotiations over your percentage split. That is always the final scale balancer.

Relationship Killer: If you have a carryover component, a player who has a large cost basis built up under him because he has had a prolonged streak of poor results is always going to be tempted to abandon his backer so that he can jump into the arms of a new backer where he can have a fresh start. And why shouldn't he? It's in his financial interests to not stay loyal. Now this great backer who had invested so much money with this player is left high and dry. What a shame for this business relationship to end like this, especially when the backer may still very much believe in the player's tournament abilities, and the player still really appreciates his backer's sponsorship and maybe even friendship.

You may conclude that this just provides a great reason for why arrangements should be long-term. I disagree. Not with arrangements being long-term. I'm all for that if both parties agree that it's a good fit for them. I just don't think that arrangements should be long-term to justify a carryover component. You should be able to decide independently what duration you want the arrangement to last for without being held hostage to what is in the best interests of the carryover component. Also, even very long duration arrangements will finally reach the end of their term sometime. Carryover arrangements that have a built up cost basis at the end of a term are a prescription for bad blood between the backer and the player. Let's say the term is over and it's time to renegotiate. The backer will want all or at least some of the overhang left hanging. The player will want to start from scratch. So the player will look for a new backer which will probably cause ill will with the old backer. If the old backer decides to waive the carryover and start a new long-term arrangement from scratch, he will always feel resentful.

All of this can be avoided if you just never have the carryover component in the first place.

Pressure Relief: There is an interesting phenomenon that staked players attest to. They believe that playing with someone else's money actually helps them to play better. This makes sense for two reasons. If you are very worried about doing well in a particular tournament because if you don't, you won't have enough money to play in the one tomorrow or next week, you are playing with "scared" money. This can often have a very detrimental effect on your playing ability. It is the same sort of pressure that players can feel when playing on a short bankroll when the rent is due. How do you think a player with a large carryover feels? The effect can be even worse! On the one hand, he is desperate to win because he needs a payday. Feelings of desperation don't encourage optimal play. On the other hand, he may feel that the carryover debt hole is so deep that it will be very difficult to climb his way back out of it anyway. This will engender a feeling of hopelessness. Hopeless players are rarely winning players. Backers should want their players psychologically poised to play their best, not their worst.

Also, if deep in the hole because of a carryover component, it is in the player's best interests to play a very high risk style of play. This style will slightly increase his chances of winning the tournament outright, while greatly increase his chances of not making it into any of the money cash-out positions at all. In other words, he will have a lower per tournament average with this style of play. This is not in the best long-term interests for the backer. But because of the carryover, the backer's and player's best interests, again, are not aligned.

Living Expenses: If a staked player has a large enough carryover, he may not have seen a personal payday (money actually going into his own pocket) in a long time, even though he occasionally had small tournament cash-outs, as these all went straight to the backer to whittle down the carryover balance. In these situations, living expenses could become a serious issue for the player. Unless the backer is providing for these living expenses, he should be worried about the psychological effects that being dead broke will have on the player. And it's not very fun psychologically for a backer to know that his staked horse is living out of his car. And what's the backer to

say if his horse calls and asks for some living expenses? Remember, at this point, the backer may already resent the large carryover that has accrued. But does he think an underfed player is likely to win back his money? So the backer now has to start paying for living expenses. To me, this just seems annoying for the backer. C'mon, the backer is probably a wealthy and busy person. Does he want to be keeping track of or debating per diems with his horse?

Here is how I believe living expenses should be handled between a backer and player. First of all, don't have a carryover. I know I'm becoming a broken record on this point. Second, the backer should not pay for living expenses either. If the player is not successful enough as just a regular cash game player to have securely stashed away enough living expenses to last for the duration of the commitment, then he probably isn't worth staking in the first place. Since there is no carryover, the player will be getting half (or whatever percentage is negotiated) of all his tournament cash outs, however small. So this can also help to keep him afloat. But if I was a backer, I'd never commit to a term longer than the player himself could pay for his own living expenses out of his own savings. Otherwise, it's just too much of a hassle and an irritant. The last thing a backer wants to see is his failed horse, who claims he needs "X" amount per week or month just to get by on the road, eating at a 5-star restaurant at The Bellagio and realize that he's picking up that tab too. This way the backer doesn't have to resent whatever spending lifestyle the player has, as it doesn't affect him. The backer and player are only tied together financially by the tournaments that are being played.

If you wanted to really plan an arrangement perfectly, you could have a stipulation which allows for the backer to exit the commitment early if the player has somehow demonstrated that he can't really provide adequate living expenses for himself. For example, if the player was hitch-hiking cross country to a tournament instead of flying, or sleeping in his car in the parking lot the night before a big event. I previously mentioned that the backer doesn't want to bet on an underfed horse and this stipulation would give him an ethical and legal out to his commitment. By the way, I have never heard of a staking arrangement with such complex legal stipulations, nor have I ever heard of a player/backer dispute ever going to court. In the new era of big time poker, however, I think it is only a matter of time.

The smartest players and investors should always protect their interests in writing, even if they don't hire actual lawyers to draw up papers. When in writing, it is much more likely that friendly business relationships don't ever get confused and become unfriendly.

I can't say that living expenses could *never* be a good idea for a particular staking arrangement. Some players, who have playing skills worthy of being staked, may not have enough living expenses saved for various legitimate reasons. If you do convince a backer that he should cover your living expenses, make it easier on the both of you. Really plan ahead how this should be handled and what kind of standard of living you both agree to be reasonable. A simple daily per diem rate, along with coach airfare and airport transfers to the tournaments, is probably the best way to go.

Carryover As An Insurance Policy

After learning about all the downsides to a carryover component, you may wonder why anyone has ever even considered one. There are two reasons. First, most people simply never considered many, if not most, of the negatives I detailed above. At least not until it was too late and one of these undesirable situations already reared its ugly head. Second, there is a major benefit for the backer to having a carryover. It is a hedge for the backer, reducing his potential downside by providing a sort of insurance element. Let's do an example to illustrate. In the "losing" scenario, we will see what happens when a player doesn't do so well. In the "winning" scenario, we will see what happens when he does. In both of these examples, we will have a staking agreement where the commitment is for ten $10,000 tourneys or a total outlay by the backer of $100,000. The percentage split is 50-50 on a net basis.

Losing Scenario (50-50 Split)

In this scenario, the player only has two small cash-outs. In tourney #3, he cashes out for $15,000. In tourney #8, he cashes out $40,000. For the other 8 tournaments, he doesn't cash-out.

With Carryover: Because the player had only two small cash-outs, there was never a point where he was in the black. Therefore, he was

not allowed to pocket any of this money. The backer was able to recoup the entire $55,000 in cash-outs.

Bottom Line: Backer loses $45,000. Player makes $0.

No Carryover: The player gets to pocket 50% of each and every net profit (per each tournament independently) because there is no carryover. So he takes away $2,500 from tourney #3 (50% of the $5,000 profit from that tourney) and $15,000 from #8.

Bottom Line: Backer loses $62,500. Player makes $17,500.

Winning Scenario (50-50 Split)

In this scenario, the player has two large cash-outs. In tourney #3, he cashes out $190,000. In tourney #8, he cashes out $560,000.

With Carryover: After cashing out $190,000 in tourney #3, the player was able to pocket $80,000. (50% of [$190,000 minus carried-over cost basis of $30,000]). After tourney #8, player pockets $255,000.

Bottom Line: Backer makes $315,000. Player makes $335,000.

No Carryover: The player pockets $90,000 from tourney #3 and $275,000 from tourney #8.

Bottom Line: Backer makes $285,000. Player makes $365,000.

At this point, you may be scratching your head wondering why any backer would even consider an arrangement with no carryover. You're probably thinking that as important as all the previously mentioned reasons against a carryover are (taxes, relationship killer, pressure relief, and living expenses), they surely don't outweigh the enormous "bottom line" differences detailed in the winning and losing scenario breakdowns. Guess what? You're right. They don't. But that assumes that all these arrangements are 50-50 splits. Who ever said that the "no carryover" arrangement had to be a 50-50 split? It can be anything you and your backer want it to be.

Let's say that you make it a no-carryover 70-30 net split in favor of the backer. Now let's look at these winning and losing scenarios again.

Losing Scenario (70-30 Split In Favor Of Backer)

Remember, in this scenario, the player had two small cash-outs out of the 10 tourneys. $15,000 in tourney #3 and $40,000 in #8.

No Carryover: Now the player gets to pocket just 30% of the net profit per each tournament independently. So he pockets $1,500 from tourney #3 (30% of the $5,000 net profit from that tourney) and $9,000 from #8.
Bottom Line: Backer loses $55,500. Player makes $10,500.

Notice how this compares with the bottom line from the losing scenario with a carryover and a 50-50 net split where: Backer loses $45,000. Player makes $0. Clearly, even with a 70-30 split in his favor, the backer still makes out worse (in this case, $10,500 worse) when there is no carryover in losing scenarios. But we're not finished yet. Notice what happens in the winning scenario.

Winning Scenario (70-30 Split In Favor Of Backer)

Remember, in this scenario, the player has two large cash-outs out of 10 tourneys. $190,000 in tourney #3 and $560,000 in #8.

No Carryover: The player pockets $54,000 from tourney #3 (30% of the net profit of $180,000) and $165,000 from #8.
Bottom Line: Backer makes $431,000. Player makes $219,000.

Notice how this compares with the bottom line from the winning scenario with a carryover and a 50-50 net split where: Backer makes $315,000. Player makes $335,000.

In the 70-30 split, even though there was no carryover, the backer makes $116,000 more than he did in the 50-50 split with a carryover. I can't imagine any backer with a brain who wouldn't jump at a 70-30 split with no carryover vs. a 50-50 split with one. Sure, the downside risk is a little greater, but the potential upside is HUGE.

Of course, if you plug in different hypothetical tournament results, all these comparisons will come out a little differently. But if you run the numbers enough different ways, it is impossible to come up with

a justification for why a shrewd backer would rather go with a 50-50 carryover vs. a 70-30 non-carryover.

What Is The Fair Split With No Carryover?

Let's assume that you don't place any monetary value to the previous reasons I listed (taxes, relationship killer, pressure relief, and living expenses) for why not having a carryover is preferable. Of course, in reality, the monetary value of these is very significant. A logical question is how do you decide what percentage split for a non-carryover arrangement is commensurate with the percentage split of a carryover one? Unfortunately, there is no way to mathematically figure this out. The calculation would have to depend on many factors such as your precise expected fluctuation rate and precise expected return per tournament (both unknowable), along with the length of your commitment, price of each tournament including number of entrants and payout structure, premium the backer places on the "insurance" factor that a carryover component provides, etc.

But why do you need to figure out how a certain non-carryover arrangement compares to some carryover benchmark? Remember that any carryover split figure was an arbitrarily negotiated number in the first place. The percentage split for any non-carryover deal (or carryover deal for that matter) should be whatever you and your backer agree it should be. It is simply based on supply and demand.

Pricing Considerations

Here are a few things for both you and your backer to consider as you are trying to negotiate a split. Living expenses, if they are paid by the player, are in practical terms just as much a part of the tournament investment as the buy-in costs. So if airfare, airport transfers, hotel and food all total $1000 for a typical tournament compared to the $10,000 tournament entry fee which is paid by the backer, then the player is already paying about 9% of the total investment cost. Of course, the time spent by the player in both tournament playing time and preparation time should be considered. And this preparation time is theoretically over an entire career. When you pay your doctor, if you understand the economic theory of skilled labor, you are also compensating him for his many years of medical school and medical practice experience.

Carryover, certainly, has monetary value to the backer because it is a hedge against downside volatility so this should be considered. But non-carryover also has monetary value because of all the reasons I previously discussed (taxes, relationship killer, pressure relief, and living expenses). It could be argued, although I don't agree in most cases, that the practical issues favoring non-carryover are so powerful that if a backer had the choice to go with either a carryover or non-carryover deal, both at 50-50 net splits, he should go with the non-carryover. It just all depends on how much value the backer and player attribute to these practical issues. It will be different for everyone. For me personally, I just feel that the hedge factor is worth more. If you really need my expert guidance, I would probably value it by about a 5 to 10 percentage point swing. So if you are a backer who is comfortable staking a player at 50-50 net split with a carryover, you should also feel comfortable with something in the range of 55-45 or 60-40 net split in your (the backer's) favor and *no* carryover.

Could A Carryover Ever Make Sense?

Theoretically, yes. For practical purposes, no. There are so many practical reasons against a carryover, I think the only way to approach this is first to accept the fact that you will have no carryover. Then, price your arrangement accordingly. The only good reason to have a carryover is because the backer really wants to stake a player, but also *needs* to hedge his bet, either because he doesn't really have enough money to be comfortably staking players otherwise, or he just so values the benefit of reducing his volatility that he is willing to complicate his tax matters, increase his chances of a strained relationship with his horse, put unnecessary pressure on his horse which could backfire because it negatively impacts his playing ability, and increase his chances of having to deal with living expense issues. Is this really a practical decision to be making?

I say, if you can't do it right, you shouldn't be doing it at all. In other words, if a backer isn't rich enough to be able to afford the added volatility even though he's being compensated for it with a better negotiated percentage split, he shouldn't be in the staking business in the first place.

Icing On The Cake For Both Backer And Player

Consider this also, although I realize this is a somewhat tricky notion to grasp. Not only is staking an incredible win-win opportunity because it creates wealth (in the mathematical long run) for both the investor and the player, each of whom wouldn't have had such a profitable opportunity otherwise. Staking also provides another win-win opportunity because a wealthy investor, who can afford to absorb high volatility in return for high returns, gets to buy *additional* expected returns at a deep discount. This is because the player, who is short on required bankroll and eventually needs some sort of income to live off of, is willing to negotiate away long-term value by giving the backer a deeper percentage cut. The player is willing to give this up in order to secure an arrangement that has no carryover and therefore lower volatility yet lower long-term returns for himself, and higher returns with higher volatility to the backer. (If you had a hard time following that idea, here's an illustrative comparison.) It's like a rocket scientist, who disproportionately values great looks in his romantic partner, marrying a supermodel who disproportionately values brains. That's what staking with no carryover can be like. A marriage made in poker heaven.

By the way, I don't see why a wealthy backer and an expert player couldn't have a fruitful win-win staking relationship with very agreeable deal terms to both parties for even as long as the rest of the player's career. Even wealthy players might always welcome even wealthier backers as this enables the player to more freely spend his considerable winnings on things like mansions, sports cars, etc. while never having to worry about always having a $1 million plus bankroll set aside if he was playing regularly in the very highest of tournaments.

Category #2 – Selling Portions

This is very similar to category #1, except that instead of having just one backer, you have more than one. Maybe you have two friends who will invest $5,000 each. You will then be splitting your winnings in half and taking 50% of each half for yourself. For example, if you cash out $50,000, Backer A gets $15,000 (his $5,000 entry fee plus $10,000 in profits. Backer B gets the same $15,000 amount. And you get $20,000. You could have 10 people each invest $1000. You could

even have each person getting different percentages. Maybe you convince one of your investors to give you 60% of their portion of the profits while another only gives you 30%. This isn't recommended if there is any chance of them finding out that another investor has a better deal with you than they do. If you just want to reduce your risk but not eliminate it all together, you could pay for and retain a certain portion yourself. Like in this example, you could put up $5,000 and act as Backer B.

Staking Reality Check

Let me be clear about a couple things. Everything I've recommended so far is how serious staking arrangements *should be* handled. This does not mean that this is how they usually *have been* handled, although the very best have. Most high-stakes staking has been done in a more haphazard way. Usually they are more of a gentleman's agreement, sealed with a handshake between a couple of gamblers. But when handled like this, especially without a lot of before-the-fact communication and understanding of all the issues that need to be hashed out ahead of time, there can be big problems.

When it comes to taxes, this may be a seat-of-the-pants afterthought decision. "You pay the taxes and I'll just hand you "x" amount of money in cash to basically cover this or that kind of equitable understanding. This can work most of the time because both parties believe it is fair enough and they are both basking in the glow of a win. But if they should ever have the misfortune of having the IRS catch wind of their quick fix, the government may not be so understanding of its fairness.

Staking, when it is for just one tournament only, can also be sorted out in a generally satisfactory manner and there aren't many tricky issues. Although, some parties to a staking arrangement have not only forgotten to pre-stipulate regarding taxes, they have also forgotten to decide if the split was going to be on the gross or net profits. You can imagine how messy arguments can be if the two parties are not on the same wavelength here. When you have long-term staking commitments, especially with a carryover component, it can get even messier. However, usually those who enter into longer-term agreements have the good sense to be much more explicit in communicating their terms. Although, many participants in carryover

arrangements have probably not thought through all the issues I've previously covered regarding their potential pitfalls.

Staking Reality Check #2

You may be reading this book thinking that this sort of staking is so common that it is going to be easy for you to find backers once you turn pro. You think, "I'll be a great player. Won't rich, smart investors beat a path to my door?" Uhhhhhhhhhh.... No. Not by a long shot. Just because you believe you deserve to be staked does not mean that others will easily agree. I imagine that there are numerous players throughout the poker playing community who have playing skills well worth staking. I also believe that there are numerous rich people throughout the world who could afford to stake these players and would stand to make a lot of money in the long run if they did. The problem you'll have is convincing these rich people of this fact. Unless you have close connections with someone who has a lot of money, believes strongly in your playing skills, and also believes in making investments that have very high profit expectation along with some high volatility, finding a backer is going to be hard to come by. Who usually stakes poker players? Other poker players. One guy has the good fortune of winning a big tournament and then he acts as Mr. Moneybags for some of his admired poker playing friends or colleagues. Tom McEvoy has publicly admitted to being staked by Phil Hellmuth.

Greg Raymer, the 2004 World Series Of Poker winner, used to solicit backers on the internet before his big score. As he mentions on his website, FossilmanPoker.com, he "caught a lot of flack from the naysayers out there" over this. Even though most scoffed unfairly at his proposal, some smart investors stepped up and partially funded his playing bankroll. He used some of that bankroll to play a $160 internet satellite, which he parlayed into the WSOP entrance fee. When he won the $5 million grand prize, his prescient backers were rewarded with 42% of it. I can only imagine how many of those internet naysayers were kicking themselves for not believing in him. Now, he can almost certainly secure a backer without much difficulty, although he may not need one. That's the cruel irony of staking. Many players who need backers can't find any. And many players who don't could beat their potential backers off with a stick.

It's the shrewd investor who can discover the profitable horse before he has won the Kentucky Derby.

Staking Options For The Mere Mortal

If you don't have rich friends or a high profile playing reputation, you will probably be resigned to the following staking options. Many of them are still quite attractive for various reasons.

Category #3 – Selling Portions Without a Premium

So far we've looked at arrangements that had a "premium." By this, I mean that the backer(s), although paying 100% (or whatever portion) of the buy-in, did *not* receive 100% (or whatever corresponding portion) of the return. Now we are going to explore staking where the backer does receive the exact matching return. This sort of staking with *no* premium is probably the most common form of staking. It is simply a way to enter a bigger tournament than you, as a player, could otherwise afford. For example, you might only have $5,000 to spend, but really want to play a $10,000 buy-in tournament. You could find a friend to pay the other $5,000 and promise him half of your winnings in return. So he is getting the exact same deal terms as you while you are doing all the actual playing. This is still a good deal, though, if no one else will invest in you and this is the only way you could enter the tournament. Of course, finding an investor who would give you a premium like in category #1 or #2 would be much better, but that's easier said than done.

This non-premium arrangement is also a great way that a group of friends, like a home poker club, could pool their money together to send one of their members to a big tournament such as the World Series Of Poker. Maybe 20 of them each put in $500 and send one playing representative. Whatever he wins gets divided in 20 equal pieces among he and his friends. An alternative, and more sporting way to do this, is if they play a winner-takes-all tournament among themselves to win the $10,000. Then the winner uses the money to enter the WSOP with the pre-set understanding that he will get 50% of any cash-out while the other 19 guys will split the other 50%. In effect, by winning the home game tournament, this player has earned the backing of his friends in a Category #2 type arrangement.

One desperate idea would be to offer your friend more than 100% of his share for partially funding you. For example, if he were paying half the entry fee, you could offer him 60% or 75% of the profits. This isn't as crazy as it sounds. If you offered him 75% of the profits while only paying 50% of the entry fee, that would leave you with 25% of the profits while you paid 50% of the entrance fee. You would be getting the same exact ratio terms that backers were getting in the Category #1 and #2 arrangements mentioned earlier if they were structured as 50-50 split deals. This is just as theoretically profitable for you as it is for these backers.[35]

However, I cannot recommend this. For one thing, because you are doing all the work, you shouldn't have to pay a premium to your investors. They should pay you. Second, let's assume that we are talking about a $10,000 tournament. If this is the case, you could just as easily play in one $5,000 buy-in tournament, two $2,500 buy-ins, or five $1,000. Why not do that and keep all the winnings for yourself? I know you probably have your heart set on playing one of these $10,000 entry TV-covered tourneys. But I think the cost is just too high considering the other options you have. A third, and very important, reason is that you are getting backers because they are rich and can afford the fluctuations. When you are giving up all that premium to them, you are increasing your own fluctuations which you really want to reduce. However bad you want to play in the World Series Of Poker, I would rather you sit it out and save your scarce money for a better investment. It's not that this one isn't profitable. It is just that others are even more profitable. The infinitely rich investor can afford to make every single profitable investment he has available to him. You can't.

Most Common Use Of Category #3

While category #3 is the most common form of staking, the most common form of category #3 is players swapping pieces of each other. For example, if you had a friend and you both respected each other's playing abilities, you could swap pieces of each other, such as 20%. So if he wins, you get 20% of his winnings. And if you win, he

[35] If you don't factor in your time as being of any value. Which, of course, it is. But maybe the fun of playing in a big tournament makes it worth offering your time in this regard at no additional cost.

gets 20% of yours. These are usually gross winnings as you both have swapped investments and consider them a wash. So even though you paid $10,000 in entry fees, if you cash out $50,000, you give your friend a gross 20% or $10,000. But make sure to spell this out first so you know you're on the same page.

There are a couple of great reasons to swap pieces. The most important is that you reduce your fluctuations without reducing your expected long-term profit. As long as you are both equal in skill, you can expect to earn the same amount in the long run with this swapping investment technique. But you will not have as long of dry spells. It is much harder for two people to go ten tournaments in a row simultaneously without any cash-outs than it is for one to do so. With a bankroll that is close, but not quite large enough for these sized tournaments, a friend with whom you regularly swap pieces can save you from the possibility of going broke.

The other great reason to swap pieces is that when you are knocked out of a tournament, you often still have a rooting interest if your friend is still in it. That can really lift your spirits. And commiserating over each other's losses or celebrating each other's wins can be much more satisfying when you have vested interests in each other.

Conflict Of Interest

There is an ethical dilemma, however, that such vested friends have. (A dilemma that is also shared by a backer and a staked player if that backer plays in the same tournament himself.) What are you going to do when you face each other during the tournament? The right thing to do is simply to have a pact that during the tournament you will play each other just as hard as you would anyone else. This is the same pact that you should have with any other player you are friendly with in any form of poker.

Tipping

For all forms of staking, you and your backer(s) should decide how you are going to handle tipping (unless the tournament already baked tipping into the entrance fees, in which case, I don't believe there is any call for additional tipping.)

The easiest way to handle this is to tip according to pre-decided percentage of the cash-out, maybe even differently tiered percentages depending on the size of the cash-out.[36] Then treat the cash-out *after tips* as the cash-out amount that you have to do your further split calculations based upon.

The nice thing about tipping is that it usually isn't a major point of contention as both the player and backer are fairly giddy after a score and don't quibble much over whatever amount the player decided to tip, unless it was foolishly high. But, again, the most dispute-proof staking arrangements will think about these issues in advance.

Should You Stake Someone?

Someday you may be in the financial position to stake other players besides just swapping pieces of yourself. It can be very profitable if done right. Just make sure you really know that the prospective horse is an expert player, including expert knowledge of proper tournament strategy. But if you feel very confident in the player's abilities and you can afford it, make the most favorable deal you can make for yourself, cross your fingers, and hopefully count your winnings.

I have no doubt that many shrewd backers have in the past, and will continue in the future, to reap huge windfalls from their astute staking of the right players.

[36] You can learn more about this in the upcoming chapter on "Tipping."

♦ ♣ ♥ ♠
SECTION 3
THE EDUCATION OF
A PRO PLAYER
♦ ♣ ♥ ♠

♦ ♣ ♥ ♠
Section 3 Introduction

I'm always amused by how easy many people think it is to become a great poker player. They see it on TV, or play it a few times in a casino or on the internet and figure that with a little bit of playing experience, they could be that good. It isn't surprising because, as you've learned, short term luck could really play tricks on an inexperienced player's head. "C'mon, I've played in a casino 5 times and won every single time. I certainly must be one of the greatest players that has ever lived! Alright, to be perfectly honest, I did lose that one time, but that was because I forgot to wear my lucky watch so you can't really count that one, right?"

As a future very educated poker player, you should love these guys. They will make you a fortune over your career. If only it could be this easy to become a great player. Unfortunately, like most things in life, it isn't. Or maybe I should say *fortunately*, because if everyone could easily become an expert, who would you win any money from? You, as someone who is willing to work very hard to become a great player, will have a tremendous advantage over all those players who aren't.

♦ ♣ ♥ ♠
Chapter 18
Study The Textbooks

Many people want to play poker for a living, but are unwilling to do the work away from the table that is required. It is probably because playing poker is so easily accessible. If you wanted to start trying legal cases, no one would hire you if you hadn't first gone to law school. In fact, there are laws against it. The same goes for practicing medicine. On the other hand, if you want to play poker, all you have to do is throw a few bucks down on the table and go to it. The problem is you won't be very good at it. You'll probably be quite bad.

Thirty years ago, ambitious players had to learn proper playing strategy by trial and error. They could write down some tips for themselves and even debate theories with other experienced players. But it might take a lifetime of playing experience and strategizing to come up with all the profitable playing ideas that today can be found in one great book. This will help you to become a professional player years, if not decades, sooner than you could have otherwise.

One problem, at least in theory, is that others have access to these great poker strategy books too. But the poker playing pool is so large now and the fraction of players willing to study these books is still comparatively small. Especially those willing to study in a thorough enough way so that they can remember and utilize the tips at the poker table. You are going to be in this poker educated minority.

You will need to study at least a couple of more books and this will just get you the bare minimum of poker knowledge required to win consistently. If you really want to move up the ranks and be as successful as you can be, you will read many more than that. Most professional players probably own at least 10 books and the best ones usually own many, many more.

Are Poker Books Worth It?

Truthfully, some are not. Some poker books are filled with so much misinformation that you could probably lose more money after reading the book than before you had read it. The good ones, on the

other hand, are probably worth their weight in gold. Wait. That might be underestimating their value. Even the books with just marginally profitable advice can pay for themselves many times over if you have a discerning and critical eye. Once you've read the books I recommend and gained a significant amount of playing experience, you should have enough knowledge to automatically dismiss most erroneous information when you read it. But what if you did pick up one or two great new ideas out of an otherwise flawed book? If the tip covered an occasional situation where you could save one bet, and you play $10-20, that could save you $20 each time that situation comes up. And if you're playing full-time, that bet-saving situation might occur tens or even hundreds of times of year. Now multiply that by all the years in your career. Plus, I haven't even mentioned the tips that will enable you to win an entire pot. The profits from a good book are multiplied exponentially compared to the cost. And strangely enough, many of the bad books can be profitable too.

College Comparison

For any other well-paying career, no one would even blink an eye if they were told they'd have to study some textbooks to succeed. Just think about any college-degree-requiring job. You probably buy and study over 50 textbooks throughout your four years. And some of these textbooks are incredibly long, dense, and expensive. The workload required to study poker strategy is almost a breeze in comparison. And I haven't even mentioned the cost of the classes themselves. The total cost of "poker tuition," which includes the recommended books plus some probable initial losses at low-limit tables as you're gaining playing experience, pales in comparison to the cost of college, or even many trade schools. But that doesn't mean I necessarily recommend skipping college. Read chapter 21.

Book Recommendations

The following books are broken up into two categories. "Round 1" and "Round 2." Round 1 books are those that you should read immediately, except for the game specific books that apply to games you aren't interested in playing. The Round 1 books will provide a firm foundation for your poker knowledge. Round 2 books are also very profitable additions to your poker library. They will increase your playing profits for two reasons.

Either they add some useful information that the Round 1 books do not cover. Or they may just present many similar ideas, but in usefully different ways. For instance, they may organize and present some important poker concepts in ways that may make them easier to grasp or resonate more strongly with you. Are all these books absolutely flawless? No. Most poker books, if not all, have at least some flaws. But these are among the best, containing the fewest ideas that I would contend with.

Although you could probably make a living with just the Round 1 books, you will make much more money if you read the Round 2 books too. All these books are listed on my website, MarkBlade.com, along with useful poker videos and software. As a service to my readers, I have links to internet stores where you can find each of these items at discounted prices.

Round 1 (Game Specific Books)

The following books are absolutely necessary if you intend to play any of these particular poker games. The first two books are intended for limit hold 'em. But even if you only intend to play no-limit hold 'em, you must also read at least one of these, and hopefully both, as many of the concepts are applicable to your overall hold 'em knowledge.

Small Stakes Hold 'em by Ed Miller, David Sklansky, & Mason Malmuth

If you are early in your playing experience or still playing low limits for any reason, this is the best book for you. It will specifically teach you how to beat the low-limit games. These tables are where all beginners should get their initial playing experience, unless you don't care about losing a lot of money during your initial learning curve. If you are absolutely brand new to playing Texas hold 'em, then you might want to start with another book, *Hold 'em* by David Sklansky, before you even read this book. If you are an experienced player who is already playing in middle-limit or higher games, then Small Stakes Hold 'em can be placed in Round 2. Although it should be close to the top of your Round 2 list as it has many pieces of advice that are useful for players of any playing level.

Hold 'em Poker For Advanced Players by David Sklansky & Mason Malmuth

This, as of now, is still the best Texas hold 'em book you will find. If you have a decent amount of playing experience, you could probably start with this book first. If you are just starting out, you should read *Small Stakes Hold 'Em* first, and then this one as you start thinking about moving up the stakes ladder.

Seven Card Stud For Advanced Players by David Skanasky, Mason Malmuth, & Ray Zee

This is a comprehensive book on the game of seven-card stud.

High-Low-Split Poker: Seven Card Stud and Omaha Eight-or-Better by Ray Zee

This is a comprehensive book on two different games, 1) seven-card stud high-low eight or better and 2) Omaha high-low eight or better.

Sklansky on Poker by David Sklansky

Half of this book is a textbook on the game razz (seven-card stud played for low only, a game that is rarely played today). The other half has general poker topics that are valuable to all players. If you don't care about Razz, then consider this as a Round 2 book.

Pot-Limit And No-Limit Poker by Stewart Reuben & Bob Ciaffone

This book is designed to take someone who already knows how to play a particular game in limit fashion, including hold 'em, and teach him how to play this game in a no-limit or pot-limit betting structure. I have included it here under "game specific" books because any game when played in no-limit or pot-limit fashion is, in some ways, a different game all by itself. This book includes separate sections for games besides just hold 'em, such as Omaha, seven-card stud, and lowball.

Tournament Poker by David Sklansky

This is the best book out right now on specific strategy for playing tournaments. If you intend to play tournaments, it's a must have. Although it doesn't apply to one specific game, I included it here among the "game specific" books as tournaments are, in a way, a form of poker all unto themselves.

Round 1 (General Books)

Professional Poker 2: The Mental Game by Mark Blade

This book, in many ways, is my proudest achievement. It teaches you what I consider to be the most neglected lessons in all of poker. So many poker books teach you the mechanics of poker, but then leave it up to you to figure out the mental aspects. You will get a taste of what is in this book when you read Section 5 of the book you are holding in your hand right now. But that only scratches the surface of what is in *Professional Poker 2*. Yes, there are many additional, powerful pieces of advice on how to eliminate the mental and emotional baggage from your head that prevents you from focusing with laser sharp concentration on your playing decisions at hand. But not only will it help you to become a sort of "Zen Warrior" at the poker table, it also goes into great detail on many other mental aspects of the game. Basically, it covers every thought that should be in your head at the table that does not more appropriately fit into *Professional Poker 3: Strategy & Theory*.

The reason that I am so proud of the book is because I believe it will have a bigger financial impact (more winnings at the table) on many readers than any other poker book in print. Even if you already know a lot about proper playing strategy, every additional great playing advice book you read is like adding another profitability layer on your poker cake. But what if you are fairly well versed in poker playing strategy, but for whatever reasons, have a hard time at the table getting yourself to execute that strategy? Or in other words, what if there is a book that can help you to more often play the "A" game that you are capable of playing? If that is case, then such a book isn't going to add another layer of profitability to your cake.

It is going to add an entire additional cake!

Professional Poker 3: Strategy & Theory by Mark Blade

This book covers all the major concepts of poker strategy, using examples primarily from no-limit and limit hold 'em, along with tournaments. Although it is not considered as a substitute for the game specific books listed above, it is just as important to your poker profitability, if not more so. You should read it concurrently with at least one of the game specific books that you are interested in. Obviously, you can't expect an objective review from me on my own book. But suffice it to say, that it is up to my highest standards, and, as with any book that I will ever put out, it introduces many ideas and profit-boosting tips that have never before been found in all of poker literature. (If it or the previous book in the series, *Profesional Poker 2: The Mental Game*, are not yet available at the time you are reading this, check MarkBlade.com for their anticipated arrival dates.)

Although you can greatly benefit from reading additional books and I highly recommend that you do so, Professional Poker 3 completes what I consider to be the indispensable trilogy for the professional poker player. With these three books plus the game specific book or books that apply to your situation, along with the right work ethic, you should be able to absolutely devour the great majority of your competition.

The Theory Of Poker by David Sklansky

For years, it has been considered a must have for any serious player's poker library. And why shouldn't it be? It's packed with profitable playing advice and gives you a foundation of poker principals that can be utilized in any game of poker. The only criticism I could possibly see a reader having with this book is that it makes many of its points by using examples from poker games such as razz and lowball. These are games which you, and most current players, have probably never played, nor ever will. That doesn't mean that these concepts aren't necessarily applicable to a game like Texas hold 'em. They usually are. It is just that many readers might have to work a bit

harder to understand them. Don't get the impression that all the examples are from games like razz. Many are from more popular games such as hold 'em and seven-card stud.

Round 2

Caro's Book Of Poker Tells by Mike Caro

This is the definitive poker book on tells. Tells are either verbal or non-verbal clues in which your opponent inadvertently gives away the strength or weakness of his hand. Reading tells, although not a foolproof science, can be a profitable weapon in your poker arsenal. Reading tells is easier against low skilled opponents, and more valuable in no-limit than in limit games. Beware that other skilled players may have also read this book and may purposely give off false tells.

This book almost made it into Round 1, but I've put it here for a reason. Learning too much about tells too early in your playing experience can be dangerous, especially when playing limit poker. For example, if, by the river, the pot had gotten quite large and you detected a possible tell that indicated your opponent had the nuts, you might fold your strong hand. This would be tragic. Often in limit poker, even if you suspect something because of a tell, the pot odds are too strong in favor of some other action that you cannot chance acting on it. Once you have gained some experience, you can implement the ability to read tells properly into your game. Note: Disregard Caro's value per hour amounts. They are ridiculously high. If you added up all the supposed value from your ability to master each of these tells, you'd instantly become the most dominating poker player the universe has ever known. But it's no big deal as there's no serious harm done by Caro's exaggeration of these dollar values. Mike Caro is such a great voice in the poker education world that I'll easily forgive him for this hyperbole.

Middle Limit Holdem Poker by Bob Ciaffone and Jim Brier

This book has hundreds of sample hands which make up the majority of the book. When you get to learn from poker experts who

walk you through their thinking in actual real-world playing examples, you learn a lot. You know I believe very strongly in the value of this book as I list it in the previously mentioned "Blade Method" quiz. The only problem I have with this book is that I do not agree with every single check, call, raise, or fold that they recommend. Although the large majority I do.

This is how you should think about this book. Once you've read the two or three Round 1 recommendations and have some playing experience, get this book. Imagine yourself in a conversation with Ciaffone and Brier. They are your two winning poker player friends. You are all discussing the playing decisions in this specific situation and that. Listen to their reasoning. You will soon be able to dissect poker decisions with the same in-depth analysis as they do. Maybe you'll disagree with your friends here or there. But you will be much better informed from at least hearing their thoughts first. This book, especially when handled like I've described, will be a very profitable addition to your game.

Poker Essays, Poker Essays II, and Poker Essays III by Mason Malmuth

A variety of poker topics are covered in these three books. When game strategy is involved, he usually emphasizes hold 'em and seven-card stud. These books are especially useful to professional players.

Poker, Gaming & Life by David Sklansky

Similar to *Poker Essays*, this book covers many poker related topics. You might remember that this book was referenced in my Bankroll Management chapter. You will want to eventually read all the details about this topic and many others. Even if you didn't play poker, this book would be an interesting read for the small portion reserved for topics on "life." He has very compelling and fresh views on subject matter from the legal system to race relations.

Gambling Theory & Other Topics by Mason Malmuth

This book was also referenced in my bankroll chapter. Besides bankroll insight, he provides useful poker and general gambling concepts. Also, when he does a revised printing, you can find up-to-date and useful reviews of just about every poker book in print up to that point.

Improve Your Poker by Bob Ciaffone

A variety of poker topics are covered. I have a lot of respect for Ciaffone as a poker instructor.

Inside The Poker Mind by John Feeney, Ph.D.

Don't let the title fool you. Although the author is a psychologist, this is not just a book on poker psychology. There are also some down-to-earth, rock solid, poker playing tips. But the title does capture the biggest strengths of this book. Just the few pages on the topic of tilt alone are worth the price.

The Psychology Of Poker by Alan N. Schoonmaker, Ph.D.

I'm glad that a couple of psychologists have entered the poker book fray. This is one side of the game that has been lacking in valuable insight. This book will add another dimension to how you evaluate your opponents' and your own play. The other thing I like about a book like this is that very few of even the best players spend much time on these psychological topics (although for many it may come naturally). This could be your leg up on them.

Internet Texas Hold 'em by Matthew Hilger

This is a solid book packed with mostly accurate playing advice, although it doesn't have many new ideas on Texas hold 'em that you won't have already learned from the Round 1 books. If you play a lot online though, this is something you'll want to own. Also, it might be worth buying even if you are just a brick & mortar player, as it is very

well organized and can act as a nice refresher course. It also has the most comprehensive starting hand strategy chart I've ever seen organized in a reader friendly manner.

Super/System by Doyle Brunson

Various authors tackle various forms of poker. Since it was written decades ago, some of the info is dated. But there are still many valuable insights to be gained, particularly the no-limit advice from Brunson himself. An updated version, *Super/System 2*, has just been published. When I read it, I'll post my review on MarkBlade.com.

Any Book or Video by Mike Caro

Mike Caro is one of the greatest minds in poker. He dubs himself as the "Mad Genius" and I couldn't agree with the moniker more. Most of his advice is genius. You will find many ideas that no one else has come up with on their own. Occasionally, though, you will find a few pieces of his advice to be "mad." He espouses a crazy, loose image, that if it works, can probably only be pulled off to maximum profitability by himself. Also, he tends to recommend certain playing strategies, particularly with starting hands, that don't quite ring true to me. That all being said, once you've read and played enough that you won't be easily swayed by his occasional flawed advice, you will find him immensely valuable and just downright entertaining. Buy his books and buy his videos. If you are playing full-time, they will surely pay for themselves many times over. And even if they didn't, they will certainly make you smile and laugh, especially when he leads you into shouting out his affirmations.

Other Recommended Poker Authors

Lou Krieger has always struck me as someone with very solid advice to share. I can't imagine that any reader could ever go wrong with one of his books. I would trust just about anything he writes on poker to have a high likelihood of being accurate. And as far as sheer writing talent goes, he is probably near, if not at, the top of the poker heap as he can articulately explain various poker concepts. My only quibble with him is that for a seasoned pro like myself, I rarely find him to break any new ground by offering unique or fresh poker ideas that I haven't read or heard anywhere before. In

fairness to him, I haven't read every single book he's written so maybe he has some cutting-edge gems out there. That said, for the vast majority of the playing public, they would be well served buying any of his books. Even seasoned pros should buy his books as they are such well-written refresher courses. I particularly tip my hat to him for one very clever idea he had for his book *More Hold 'Em Excellence*. On the inside of the back cover, he has a color-coated starting hand chart that is probably the easiest way for a player to memorize which hands should be played from which positions.

Roy Cooke is a columnist for Card Player magazine and I've always been a fan of his articles. I shamefully admit that I haven't yet gotten around to reading any of his books, though I certainly plan to. See, you and I are in the same boat. We both have our reading assignments. Anyway, if Cooke's books (I like the sound of that) are anything like his columns, and I can't imagine why they wouldn't be, I'm sure they are first rate.

T.J. Cloutier and **Tom McEvoy** have written some books together, while McEvoy has also written some with **Brad Daugherty** or alone. Although I find myself disagreeing with some advice in these books a little more often than I disagree with the previously mentioned books, there is still a lot of value here. Why wouldn't you want some additional poker insight, particularly from a very consistent tournament winner such as Cloutier?

Lee Jones has a popular book titled *Winning Low Limit Hold 'Em*. Like Krieger and Hilger's work, his book is very valuable as he has a very well organized and easily digestible way of presenting important poker strategies. My only quibble is that this book is not densely packed with information and doesn't break much new ground as far as poker theory goes. But in fairness to him, that is probably not the audience he is going for. So if you want a nice introduction to Texas hold 'em advice, particularly for low-limit games, and don't want to spend the greater time and effort that the Round 1 books require, then this is an ideal book for you. In fact, I highly recommend it for the great number of casual, recreational low-limit players. I'm just not sure that many readers of my book will fall into that category.

Poker Books Final Thoughts

This is not a comprehensive list of every poker book ever written. There may be some great ones that I haven't covered. There are definitely many bad ones that I haven't mentioned. As I read new books that come out, I will have more up to date reviews on my website, MarkBlade.com, along with the previously mentioned links to discounted internet prices for these newer books, along with the ones I have already listed. So please check there for updates before purchasing a new poker book. There are two surefire safe bets as far as upcoming poker books go. Of course, any books that I write in the future (and by the time you read this, there may be a few new ones) will be the most profitable books you could ever buy.

TOOT-TOOT-TOOT! – Did you hear that? That's the sound of my own horn blowing. But seriously, I would only write poker books that you could basically take straight to the bank. And, as I believe I've already demonstrated, my books will never be just complete rehashes of previously published ideas like the majority of new poker books are these days. My books will always contain, at the very least, a considerable portion of original poker thought that even experienced professional players can use to increase their profits.

Alright, enough. I'm so winded from blowing this horn that I'm gasping for air.

After my own books, the next best ones are usually anything that Two Plus Two Publishing puts out. That is the book company run by Mason Malmuth and David Sklansky. As long as those current owners stay in place, you can be pretty confident that they have reviewed and personally believe in the validity of any books under their banner.

Final Thoughts #2 (now that's an oxymoron!)

Just because you see that a well-known poker star has written a book, don't assume it's any good, although it certainly could be. Some of these guys just try to capitalize on their popularity with a book that has very little practical value. There may be some interesting anecdotes, or if they provide poker tips, these tips will not necessarily

be wrong.[37] They are just rarely very information packed. It's a shame because it would be a great resource to tap these poker minds for everything they know.

I suspect that some of these high profile books are lacking for one of two reasons. The big-name player may not want to reveal all of his secrets, worried that opponents will now know how to better play against him. That's a valid worry. Just as likely, if not more so, is the fact that while these may be great players, they are usually not great teachers. They just don't understand how to best organize and express everything they know about poker into book form. Hey, if you want to learn how to play golf, you'd probably be better off going to Butch Harmon, the renowned golf instructor, than Tiger Woods himself.

Poker Magazines

Various poker magazines come and go. The top selling one right now is Card Player and has been for many years. It is packed every two weeks with many useful articles by some of poker's best writers. I highly recommend that you subscribe if you don't already get free copies at your local card room. After studying some of the recommended books I've already listed, you should be able to sort out the information in the articles with a critical eye. One of the best things about Card Player is that it will also keep you on top of any news or changing trends in the poker world.

I suspect that as poker continues gaining popularity, other magazines may try to challenge Card Player's current king-of-the-mountain position. Keep your eyes out for them as they could be useful also.

[37] Although, they certainly could be.

♦ ♣ ♥ ♠

Chapter 19
Do You Need To Be Good At Math?

The answer is yes and no. You certainly don't need advanced math like calculus. You don't even need to have been good at math in grade school or high school, although if you were, you will probably have a little easier time of it.

What you do need to become an expert in is "poker math." Maybe "need" is too strong of a word. I must admit that if you examined a pool of professional players, some would have almost no math skills whatsoever. Instead, they have such a natural poker sense, probably developed over many years of playing, that their decisions are generally sound in a mathematical sense even though they weren't designed that way. They are the exception to the rule, even though they may represent a decent amount of the professional pool.

Why Some Non-Mathematical Players Succeed

What do I mean by this? If you take a bunch of aspiring poker players, who don't want to learn poker math, and throw them at the success wall, only a very few of them will stick. If you take a bunch of aspiring poker players, who dedicate themselves to learning poker math, and throw them against the same wall, a much higher percentage of them will stick. The fact is, though, that the number of players in the non-math pool is much, much larger to begin with. So even though they are quite unlikely to succeed taking this route, the small percentage that do, end up representing a significant portion of the professional community. As you rise up in stakes, these non-math players find it harder and harder to keep up. At the highest levels, it becomes extremely difficult.

How is it even possible to be a good player without poker math skills? Let's look at an example. In a particular hand situation, let's say a player, who is an expert in poker math, concludes that he shouldn't call this particular bet unless there are exactly 10 big bets in the pot or more. A non-math natural might sense this instinctually. Maybe he wouldn't hit it right on the nose, but he'd know that his hand was enough of a long-shot that he needed a larger sized pot to warrant a call. This ballpark accuracy may be enough for him to earn

a solid living, especially if he is exceptional in just about all the other poker skills. Of course, he could earn even more if he could just get his poker math skills up to par as well.

You Can Outplay A Mathematical Genius

The fact is that even a mathematical genius does not know everything you need to know to make every decision. There is both art and science to playing poker. The math expert may be able to figure out precisely what his mathematical chance is to hit his flush in a certain situation. But unless his opponent's cards were showing, he wouldn't know precisely what his chances were of that flush being the better hand, except in those situations where he was drawing to the nuts and knew that he needed to hit his draw to win. Most situations aren't so clear cut. So the mathematical aspect only plays a part of the decision-making equation. But it's a big part. So big, in fact, that if you master it, you will instantly elevate your game by leaps and bounds. And if you ever aspire to be in the top echelon of poker professionals, you should become an expert in poker math along with every other aspect of the game.

The great part about poker math is that it can be learned by just about anyone who is dedicated enough to really study it and work hard at it. All poker skills are not like this. Some of the art of poker such as reading hands and players, bluffing at the right times, or picking up tells can only be taught so much. The best players may bring some innate facility for these skills with them.

So lacking poker math skills is like boxing with one hand behind your back. If you are good enough, you'll still be able to beat up some of the weaker competition, but you'll probably never be the heavyweight champ. And why would you want to make it so hard on yourself? Get over your fear of math and dive right in with an open mind and a can-do attitude.

Chapter 20
What Do You Need To Know About Odds?

Poker math really comes down to understanding odds. The first kind of odds you need to learn about are your odds of making a hand that you are drawing to. This doesn't require a lot of mathematical aptitude because you can just memorize the following odds tables. But it does require some effort.

Understanding Outs

To understand these tables, you must first understand what an "out" is. An out is one specific card that can complete your desired hand. Let's say that after the flop, you find yourself with four hearts. That means that there are 9 remaining hearts left in the deck or in the other players' hands that can make your flush. Of course, if any of these specific hearts are actually being held by other players, they cannot be dealt on the turn or river. But because we can't see the other players' hands, we include all 9 unseen hearts as your outs and make a mathematical probability calculation based on your 9 outs out of the 47 unseen cards left. The two cards in your hand and the three on the flop are the 5 seen cards. You do not have to keep track of how many cards are still left unseen because those numbers are already baked into the following tables. All you have to know is how many outs you have. Here are a few common situations:

# Of Outs	The Hand That You Have
4	Inside Straight Draw
6	Two Overcards Drawing To A Pair
8	Open Ended Straight Draw
9	Flush Draw
15	Straight Flush Draw

After some practice, you will start to get good at figuring outs. For example, if you have K♥Q♠ in your hand and the flop is J♦10♣3♥, you can figure that you have 14 outs. The open ended straight draw, plus the chance of either your king or queen (the two overcards) making a pair.

If you had K♥Q♥ and the flop was J♥10♥3♠, notice that you no longer just have a straight draw plus two overcards, you also have a flush draw. You might think you have 23 outs. This seems to make sense because you add up 6 outs for the overcards, plus 8 outs for the open ended straight, plus 9 outs for the flush. But this is wrong because you have mistakenly counted the A♥ and the 9♥ twice as they belonged to both the straight and the flush categories. You only have 21 outs. So be careful as this often happens when you are figuring straights or flushes into a multiple-out-category grouping.

Discounting Of Outs

Once you have figured out the number of outs you have, you must realize that each of these outs does not guarantee you of having a winning hand unless you are drawing to the nuts (the best possible hand considering the possibilities afforded by the board cards). If you aren't drawing to the nuts, you must consider your chances of hitting one of your outs and still losing. This calculation is just a judgment call on your part. This judgment is best honed through a lot of playing experience. It depends on what types of hands you believe your opponents are likely to be holding.

Factoring into your judgment is the fact that certain types of draws are inherently more likely to catch one of their outs and still lose. For example, with two overcards, you will often make your pair and still get beat by someone with a higher kicker, two pairs, a straight, a flush, or even better. If you are drawing to a heart flush, you are much more likely to win if you have a K♥8♥ in your hand as opposed to just 9♥8♥. With A♥8♥ in your hand, you will know you have the best hand if you get your flush unless a pair or straight-flush-making possibility is on the board.

Explanation Of Table #1 – The Next Card

The following table refers to your chances of making a hand on the very next card you are dealt in Texas hold 'em. Let's say that once the flop is dealt, you find yourself with just two overcards. You have 6 outs to make one of your pairs. So if you want to check out your chances of hitting one of these outs on "the next card" which is the "turn," you first find the row that corresponds to your outs. Once you've found the row for "6" outs, then find the "turn" column and

see that you have a 6.8 to 1 chance of getting your pair on the turn. Let's say that everyone checked on this round and now the turn card comes. It is a low card that doesn't seem worrisome. So you are still very interested in what your chances are of hitting either of your overcards. You now check the "river" column and see that your chances are 6.7 to 1. Very close to what your chances were on the turn, but a hair better as there is one less unseen card remaining.

Because the next card odds are very close regardless of whether you are on the flop and thinking about your chances on the turn, or on the turn and thinking about your chances on the river, I have added one more column called the "next card average." This is really the only number you have to learn, and just apply it to any next card situation.

Table 1 – The Next Card

# Of Outs	Turn Odds	Turn %	River Odds	River %	Next Card Average Odds
2	22.5	4.3	22	4.3	22.2
3	14.7	6.4	14.3	6.5	14.5
4	10.75	8.5	10.5	8.7	10.6
5	8.4	10.6	8.2	10.9	8.3
6	6.8	12.8	6.7	13	6.7
7	5.7	14.9	5.6	15.2	5.6
8	4.9	17	4.75	17.4	4.8
9	4.2	19.1	4.1	19.6	4.2
10	3.7	21.3	3.6	21.7	3.6
11	3.3	23.4	3.2	23.9	3.2
12	2.9	25.5	2.8	26.1	2.9
13	2.6	27.7	2.5	28.3	2.6
14	2.4	29.8	2.3	30.4	2.3
15	2.1	31.9	2.1	32.6	2.1
16	1.9	34	1.9	34.8	1.9
17	1.8	36.2	1.7	37	1.7
18	1.6	38.3	1.6	39.1	1.6

Explanation Of Table #2 – Seeing It Through From Flop To River

The following table refers to your chances of making a hand if you are willing to see both the turn and the river in Texas hold 'em. The second and third columns called "Turn Or River" refer to those times when you need to know what your chances are of making your hand whether your desired out comes on the turn or the river. So for example, if you have four hearts on the flop, you still have your 9 outs, but these two columns show you your chances of hitting your hand by the river regardless of whether your fifth heart comes on the turn or river, or even both.

The fourth and fifth columns provide figures that many poker experts neglect to mention numerically, although they do speak of them conceptually. These figures are your chances of making a hand if you need one of your outs to come on both the turn and the river. This is commonly referred to as a "backdoor" hand. Let's say that on the flop you only have three hearts. In certain situations, you will want to know what your chances are of hitting your flush by the river – a "backdoor flush." To do this, you will need a heart on both the turn and the river, hence the name of the column, "Turn And River." Remember that in this case, you have 10 outs to begin with, not 9, so you find that you have a 23 to 1 chance of hitting your flush.

Table 2 – Seeing It Through From Flop To River

# Of Outs	Turn Or River Odds	Turn Or River %	Turn And River Odds	Turn And River %
2	10.9	8.4	1080	.1
3	7	12.5	359.3	.3
4	5.1	16.5	179.2	.6
5	3.9	20.4	107.1	.9
6	3.1	24.1	71.1	1.4
7	2.6	27.8	50.5	1.9
8	2.2	31.5	37.6	2.6
9	1.8	35	29	3.3
10	1.6	38.4	23	4.2
11	1.4	41.7	18.65	5.1
12	1.2	45	15.4	6.1
13	1.1	48.1	12.9	7.2
14	.95	51.2	10.9	8.4
15	.85	54.1	9.3	9.7
16	.75	57	8	11.1
17	.7	59.8	6.95	12.6
18	.6	62.4	6.1	14.2

Why Are Percentages And Odds Listed?

When you start implementing these numbers into your game, it is probably best to stick with just memorizing the odds numbers. These are most practical as you will also be counting the pot amounts in figures that correspond to odds. (This will be explained shortly.) Once you get very advanced, you will want to know the percentage numbers also, especially when you do some away-from-the-table thinking about your proper playing strategy. When combining numbers from different tables, you will add these numbers using percentages. For example, you may have an inside straight which provides a 16.5% chance of hitting your straight by the time you get to the river.

You also want to consider the fact that you have a backdoor flush draw which gives you a 4.2% chance of hitting your flush. So the chance of hitting your straight or flush, assuming that none of these outs overlap, is 20.7% (which is 16.5% plus 4.2%).

To convert this number to odds, you substitute 20.7 for "x" in the following equation: (100-x)/x
This gives you (rounded off) a 3.8 to 1 shot of hitting either a straight or flush by the river.

An easier way for you to get a close estimate of your odds without using this formula is to just extrapolate from some other numbers in these tables. For example, in the table 1 "turn" column, you will find that 21.3% (for 10 outs) equates to 3.7 in odds. The 19.1% (for 9 outs) equates to 4.22 in odds. So the 20.7% that we are trying to convert fits somewhere in between, but closer to 21.3% than 19.1%. So you could easily guess around 3.8 simply from extrapolating from numbers that are close on the tables, and be rather accurate without doing any calculations. So now you know that the "frontdoor" inside straight draw plus the "backdoor" flush draw totals to about a 3.8 to 1 shot. That's a noticeably better chance of hitting your hand than if you had just figured the inside straight draw alone which was a 5.1 to 1 shot. Many times in real world playing conditions, this difference is enough to turn a recommended fold into a call.

Other factors do also apply to your decision making, as you will soon learn, along with the fact that you will not be forced to call on the turn if you don't hit the first half of your backdoor flush.

I have only included figures for 2-18 outs.[38] Pots are almost never big enough to consider playing with a 1 outer. Over 18 outs and almost all pots are not just worth playing, but usually worth pumping up on the flop even with just one caller and pumping up on the turn with more than one caller. Of course, discounting outs, and balancing how to best build a pot vs. thinning out a crowd so you can increase your chances of winning that pot also factor strongly into your decisions.

[38] I will include more comprehensive odds tables in my book, *Professional Poker 3*, which may be out by the time you are reading this.

Table Reading Tip

Remember that all the "odds" numbers refer to the odds "to 1." So if the odds number is "8.4" then it means you have an 8.4 to 1 chance of making your hand with the 1 referring to you making it. In other words, you will only make your hand 1 time for every 8.4 times that you miss it. In the "percentage" columns, the number is the percentage chance of making your hand. So "10.6" in the percentage column means you will make your hand just over 10% of the time.

Warning: Difficult Reading Ahead

The next few topics on pot, implied, and reverse odds get progressively more difficult. Please try to hang in there. If you hate math, you'll probably want to strangle me by the time you are done reading them. But I plead with you to read them very slowly or read them over a few times if necessary. They are very important to your game, particularly if you want to achieve the highest earnings potential that you possibly can.

Additional Note To Readers: The theme of this book you're reading right now is so broad that it does not provide the space for me to teach you about poker odds and math or many other extremely important poker strategy topics as completely as the subject matter requires. To present this information in the most complete way so that you can most easily understand, digest, and make use of it all would require a much more drawn out approach.

So if you do not understand all these complex topics, even after reading them over a couple times slowly, not to fear. Your poker career dreams are still alive and well. I am coming to your rescue with an upcoming book, *Professional Poker 3*, which I believe will be the most comprehensive, expert-level analysis packed, yet reader friendly, poker strategy book ever published.[39] Oh, did I forget to mention that it will also dramatically increase your profits at the table, no matter what level of expertise you are currently at. Alright, alright, grab the remote and turn off my infomercial so you can get back to the book.

[39] If this book is not already available at the time you are reading this, please check MarkBlade.com for the scheduled availability.

Pot Odds

The odds tables don't mean much if you don't know the odds that you are receiving from the size of the pot. If there is $90 in the pot and it costs you $10 to call, you are getting a 9 to 1 payoff if you win the pot. In the simplest terms, you will just compare your pot odds to your drawing odds. If your pot odds are greater, you would want to call. If not, you would want to fold. If they are tied, you can call or fold, it doesn't matter. As you will soon see, however, there is more to the analysis than just pot odds. In fact, comparing your pot odds to your drawing odds only really applies when putting in your money puts you all-in or all of your opponents are all-in when they put in their money.

Implied Odds

If these all-in situations do not apply, then you should take your analyses to another level of sophistication. This next level concerns implied odds. This refers to the fact that there probably will be additional betting on the next round(s). For example, let's say you're on the turn. There is one player against you and you are playing $5-10. He bets the turn and, for argument's sake, you know that he has a pair of Aces with no big draws. You have a flush draw and nothing else. So you need to hit your flush. If you do, you'll win the pot. If you don't, there's no way you can win because even if you bluffed, we'll assume he'd call. You might look at the odds chart and see that you have a 4.1 to 1 chance of hitting your hand. That means that, according to our previous pot odds discussion, there would have to be over $41 in the pot to make it worth calling a $10 bet, as your pots odds must be greater than 4.1 to 1. If there is only $35, you might conclude that you shouldn't call as your pot odds would be only 3.5 to 1. But if you knew that he would also bet or call another $10 on the river, you can figure that you are getting a $45 return (not $35) on your $10 bet. So your "implied odds" are 4.5 to 1. This is what you should base your decision comparison on. And because your implied odds of 4.5 are greater than your drawing odds of 4.1, you should call as opposed to fold.

Reverse Implied Odds

The precise definition of "reverse implied odds" seems to differ from one poker expert to another. I'm not even sure who first coined the term (maybe it was Sklansky?), but it doesn't really matter. I'm going to explore a few odds concepts that I'll put under this topic umbrella, but you can call them any term you want.

Reverse #1

First, you must realize that all your outs won't necessarily win you the pot. So your pot odds or implied odds may not be as strong as you think. You must reduce them by making your best educated guess as to what your chances are of winning the pot. If you think that the hand you are drawing to will only hold up (win the pot) half of the time that you get there, then you must reduce the pot or implied odds by half. This makes a major impact on your specific threshold between calling and folding. Let me give you an example. Let's say that the turn card has just been dealt. You are drawing to a possible flush on the river. Because of your playing experience in this type of situation, let's say you assess that your made flush will win 75% of the time that you get there. Maybe you have reason to worry about a higher flush (or maybe a full house) being made by one of your opponents. You have calculated your implied odds to be $45 to $10 or 4.5 to 1, just like in the previous example. But with your 75% assessment, you must only figure your "reverse implied odds" as a $33.75(75% of $45) to $10 payoff, or 3.375 to 1 odds. This is less than your drawing odds of 4.1 to 1. So you should fold.

Reverse #2

Another thing to consider is the fact that in certain situations, you will be putting in extra bets in the future without knowing that you have the winning hand. Let's say that you flop a straight. There is also a pair on the board and three flush cards. Your experienced opinion tells you that you only have a 20% chance of this hand holding up as the winner by the time the hand is over. That is equivalent to drawing odds of 4 to 1. There are 7 small bets in the pot right now after three opponents have made 1 bet on the flop and

are awaiting your action as you are last to act in this round. So your pot odds are 7 to 1. That alone would seem to make calling worth it.

But now you've learned about implied odds and decide to factor that in too. You make an educated guess that there will be one round of betting on both the turn and the river. You also make an educated guess that one of your opponents won't call on the turn, but the other two will call on both the turn and river. So you add in 2 big bets on the turn plus 2 big bets on the river for a total of 8 more small bets that your opponents will provide on the following two rounds. Now your implied odds aren't just 7 to 1, they are (7+ the 8 additional small bets) to 1, or in other words they are 15 to 1. Therefore, your implied odds are *much* greater than your drawing odds (which you have effectively assessed as 20% or 4 to 1) so you figure you should call. Not so fast.

To get to the end of the hand, you will also need to call these bets on the turn and the river. So assuming that you do so, you are effectively deciding right now to not only put in the 1 small bet right here on the flop, but also 2 more small bets on the turn and 2 more small bets on the river. So you are, in effect, deciding right now to bet 5 small bets in an attempt to win 15. So your reverse (#2) implied odds are 15 to 5 which reduces down to 3 to 1. You must compare this 3 to 1 figure to your "drawing" odds of 4 to 1. Wow, this changes everything. Now, you have just determined that you should fold this hand because your reverse implied odds are not greater than your drawing odds. In order to justify a call, there would have needed to be greater than a 20 small bet payoff. By "payoff," I'm referring to the amount in the pot right now, plus the total of all of your opponents' future bets (not your flop or future bets) on the turn and river. This would have meant that your reverse implied odds were greater than 20 to 5 which reduces to 4 to 1. If the reverse implied odds equaled precisely 4 to 1, then it wouldn't matter if you called or folded as, in the long run, it is an absolute wash. You would not win any money, nor lose any money.

Of course, making educated guesses as to what the chances were that your hand would hold up and what the chances were of certain amounts of betting taking place on the next two rounds were absolutely key toward providing the foundation for this mathematical

assessment. This is how the art of poker and science of poker intersect.

I realize that this might not be easy to understand at first read. Please, keep trying until you get it. Unfortunately, it's about to get even a little trickier. Hold on to your hat.

Reverse #3

Another thing to consider is backdoor draws. For example, when you are drawing to a backdoor flush, you see from Table #2 that with 10 outs (remember this is backdoor flush draw vs. the 9 outs you normally think of for a frontdoor flush draw) your drawing odds are 23 to 1. Let's say that 5 players, including you, had put in 4 small bets before the flop. Then on the flop, all four players bet (or called) one bet before it gets to you. You have 24 small bets in the pot compared to your 1 small bet required to call. To illustrate this point, we will assume that you will win every time your hand gets there (makes the flush).

With all the lessons you've learned, you might think that you've got this problem figured out. A simple assessment, by just comparing your immediate pot odds of 24 to 1 to your drawing odds of 23 to 1, will conclude that a call is in order. But you know how to take it to the next level of analysis by figuring out what are your implied odds (what's already in the pot plus your opponents' future bets vs. your current call.) You make an educated guess that you can expect your opponents to contribute another 10 small bets on the next two rounds. So your implied odds are 34 to 1. Because we are assuming that you will win this hand every time that you complete your flush, we will not be factoring in any discounting of your drawing odds as we did in Reverse #1. But now you remember from what you have just learned in the last topic, that to see this hand through, you are probably going to have to call more bets later on. So you have to figure that in too. As you did in Reverse #2, you might think that you should add in something like 4 more small bets on your part which represents a likely round of 1 big bet worth of betting on the turn and another 1 big bet on the river. This, however, would be wrong for two reasons.

First the river bet does not get added in. In the example in Reverse #2, you had to call the river before you found out if you had the winning hand. Here, you don't. If you don't hit your flush on the river, you will fold without calling any river bets. If you do hit your flush, your bet on the river is meaningless. We already assumed in this example that the flush would win, so your river bet is not at risk. You could put the keys to your car in the pot on the river for fun. Who cares? It's coming right back to you in a second. So you do not even consider it when figuring your reverse implied odds. The only river bets that you count are the likely ones from your opponents which you figure into your implied odds.

So now you may think that you just figure in your flop and likely turn bets. Not exactly. Because this is a backdoor flush draw, you will not be continuing with this hand if you don't get a card of your desired suit on the turn. So you only count in the percentage of turn bets that represent the times when you *do continue on* to the river. So since you have a 10 out of 47 chance of getting one of those suits you are looking for on the turn (which will enable you to stay in until the river), this roughly equates to a 20% chance. So you add 20% of 1 big bet into your equation. In $5-10, this is $2. So now you must look at this $5 call on the flop as actually a $7 calling decision ($5 for the small bet on the flop + $2 for the 20% of the big bet on the turn).

So now, applying the general concepts you learned in reverse #2, the reverse #3 implied odds (the 24 small bets currently in the pot plus all the future bets of your opponents vs. your current and future bets) must be greater than 23 to 1 which are your drawing odds. Let's see if they are. We already figured that "34 small bets" is the amount of the current pot plus future bets from your opponents. We also figured that "$7" is the amount of your current and future bets. We need to express this $7 amount in the context of "small bets" as that is how we have expressed the "34" small bets. $7 equals 1.4 small bets. Do you see how you get 1.4? Either you can just realize that mathematically $7 equals 1.4 small bets if $5 is a small bet. Or you may prefer to think of the "1" in "1.4 small bets" as representing your $5 flop bet (1 small bet). ".4" represents the $2 turn bet which represents 20% of $10. If we were expressing this as big bets, we would state is as ".2" but since we are expressing it as a small bet, it is 40% (or .4) of $5. So your reverse implied odds are 34 to 1.4.

To convert "34 to 1.4" into some figure "x to 1" you must divide 34 by 1.4 which equals 24.3. So your reverse implied odds are 24.3 to 1.

So finally we can make our comparison decision. Because your reverse implied odds of 24.3 to 1 are greater than your drawing odds of 23 to 1, you can profitably call the flop bet and if you get one of your desired suits on the turn, you can call that bet too in order to see the river. In other words, factoring in the current pot size, your call on the flop, and the likely amount of money from you and your opponents on future rounds, makes it worth it for you to draw to your backdoor flush draw.

Unless you are a mathematical genius, it would be almost impossible to do the precise calculations that I have done when you are sitting there at the table. One way that a very quick thinker who is very experienced and has really done his homework could do something similar is like this. You recognize the situation you are in. You have memorized that a backdoor flush is a 23 to 1 shot. You realize that you must put in $5 now and 20% of the time on the turn you must put in $10, so you quickly come up with your end of the bargain which is $7. If you have thought out some situations just like we did here, you could come up with this $7 figure. Then, you must be pretty good with doing multiplication in at least a ballpark-like accurate manner. So you multiply 7 times 23. This gives you $161 (or hopefully you quickly figure out something close enough to the right answer of $161). Now, you just think about if the current pot plus the likely amount of money of your opponents future bets is going to total more than $161. If it does, then you call. If not, you fold. You already have $120 in the pot right then at your decision time, so you just need to count on at least 5 more big bets on the last two rounds coming from your opponents.

Things Worth Noticing

After this very complex calculation, you have learned that the "reverse implied odds" for this hand were 24.3 to 1, but the much simpler to calculate "immediate pots odds," which were cited toward the beginning of this hand analysis, were 24 to 1. Wow, in this case at least, they were almost identical! The truth of the matter is that when you are figuring out reverse implied odds, the future bets you can expect from your opponents, and your own future expected bets, will

counter-balance each other out to at least some degree. They will certainly not always balance each other out to match the pot odds almost perfectly as they did in this case.[40] They may demonstrate even greater or lesser potential payoff odds that what the pot odds indicate. But they will counter-balance enough to provide some usefulness in a practical sense. This usefulness I am referring to is that pot odds can act as a crutch for the lazy pro player (at the table and/or regarding numbers-crunching practice away from the table) or the mathematically challenged pro player.

The hardworking pro will always have a leg up in his chances of making accurate decisions over the pro who, assuming all other poker skills are equal, simply goes the easy route by analyzing decisions simply with pot odds. This easy-route pro will always have a leg up over other players who (again, assuming all other poker skills are equal) doesn't even factor pot odds into his decisions. But don't you want to strive to be at the top of this playing totem pole?

If, for whatever reasons, you resign yourself to the fact that you will never take your analysis past the pot odds level, at least try to understand the following simple facts. If you are facing a close decision between calling and folding according to current pot odds and your assessed chances of winning the pot, and you anticipate a highly leveraged potential payoff for your future bets, then lean toward calling. If you anticipate a lower return on your future bets, such as when you are only against one player, then lean toward folding.

Your Opponents' Odds

Once you have a better grasp on pot odds, implied odds, and reverse implied odds, you will begin to get a feel for when your opponents are making bad drawing decisions. You can use this knowledge to your advantage. For example, if you are against an opponent who you believe is probably on a flush draw, you may want to raise on the

[40] Actually, even in this case, because I wanted to show you the Reverse #3 calculations in a simpler way, I ignored discounting your drawing odds as we had done in Reverse #1. Had we factored this in, it may have swayed the decision to a fold instead of a call, which therefore wouldn't have so closely matched the conclusion derived solely from pot odds.

turn if forcing him to call a raise cold would not offer him profitable odds to do so, whereas not raising would enable him to profitably call. When he is drawing in unprofitable situations, you are making money.

Final Thoughts On Pot, Implied, And Reverse Implied Odds

You may have noticed that the topics of pot, implied, and reverse odds all center around decisions on whether to call or fold, and in situations where you are assuming that the best hand will win the pot. In many situations, particularly where there are many players in a pot, these lessons you have learned will be all you need to know to make the right decisions. In other situations, you will also need to know when to bet, raise, or bluff. You may have already gained some knowledge from these lessons on odds that will help you to make some of these decisions, and you will also be learning some lessons soon that may help you. But many playing situations will require further education. As already noted, this book cannot teach you everything you need to know about every poker decision. Game specific books and *The Theory of Poker* by Sklansky go into much greater detail on most of the other playing decisions you will need to be making.

The first thing you should do with the information you've already learned is to memorize some of the most popular drawing odds, like for straights and flushes. These will come into play frequently. The more of these common draws that you have seared in your brain, the better. Remember that implied odds are derived from your own guesses as to what the future holds regarding your opponents' betting. When you are out of a hand, try to practice adding up pot odds and guessing at implied odds. See how accurate you can get over time. Experiment with what works better for you, thinking in terms of small bets or big bets. Also realize that once you get pot odds down, you are basically more than halfway there. Often the implied odds and reverse implied odds are in close enough ballparks that they cancel each other out. Some players make a big mistake by learning only about implied odds and ignoring everything else. And they wildly inflate their educated guesses as to how many future bets their opponents will be putting into the pot. This is rather dangerous

as they will often find excuses as to why they should chase just about any long-shot draw. "Sure, the pot odds don't justify my calling here with just an inside straight draw, but if I hit it, I'll get loads of additional bets." Then they get lucky and hit their long-shot hand, someone bets, they raise, and everyone folds. So much for those great implied odds.

Most winning players do not run through precise calculations at the table besides a close estimate of their pot odds, although, the ones that do are really a force to be reckoned with. What you should at least do, though, is thoroughly think through these concepts away from the table. Especially after a playing session, walk through some of the memorable hands again. Check the tables to see what your actual drawing odds were. Then figure out the pot, implied, and reverse implied odds to see if you made the correct decisions. If you do this enough, you will eventually find yourself at the tables, facing complex situations, and knowing exactly what you want to do in them. People who observe your incredible poker playing expertise will think you are some kind of natural. Only you need to know the actual secret. It's the same secret that is shared by most top athletes who are considered "naturals." It's called hard work.

Odds Of Pulling Off A Bluff

You must also understand the chances of pulling off a bluff depending on the number of potential callers.[41] Let's say that there are three potential callers and you think that each has only a 40% chance of calling. You must multiply 60% (the chance that each player will *not* call) times 3 to get your actual chances of getting away with it. So because .6 x .6 x .6 = .216, you have a 21.6% chance of pulling off your bluff. In most real playing situations, your opponents will each have a greater than 40% of calling you. In many situations, you might figure that each of the three players is 75% likely to call on the river. So your chances of pulling off a successful bluff in these situations are .25 x .25 x .25 = .0156 Rounded off, that's only a 1.6% chance of a successful bluff. If you use the previously mentioned formula for converting percentages to odds, you will discover that you need greater than 61.5 to 1 pot odds to make this bluff profitable.

[41] Mike Caro often writes about this.

If you just had two potential callers who each had a 75% chance of calling, you would have a 6.25% chance of pulling off the bluff. That's 15 to 1.

By the way, I do not expect you to be able to do these calculations at the table. But I do expect you to experiment with them away from the table so that you can have much greater insight into your game, especially as you review some of the playing decisions that you made during a previous session.

Here's what you should take away from this analysis. Two factors have an enormous impact on your chances of pulling off a successful bluff. One is your estimate of the likelihood that each of your opponents will call. Notice how just the difference in calling chances from 40% to 75% for three callers changed your chances of a successful bluff from 21.6% to 1.6%. It's staggering. The other factor is the number of your opponents. There is a tremendous difference in your chances between bluffing one person vs. two, and two vs. three. To bluff four people is extremely risky in most real world situations. Even three is usually pushing it.

Card Combination Odds

Another kind of odds figuring that only the best players do is "card combinations." As you become more experienced, you may develop a skill to "put someone on a particular hand." This means that you really know by the way the hand has been played out that your opponent holds pocket aces, for example. If you could possess this ability on every hand, you would be the richest poker player that ever lived. More often than these rare occasions, will be the times when you can put your opponent on a collection of possible hands. This is where figuring out card combination odds comes in handy.[42]

For example, you may have a pair of jacks in your hand. By the way the hand was played so far (many pre-flop raises) and your knowledge of this opponent, you strongly believe that he must have pocket aces, kings, queens, or AK. The flop comes 2-5-8. What are your chances of currently having the best hand?

[42] Sklansky also addresses this in his book, *Poker, Gaming & Life.*

To figure this out, you must know how many ways each of his possible hands can be made. A pocket pair, such as pocket aces, can be made 6 ways. (♥♦, ♥♣, ♥♠) = 3, (♦♣, ♦♠) =2, (♣♠)=1, for a total of 6. Two cards that are not of the same rank, such as AK, can be made 16 ways. Run through all the possibilities if you want to see how we get to 16 (A♥K♥, A♥K♦, …). So to answer our question, there are 18 chances (3x6) that he has aces, kings, or queens. There are 16 chances that he can have AK. You are a 1.125 to 1 (18 to 16) underdog. Depending on how much money is in the pot, you can use your odds calculation knowledge to evaluate whether or not this is going to be a profitable hand to stick with. Remember one additional factor though. If he does have only AK, he still has a 24.1% chance of improving. (See Table #2, Row "6 outs" which corresponds to a two-overcard draw) You, on the other hand, with your 2 outs, only have an 8.4% chance of improving.

What if you had two queens instead of two jacks? Now what would be the chances that he already had you beat? He'd still have 6 chances of holding pocket aces, 6 chances of holding pocket kings, and 16 chances of holding AK. But his chances of holding pocket queens would now be just 1. Do you see why? There are only two queens left unaccounted for. Those two queens can only make a pair of pocket queens one way – with each other. So he has 12 chances (6+6 for the aces plus the kings) of having you beat, 16 chances of you having him beat, and 1 chance of you two being tied. This is similar to the situation where you have JJ, but the flop comes Q-Q-2. In this situation, he now has 13 chances of beating you (that 1 chance of him having pocket queens now beats you instead of tying you). And you still have 16 chances of beating him.

This is the other factor in figuring out card combination odds. - How many pertinent cards are missing? For example, if want to know how many ways he can have AK, but there is one ace on the board, then for the following odds tables, you would consider this situation to have "one ace missing." If you wanted to know his chances of having a pocket pair of aces, since the ace on board is a pertinent card for this, you would consider it as "one card missing" for the following pocket pairs odds table.

Practice applying the numbers from the following tables into various hand scenarios. This is a skill which you can really hone when you're

out of a hand and not having to concentrate on anything else. You can practice putting other players on a range of possible hands and figuring out the chances of those possibilities depending on what cards are out. If you open your eyes to where and when this analysis can apply, you will start to see many applications for it, especially in no-limit tournaments. And the great thing is that very few of your opponents will be using this skill against you because it takes some practice and most players, even most pros, aren't even aware of it. Actually, this is the first time, to my knowledge, that this information has ever been broken down in a way that can facilitate memorization and therefore most easily be implemented into your game.

FYI - Although all the numbers in these tables can apply to real world situations, the ones that refer to many missing cards, such as four or more, rarely come into play.

Card Combo Odds Table #1 - Pocket Pairs

# Of Cards Missing	Ways Of Making Hands
All Cards Available	6
One Card	3
Two Cards	1

Card Combo Odds Table #2 – Two Unpaired Cards (AK used here, though any two unpaired apply)

# Of Cards Missing	Ways Of Making Hands
All Cards Available	16
One Ace or One King	12
Two Aces or Two Kings	8
Three Aces or Three Kings	4
One Ace and One King	9
Two Aces and One King (or) Two Kings and One Ace	6
Three Aces and One King (or) Three Kings and One Ace	3
Two Aces and Two Kings	4
Three Aces and Two Kings (or) Three Kings and Two Aces	2
Three Aces and Three Kings	1

Two Unpaired Suited Cards

Table #2 about "two unpaired cards" applies to both suited and unsuited combinations. There are certain times when you may be able to narrow an opponent's hand to only a certain suited combination of unpaired cards. For example, ace-king suited. If that is the case, then you don't need a table, just understand that there are 4 ways for a suited combo of two particular ranks to occur. For ace-king, there are the AK of hearts, diamonds, clubs, and spades. Any time that any (or both) suit representative is missing, you reduce the remaining ways by 1. For example, if the A♥ is out, then only 3 ways remain. If the K♣ is also out, then the ways of making an AK suited are now reduced to just 2 ways. If the K♥ is also out, however, you do not reduce your possible remaining ways to 1, you keep it at 2 because the A♥ already represented the heart suit as missing. There are still two ways that remain for ace-king suited, either (A♣K♣) or (A♦K♦). Got it? Good.

All-In Odds

Particularly if you are a no-limit hold 'em player, and especially for tournaments, you need to know the odds of many heads-up all-in confrontations. You can find these either through a good poker software program or on free poker calculators found at CardPlayer.com.[43]

Often in no-limit tournaments, you will be faced with a decision as to whether or not you should bet or call when doing so would either put you or your opponent all-in. Forget about implied odds or reverse implied odds, you usually know the exact pot odds you are facing. Now all you need to know is the hand you are facing. These confrontations often occur before the flop. Card combination odds are important to your analysis. But maybe the most important knowledge is how certain hole cards match up vs. other certain hole cards when they are going to be played all the way to the river.

Following are some interesting examples derived from the calculator at CardPlayer.com. All percentages have been rounded off.

[43] Card Player is a subscription must if free copies aren't available at your local card room. Find discounted subscription links at MarkBlade.com.

Heads Up Matchups When All-In Before The Flop				
Hand #1	A♥K♥	69%	7♣2♠	31%
Hand #2	A♥K♦	67%	7♣2♠	33%
Hand #3	A♥K♦	64%	Q♣J♠	36%
Hand #4	A♥A♦	87%	7♣2♠	13%
Hand #5	A♥K♦	43%	Q♣Q♠	57%
Hand #6	A♥K♦	44%	9♣9♠	56%
Hand #7	A♥K♦	74%	A♣Q♠	26%
Hand #8	A♥6♦	54%	K♠Q♠	46%
Hand #9	A♥A♦	81%	K♣K♠	19%
Hand #10	A♥A♦	86%	K♣Q♠	14%
Hand #11	A♥A♦	93%	A♣K♠	7%
Hand #12	K♥K♦	70%	A♣K♠	30%
Hand #13	2♣2♠	53%	7♥3♦	47%
Hand #14	2♣2♠	53%	A♥K♦	47%
Hand #15	A♥K♦	58%	8♠7♠	42%
Hand #16	K♥10♦	59%	8♠7♠	41%
Hand #17	A♥K♦	62%	8♣7♠	38%
Hand #18	A♥K♦	67%	8♣3♠	33%
Hand #19	10♥3♦	51%	8♠7♠	49%

All-In Odds Analysis

There are many interesting lessons to be learned from these heads-up matches. Before we get into them, you must realize an important distinction. Deciding if you play some of these hands depends very much on how much money you have. If you are short-stacked and will likely go all-in before the flop with any hand you decide to play, then your decision is very different than if you have a lot of chips and would have to risk more and more of them on the flop and the turn to see your hand to the end. For example, if your hole cards are 72 and you are all-in before the flop, you will beat AK sometimes in a situation such as when the flop comes AQ2 and a 7 or 2 comes on the turn or river. On the other hand, if you still had a lot of chips and your opponent made a sizable bet into you on this flop, you couldn't possibly call with your mere bottom pair, horrible kicker. So keep this important distinction in the back of your head as I explore these hands. Remember, my analysis applies only to all-in before the flop situations.

Lesson #1 - Bad Hands Can Be Worth Playing

Don't get carried away by this topic heading. The situation has to be just right to warrant playing really bad hands. But consider Hand #1. Even 7♣2♠, often heralded as the worst hand in all of poker,[44] is not a huge underdog in many situations where you might think it would be. You should consider playing hands as bad as this in situations such as when you are very short-stacked and have what you believe to be a great opportunity to steal the blinds. You should definitely play if you are in the small or big blind with a significant portion of your remaining chips already in the pot. You should also play it if you tried to steal the blinds and are re-raised by a short stack, making it cheap for you to call his all-in bet. Unless you know to an almost certainty that your opponent has a pocket pair (like in hand #4), your pot odds will often make playing worth it in these types of situations. And sometimes the pot odds will justify a call even if you do know your opponent has a pocket pair.

Lesson #2 – Ace-King Is Not Always Worth Playing

Conversely, don't go overboard in going all-in with AK before the flop unless you are somewhat short-stacked. You are an underdog to pocket pairs and you never dominate another hand. Many no-limit tournament players will never fold any AK before the flop no matter how many chips they have to put in. That is a big mistake. Save all your biggest stack moves for more advantageous situations. That said, if you are somewhat short-stacked, do go all-in. You are only dominated by one hand, the AA as seen in hand #11. Hand #12 shows that even against KK, you have a 30% chance of winning.

Lesson #3 – Being Suited Is Overrated

Being suited means a lot when you are not all-in. It allows you to make a hand that you sometimes know is the nuts. It allows you to push in a lot of chips when you hit your hand. It also allows you to sometimes pursue draws that turn into something unexpected like a backdoor straight or trips. But if you don't flop the flush or strong draw, you can often get away from your hand cheaply. It also allows you to semi-bluff which greatly benefits from the possibility of your opponent folding right then and not seeing his hand to a showdown. When all-in, though, the flush draw is the only differentiating factor

[44] 7♣2♠ is not always the worst hand. 3♣2♠ can be even worse in many situations.

for the fact that you are suited. You were going to get all the backdoor perks of your hand anyways if you were all-in. So what is that flush possibility (or in other words, the fact that you are suited) worth? About a 3% difference from if you weren't suited. Yet many players who are short-stacked find any suited hand and immediately push all their chips in. You'd be much better off pushing in your last chips with any Ace or even a King and hoping that someone calls you with their suited QJ.

Do you want further proof that suited cards are overrated when you go all-in with them before the flop? Look at hand #8. K♠Q♠ is a definite underdog to A♥6♦, or any Ace for that matter. Most players, even many (if not most) tournament pros, would never guess that fact.

Lesson #4 – Suited Connectors Are Overrated Too
Hands #15-18 show you the difference that being suited *and* connected makes, especially with a hand like 87 where you have plenty of room to make your straight on either end of your draw. Even with this ripe draw setup, you are still an underdog to any two overcards. In fact, in this situation, not only are you an underdog, but your 87-suited doesn't even add an additional 10% chance of winning on top of what you would get with just 83 offsuit. And think about this next fact the next time you are considering going all-in before the flop with them. Almost every suited connector you have gets beaten by almost every opposing hand that has even one card higher than your highest card, even if that opposing hand isn't coordinated at all. Look at hand #19 for a perfect example.

These lessons just scratch the surface of the insight you can get from experimenting with many other heads-up matchups and then thinking about their implications to your playing decisions. In my next book, *Profession Poker 2*, I will really get into this for all you no-limit tournament buffs.

Odds Final Thoughts

For those of you who are numbers averse, and maybe even those of you who didn't think so until now (I realize this chapter on odds may have given you a headache), don't be discouraged. Take it slow.

Work on one small piece of the puzzle at a time. If you keep at it, sooner or later you will start to get the hang of this stuff.

Most of your opponents, if they ever come across this type of information, immediately dismiss it as too complicated and unnecessary. Great! That's what we want them all to think. That's how you are going to have a competitive advantage over even your fellow pros every single time you face them at your table. Lifelong winners who have a pretty good natural ability will wonder why they keep losing so many of their chips to you. If you master all this, along with the other important poker skills, plain and simple, those players will not be able to compete with you. After many years of play, they may have gotten a moderately accurate hold on these odds. But with many less years of work, your mathematical calculations will be even more accurate than their guesses or "feel for the cards" could ever be. You can take your game to another level with this kind of expertise.

If you are serious about becoming a professional poker player, then get serious about this.

Chapter 21
Any Educational Background Necessary?

As you probably already know, playing poker for a living doesn't require any educational background whatsoever. Even if you dropped out of grade school, you can still become a professional poker player. And not just a pro, you could become the greatest poker player that ever lived. That doesn't mean, however, that there is no correlation between a formal education and your chances of success as a player. There is. But if you are dedicated enough, with enough brainpower wattage, you can succeed regardless of your education. In fact, many of the very top earning poker players of all time lack impressive education resumes.

Why A Solid Formal Education May Help In Poker

Some of the following factors or skills that will help in your poker career are often enhanced through an advanced formal education. Though you can develop them on your own, it is probable that if you take a pool of college graduates and compare them to a pool of high school graduates, the college alums will possess these skills in much higher numbers.

Ability To Study Textbooks

College students often have to study very challenging material, remember it, and apply it properly in their work or on tests. This ability is also important in grade and high school, but obviously, at a lower level of complexity. The ability to study textbooks in a productive way is probably further honed in college and even higher learning. There is also a non-causal correlation in that people who have the ability to study textbooks well are usually drawn toward higher education more than those who aren't. If you didn't go to college because you hate studying, you may also not like to study poker textbooks. This aversion is going to be a major hurdle in your path toward success in poker. But you can certainly overcome it.

Mathematical Ability

Many primary school students who hate math avoid higher learning. This aversion will also be a hurdle to your poker career. The more familiar and comfortable you are working with numbers, the easier it will be for you to calculate pot odds and your percentage of outs still available. If we designed a contest to see who could most quickly and accurately figure out the pot odds or reverse implied odds of a given hand, I would bet on the randomly selected math degree holder over the random high school drop out every time. Wouldn't you?

Well-Rounded Thinkers

Higher education also exposes you to a variety of thought on a variety of subjects. This tends to create much more well-rounded thinkers. Poker is a multi-dimensional game. Human psychology, for example, plays a big part in it. All things being equal, someone who has studied a little psychology in college would probably have an advantage over someone else who hadn't. Not because you need to know specifically whether or not your opponent has an oedipal complex, but because it opens your mind to thinking about more things. You may remember that I earlier recommended a book called *The Psychology Of Poker.* Don't you think the author, Dr. Schoonmaker, who is a psychologist, would have a leg up on this subject? I do.

Most Important Reason For A Solid Educational Background

So there are reasons why someone with a higher education may have a little better chance of succeeding at poker. But these reasons pale in comparison to the drive and determination that any one individual may have regardless of his education. Also, any particular individual, who dropped out of school at any age, could possess the previously mentioned abilities in greater quantities than any particular college grad. Conversely, someone with a Ph.D., if it wasn't in math, could easily be lacking in mathematical ability and well-rounded thinking. So if you lack a college degree, it is nothing to worry about. You can easily succeed at poker if you want it bad enough and possess a minimally adequate level of brainpower.

There is only one reason that I would consider as a highly important reason for a poker pro to have a higher education. It is this. Having that additional degree will be very handy should you need to come up with a back-up plan if playing poker for a living doesn't pan out for some reason. Maybe after years of playing, you just get sick of it. Maybe poker playing vanishes when the popularity of betting on inter-galactic foozeball sweeps over the universe. Who knows why you may want or need to stop playing poker in the future? If you have a degree to fall back on, you will probably have an easier time getting a job than if you didn't. Many, if not most, potential employers will probably not recognize years of successful poker playing as meaningful work experience.

♦ ♣ ♥ ♠

Chapter 22
How Do You Get Experience?

Studying poker textbooks and getting the proper playing experience go hand-in-hand in the education of a winning poker player. Fortunately for you, there are more ways than ever before to get playing experience without risking much, if any, money.

Getting Experience Rule #1

This rule is so important that there isn't even a rule #2. You must not view micro-limit or very low limit games as money making endeavors. They are simply practice sessions to see if you can play your best, utilizing everything you've learned up to this point. This will have great financial importance when you are eventually in a game where real money is on the line. Do not focus on the actual value of the money (good advice for all levels of poker while you are actually at the table playing). You will never be happy with your results and it will only entice you to gamble recklessly. You are not there to earn a meaningful amount of money right now. You are there to work on your poker skills. Period.

The funny thing is that many great players can't win at very low limits because the stakes don't mean anything to them. Losing tens of dollars or even hundreds or more doesn't mean much compared to their normal wins and losses. If this money doesn't mean anything to you and you feel like you need a motivation greater than just the sake of practicing, fine. Donate your winnings to charity. You've seen those commercials for how $5 can feed a family of four for a day or a week or whatever. Great! Feed that family of four. Just get into the habit of always playing your best poker. <u>Always</u>. It is the most profitable habit you could ever develop.

Free Games On The Internet

The upside of this option is that you won't risk a penny, and it is definitely legal because you aren't playing for any actual money. Sites like Yahoo and many poker sites which offer money games also offer free games to give people a taste of what it's like. If you are an absolute beginner, this is a good place to start playing. You can begin

to understand how the betting order and rounds work. You get to practice reading a flop and how it interacts with your own hole cards. For the novice, this is a very useful and non-intimidating introduction to the game. Beyond an introduction, however, it is rather useless. The play of your opponents will barely even resemble the way they would play if money was at stake. Most players, in these free games, see every hand to the flop and most hands to the river. Some money games are very loose, but this is ridiculous.

You could play a couple of tables simultaneously I guess, if you just want to practice some of the playing decisions in a simulated situation. You can practice which hands you want to go with pre-flop. Also try to calculate pot odds or different poker concepts. The reason I recommend more than one hand is because the play will be so absurd that once you've folded, it won't be very interesting to follow.

For experienced players, these games can also be of value if you are trying out a new game. For example, if you are trying Omaha for the first time, I highly recommend you play for a little while in these games while you get a feel for figuring out your hand when you have four hole cards to choose from. If it is high-low split, you must train your brain to start seeing both the high and low possibilities simultaneously. Also, Omaha may initially throw you because you must use exactly two cards from your hand. For example, in hold 'em, if there are four clubs and no paired cards on the board nor any straight-flush possibilities, you know you have the nuts if you hold the Ace of clubs. In Omaha, an Ace of clubs in your hand, without another club to go with it, doesn't make a flush. You have to be able to instantly think like this when you are playing for real money.

Internet Micro-Limit Games

If you are comfortable playing poker for money on the internet, these games can be played for as little as 1cent-2cent. Even though these stakes are miniscule in value and, in practical monetary terms, almost no different than free, there is a considerable jump up in quality of your opponents' play from the free games. Mind you, this difference is from absolutely insane to merely horrendous, but that's still quite a leap. You can at least start to say you are practicing poker

with more of a straight face. A beginner will start to gain meaningful experience in these games.

Poker Software

Some poker software isn't too bad these days. You can populate your game with different caliber levels of opponents. Poker is so complex that these software games still don't perfectly capture real world play, but they are close enough to provide you with meaningful playing experience. The best software titles change so often that you are best advised to visit MarkBlade.com where I have the current best title(s) listed. I also provide a link to any discounted internet retailer I can find for my loyal supporters.

Home Games

These games can vary widely in their usefulness as training ground. If the games you regularly play involve frequent use of wild cards, sticking cards to your forehead with spit, or removing articles of clothing, you may not be gaining a lot of experience that can build a solid foundation for your transition to the public card rooms. (Although you may want to call me as I may be interested in flying into town to join you in one of these games.) Also, with some home games, you can start to develop some in-bred playing skills. Maybe everyone bluffs like crazy. You can start to develop winning strategies against players who bluff half the time that they bet. But this isn't the case in public card rooms. You will end up calling off all your money. Or maybe every single player plays every single time they have an Ace. In public casinos, this may occur with some players, but not every player. If you start thinking that Ace-Ten is a monster starting hand because it so often out-kicks your home game opponents, you will be in for a rude awakening.

Some home games take things more seriously. Maybe your friends are all aspiring pros themselves. You could have an excellent training ground in this situation. In fact, under the best circumstances, you could all go from playing for pennies at home straight to playing for middle stakes at the casino.

Low Limit Public Games

These games are just about guaranteed to be the best place you can gain valuable playing experience. If you want to play $2-4, but don't want to risk as much learning it, the closest thing resembling it for less money will be the $1-2 games. The closest thing resembling $4-8 will be $3-6. This is a pretty obvious concept to grasp. The moral of the story is that the best way to slowly gain playing experience at the level that is appropriate for you is to slowly move up the ladder, one step at a time.

Getting Experience Final Thoughts

As you may remember from previous parts of this book, the amount of low level experience you choose to get has a lot to do with your own risk tolerance. If you are very risk averse, get plenty of low level experience and move up the ladder very slowly. If you are very risk tolerant, just get a little bit of experience at these lowest levels and quickly move up in limits. You will have the potential for greater returns much sooner but you will also incur much higher risk to your wallet. Depending on the current size of your wallet, you may not have a choice but to go slow.

♦ ♣ ♥ ♠
Chapter 23
Keep Accurate Records

This topic was already covered in the chapter on "Transitioning From Part-Time To Full-Time. It is just so important to your poker education that I wanted to make sure you didn't overlook it.

Also, I wanted to clarify any misunderstanding you might have concerning playing records after everything you've learned in the chapter on Bankroll Management. The bankroll chapter was designed with one overriding goal in mind. That is to insure that, if you are a winning player, you never go broke at any point during your poker playing career as this would prevent you from being able to play. Without play, there is no income. It's that simple.

But just because records can be wildly inaccurate in representing your true playing ability, at least in the short-term, does not mean that they usually are. In fact, most of the time, they are pretty indicative of the quality of your play, even in as short a period as a couple of weeks. If you are losing money after playing for three weeks for example, could you actually be a solid, winning player? As you've already learned, of course you could.

But are you much, much more likely to just be a losing player, both in your results and your true playing ability?

YES! - YOU ARE PROBABLY A LOSING PLAYER!!!!

I hope my shouting shook you out of your denial. That is what is so great about keeping accurate records, even in the short-term. All players have a natural tendency to want to believe that they are more skilled at poker than they really are. Your records are like a strict school principal, lifting you out of you seat by your ear and saying, "Don't you lie to me. I know you've been playing poorly." If you are 100% honest, then the vast majority of time you'll reply, "Alright, alright. I admit it. I haven't been playing the way that all the top poker teachers told me I should."

♦ ♣ ♥ ♠
SECTION 4
THE LIFE OF A PRO
POKER PLAYER
♦ ♣ ♥ ♠

Section 4
Introduction

Playing poker for a living, like most other careers, can have a profound effect on many aspects of your life apart from just the time you spend at the tables. In this section, you will discover many drawbacks to a poker career that you may have not previously considered. These should be contemplated with a lot of serious introspection. These issues should also be discussed with your family members as they are also likely to be strongly impacted by your career choice. Don't get me wrong. There are many advantages too.

If you choose to pursue a career in poker playing, this section will help you to have a much more satisfying life both inside and outside the card room.

Chapter 24
The Effect On Your Social Or Family Life

There are three main ways a poker career can affect your social and family life. The first has to do with your hours and possible traveling. The second is in regards to the inconsistency of your income. And the third deals with the social disapproval you might have to deal with.

Odd Hours And Travel

These are the same problems that many people in other careers deal with. But that doesn't make them any less bothersome. If your spouse, girlfriend, or boyfriend works a typical 9-to-5ish job, you are going to have a lot less quality time to spend together. The frequent traveling of a tournament pro can be even worse. The World Series of Poker tournaments span an entire month. You don't have to play all of them, but many top pros do. You can always choose to play Monday through Friday 9-to-5 if such cash (or tournament, such as on the internet) games are available, but you probably won't make as much money.

Of course, many professional players, including top tournament pros have very happy and stable long-term relationships. You can too. You'll just probably have to work at it a little harder than a lot of couples do.

Benefits Of Odd Hours

There is a major plus to the poker lifestyle. You have a tremendous amount of flexibility. If you just don't feel like playing today, you don't have to. You love the NCAA March Madness, you can take the whole month off if you want.

This is especially beneficial to certain family or social engagements. If your kid has a baseball game Thursday night, you can be there. Your wife gets off early from work and wants to catch a matinee movie. You can meet her there in ten minutes. Her vacation days are now your vacation days too if you want them to be.

Inconsistent Income

This is similar to the problem that commission-only sales people have. But it's worse because you can actually lose money every day at work, instead of just not making anything. Money issues are said to be the number one reason for relationship problems. And many of those problematic relationships have consistent income. If your spouse is not very keen on the idea of you playing poker in the first place, try explaining to her why you keep losing money every day when you're suffering through a terrible bad streak.

The solution to this is through very informed and realistic expectations, along with proper bankroll management. You and your spouse must understand the earnings fluctuations that are a normal part of a professional poker career. Just because you may currently have a lot of money, doesn't mean you can spend it. If you regularly violate my bankroll recommendations, you are inviting disaster. Not just to your poker career, but to your family life as well.

Social Disapproval

The boom in poker popularity, due to the seemingly ubiquitous TV coverage, has dramatically reduced the social stigma attached to playing poker. But it hasn't erased it entirely among all observers. Many strongly religious people consider it to be downright sinful. Others consider it frivolous or pointless because "you can't win." Some people will never date a poker player or certainly not marry one. They consider all poker players to be potential problem gamblers. When you say you do it as your job, you actually confirm their suspicions. Doctors and bankers don't elicit such reactions.

How To Explain To Others What You Do

If you become a professional player, you will find yourself in frequent social situations where you are asked the common question, "What do you do for a living?" Don't respond, "I play poker." Particularly among family and friends who you care about, this sounds a little less assuring and substantive than if you say, "I'm a professional poker player." Something about the word professional connotes something more significant. It almost feels like you went to

school or have some kind of special license for it. (Of course, reading this book is the next closest thing.)

People might follow up with a question like, "Wow, isn't that pretty risky?" This is where you should always separate your career from other games of chance. Try something like, "No, poker isn't like other games like blackjack, craps, or roulette. In those games you play against the house. And the house always has a mathematical advantage.[45] In poker, you play against other players and the house just charges a small fee to pay for the overhead and a little profit. So if you are a better player than the others, you will always win money in the long run because *you* have the mathematical advantage. When you know how to play as well as I do, it's really more like being a casino owner where the casino always wins money in the long run against the craps and roulette players."

This seems to work. At least they may figure that you've thought things through on at least some level. Of course, you can shorten your answer if they seem to get it sooner.

If they still really look concerned (maybe it's your grandma and you don't want to put too much strain on her heart), you could follow up with, "But don't worry, Granny. I would never risk too much. If I ever start losing any money, I'll definitely stop playing and do something else." This lets the intractable poker cynics know you haven't completely fallen off your rocker.

Social Approval

People in the know regarding poker have always realized the upsides. Many families have been extremely well provided for through poker income. But it wasn't until the poker TV coverage boom that a new phenomenon has emerged. The poker celebrity. One top tournament pro recently mentioned that his fame has really helped him in the singles' bars. And a somewhat famous actress recently mentioned that she was dating a star player on the World Poker Tour.

[45] Yes, I know that a card counter can have a mathematical advantage over the house. But remember, this is just the line you are giving to an uneducated skeptic. No need to make it more confusing for them.

This was almost unheard of previously. Even World Series Of Poker Championship winners were completely anonymous when outside the very small inner circle of the poker world.

Who knows? Maybe sometime soon, mentioning that you are a professional player will be just as accepted and admired as being a fireman or brain surgeon.

Alright, maybe I'm getting a little carried away with myself here.

Chapter 25
Will You Have To Move Or Travel A Lot?

This depends on where you currently live and whether or not you want to concentrate on tournaments to make your living. Of course, if you plan on playing poker on the internet, you won't have to move and the only traveling required is from your bedroom to your office. Unless you have a wireless laptop hookup, in which case you won't even have to leave your bed.

Tournament Player

Some large casinos and card rooms have frequent smaller tournaments throughout the year. You could conceivably make a living just playing these tournaments on a practically daily basis if you live in Las Vegas or Los Angeles for example. But if you want to make a very substantial amount of money through tournaments, you have to chase the major $1000+ buy-in tournaments, and possibly the very large $10,000+ buy-in tournaments. These are usually scattered throughout the country and even the world all through the year.

If you want to play in most of these major tournaments, you will have to get used to living out of a suitcase, and moving from hotel to hotel. Most top tournament pros admit that this is probably the biggest drawback of tournament life. It also can get expensive, especially if you aren't willing to stay in just any fleabag motel. The upside is that if you stay at the casinos that hold these large-sized tournaments, they are usually upscale establishments with all the round-the-clock conveniences that you would expect from a major hotel or resort. You also get to put in a lot of time playing poker as you probably don't have many family or household distractions. Often, in the downtime between tournaments, you simply decide between watching TV in your room or hitting the tables to play in some cash games or satellites.

Sleeping On The Road

Plan your sleep time very carefully. The last thing you want to do is get yourself stuck in a side game all night. And then the next day you

find yourself trying to keep your eyes open during the main tournament which is the only real reason you came to town in the first place. Keep your eye on the prize.

Eating And Exercising On The Road

Another common mistake that many tournament players, even pros, make when traveling for tournaments is the way they eat. Just because it feels like vacation doesn't mean it is. You're there to work. Loading up at the buffet can send you into a food coma just when the tournament begins and you need to be at full alert. You might dismiss this advice, but I truly believe that tournaments are won and lost every day of the year based solely on who came to play that day in the most fit and alert state.

Exercise is important too. Moderate exercise during long tournament schedules, particularly month-long ordeals such as The World Series Of Poker, will give you more energy, not less.

Cash Game Player

If you plan to play in cash games and aren't comfortable playing online, then where you live, unfortunately, means a great deal. The good news is that your options are expanding all the time. Just a couple of decades ago, there were very few places in America where you could make a comfortable, full-time living playing poker in public card rooms. Today, there are many. Here is the main thing to consider:

Table And Limit Selection

Just because your local casino has ten poker tables going round the clock doesn't mean much to you if the largest is a $5-10 limit game. Unless you are just supplementing your income, these probably aren't large enough stakes to provide a great living. You should have at least a couple of tables going at least 6 to 8 hours a day on a dependable basis with stakes high enough to provide your minimal income requirements.

You are going to have to do a little research on your own about where the closest poker centers are to you, and if you have to move, where you would best fit in. Listing them here would be a mistake as the place or playing conditions might change at any time. Needless to say, poker opportunities in Las Vegas, Atlantic City, and Los Angeles probably don't have a great risk of drying up anytime soon.

♦ ♣ ♥ ♠

Chapter 26
What Kind Of Hours Will You Work?

There is a lot of flexibility regarding the working hours of a professional poker player. Much of it depends on how good you are and how much you want to make. You can easily do the math from the hourly expectations figures dissected previously in the book. In general, most pro poker players do not differ that much from typical workers. A forty hour work week with a couple of weeks off for vacation is a general ballpark figure that holds up for poker playing as well. Of course, you have quite a lot of latitude as to how you accumulate those hours. Six 7-hour days. Four 10-hour days. Three 13-hour days if you can handle it. You get the idea. You can also have 50-hour weeks for a while and then take a couple of months off. It's all up to you. But to earn a decent living in the early periods as you are working your way up the stakes ladder, you will be putting in common work hours.

Once you get into the higher limits, your options really open up. I know of many lazy (not necessarily a bad thing) pros who play twenty hours a week. When you make $50 an hour and you only need $50,000 a year to live off of, why not?

Some top tournament pros can work even less than this. Figure an average of a couple of days work for an expected $10,000 profit in a $10,000 entry tournament and you can see how they can easily make $100,000 a year with only a couple of days work each month.

Reality Check

It is very hard to get to be that good of a player so that you are capable of expecting a $10,000 profit on each big $10,000 entry tournament you play in. You probably need to be getting a lot more regular playing experience to keep on top of your game. You also probably need many years of experience to get this good in the first place. But is it possible? For the sharpest poker minds, with at least some leisurely study on the side, the answer is yes.

Reality Check #2

Oh, did I mention that this rich lazy tournament pro would also need to get lucky, have a trust fund, or have previously accumulated an incredibly large bankroll? Remember the lessons you've learned about tournament fluctuations. If this tournament player doesn't make a big score almost right out of the box, he is going to go broke long before he gets to play in many of these $10,000 entry tournaments. So don't plan on hitting the ground running.

Vampire Friendly Hours

If you want a poker career that is the most profitable it can be, it helps to be a night owl. Poker games are most heavily populated with inept players from roughly 6pm to 3am. Add a few additional choice hours on the weekends. It might be hard to even find a game, or at least at your preferred limits, during weekday hours in many poker rooms. Even the breadth of internet games corresponds to these hours. Although, the selection is quite large on the net at just about anytime of the day. Many retired seniors who supplement their retirement income with poker choose to play regular daytime hours. As do some pros who just prefer these hours for many reasons. This is fine. It's up to you. Just realize that you might not hit the full hourly expectations that you might otherwise. In fact, you may make as little as half.

Benefits Of Poker Hours

Poker hours are not all bad. In congested traffic areas like Los Angeles, you can avoid rush hour traffic if you plan wisely. You can also eat at the table in some card rooms which is like killing two birds with one stone. That just means more leisure time away from the table. Also, fewer working days per week, like if you elect to play a schedule of four 10-hour-long days per week, means less total time commuting per week which also equals more free time. Not to mention less gas, and wear and tear on your car. It all adds up. But you must have the physical and mental stamina to play your best over such long periods. Many players don't.

♦ ♣ ♥ ♠

Chapter 27
Protecting Your Bankroll

Although bankroll issues have already been explored in depth in this book, I thought this issue to be so important that it warranted special mention in this section on "The Life of A Pro Poker Player."

When you play for a living, your bankroll is your lifeblood. It is the same to you as a medical license is to a doctor, or a bar card is to a lawyer. Without it, you cannot be a professional player anymore. Your career is over. (Unless you can borrow money, of course, which is never a corner you want to back yourself into.)

The precarious thing about bankrolls is that they are very easy to lose and much more difficult to build back up. Someone on extended and extreme tilt could easily blow through $20,000 at a $20-40 table in just a week. Even if you can make $40/hour at these limits, it would take you about three months to make back that $20,000.

PROTECT YOUR BANKROLL!!!

Don't blow it on hunch sports betting or craps.
Don't waste it on a crazy stock tip.
Don't spend it on a Rolex.
Don't buy your girlfriend a diamond bracelet with it.
Don't smoke it, snort it, or shoot it into your veins.
Don't throw it away by playing while you're drunk.
Don't lend it to some poker room buddy you really barely know.
And don't leave it all under your mattress or in your back pocket where it can be stolen.

Put it in the bank where it belongs, along with enough in the casino lockboxes so you can get to it when you need it.

Bankroll Busters

Besides the many foolish vices or discretionary spending money pits that you can fall into, there are three common bankroll busters for the experienced poker pro.

Life Changers

Every now and then, someone who has been a winning player for years will have a personal crisis of some sort. This could be a divorce, death of a family member, personal health issue, or unrelated-to-poker financial crisis. These kinds of extreme life changes can sometimes have profound effects on one's poker game. Poker skills can quickly deteriorate under the emotional toll, and turn a positive expectation player into a loser.

The shame of this is that as an experienced poker pro, Hardluck Joe could've fallen back on his bankroll cushion to take an extended break from the poker tables while he got his life back in order. If you ever go through a life changing experience like this, seriously consider taking some time off from the tables. Most people in non-poker jobs can be absent minded at work for a time or not be so productive without risking being fired or demoted. You, as a pro player, do not have that kind of luxury. The cards don't care about your problems, and, sadly, your competitors might not care too much either. They certainly aren't going to play any easier against you because you're going through a rough spot in your life. Only you can do something about it. So check yourself before you wreck yourself.

Playing Over Your Head Financially

I hope that you have thoroughly read the portions of this book on how much money you need to play at certain limits and how you should manage your bankroll to insure you never go broke. If you have, you have no excuses for this. But many pros really never have understood how large negative fluctuations can be for even the 1 big bet per hour player. It is quite possible for a pro to go years without ever having lost 150 or 200 big bets over any span of time. For example, a $20-40 player may have done just fine for years with a $7000 or $8000 bankroll. All of a sudden, after a horrible couple of weeks, he finds himself tapped out. Or he's so close to tapped out that he alters his play because he's playing with scared money. This is how a lot of otherwise promising and quite sustainable poker careers end prematurely. Lucky for you, you've purchased this book and know how to keep yourself out of that mess.

The Peter Principle

This is a business term for what plagues many corporations. It describes how in a typical company, people keep getting promoted until they finally land at a position in which they do not excel, and that is where they remain. Stuck in a job that they are no good at. This phenomenon also affects the poker promotion ladder. For example, you are a winner at $10-20, so you go to $20-40. You're still a winner, so you graduate to $30-60 and $40-80. Still nothing but roses. Then you step up to $75-150. All of a sudden you are not making anywhere near 1 big bet per hour. You probably aren't losing, though theoretically you could be. That would really be "The Peter Principle" in full effect where you go from making $60 or so an hour at $40-80 to making nothing at $75-150. More likely, you make something like $40/hour or so at this limit. You just can't adjust to the regularity of expert play you are facing. Maybe your full potential for whatever reason is $60/hour at the $40-80 games, but you never admit to this truth and stay at these sub-optimal levels.

An even greater tragedy for this situation is if you still fancy yourself as a 1 big bet an hour player and plan your bankroll requirements accordingly. It won't take too long for a ¼ big bet per hour player to lose 400 big bets in a modest run of bad luck. You're broke, back to pushing pencils behind a desk somewhere, wondering why you couldn't make it as a pro poker player. You could have. But you fell into one of the most common bankroll busting traps.

♦ ♣ ♥ ♠

Chapter 28
Avoiding Destructive Vices
Including Gambling

The biggest obstacles to a professional poker career for some people are their own personal vices. Although there are more, I will just touch on the most prevalent ones.

Drugs And/Or Alcohol

Many poker players struggle with these problems. There is a difference between being high or drunk at the tables vs. away from the tables. Those who have major drug or alcohol problems, but only indulge when they are away from the table, can possibly still have a successful playing career, although it is very hard to pull off. Just like in other careers, there are functional drug addicts and alcoholics. But just like in other careers, these problems often are too powerful to be compartmentalized, and they can bring down your playing career sooner or later.

Being high or drunk while playing is a recipe for bankroll disaster. I hope it is obvious to you that the more focused and clear-headed you are at the table, the better your play and therefore long-term profit expectations. Many players argue that they need a drink or two to calm their nerves or to loosen their bluffing inhibitions. With less nervousness, they can also bluff without revealing a tell. All of this is theoretically possible for the certain player, but it usually doesn't work out that way in real world scenarios. How realistic is it that a person could not get himself to ever bluff unless he had a drink? Plus, there is always going to be a tradeoff, as even a small amount of alcohol will impair your poker judgment, at least slightly. Will just a drink or two guarantee that you will lose? For the best players, usually not. It might have a similar skill-dampening effect to reading or watching TV while playing. But those activities usually enable you to play longer. Drinking will wear you out a bit and cause you to play for less time, at least in the long run. If you watch carefully, you'll notice that most of the top players never drink while playing.

Even if it didn't affect your poker bottom line, drug and alcohol abuse are enough of negatives to your personal life that it is obviously wise to seek help if you suspect you may have a problem.

Gambling

A gambling problem can affect the professional or aspiring pro in two ways also, either at the poker table or away from it. Some players are able to control their "gambling" impulses when at the table. When I say "control," I mean that they let proper poker strategy dictate their playing decisions. They won't draw to an inside straight when the pot and drawing odds do not justify it. When the odds do justify it, they do get a kick out of the excitement of the unknown outcome. To me, that is not a gambling problem anymore than long-term investing in the stock market is a gambling problem. For whatever reason, some of these players who don't have a problem with "gambling" at poker, have a gambling problem with other games. They play craps, slot machines, or bet on sports.[46] In fact, they take large portions of their poker winnings and blow them at these other forms of gambling. Just because overall they are still long-term gambling winners does not mean they don't have gambling problems.

The more common problem for poker players is a gambling problem overall or specifically with poker. Most of these players are long-term losers. If you have too many uncontrollable impulses to make long-term unprofitable gambling decisions at the table, the odds will catch up with you and you will lose. The following tests will help you determine whether or not you have a gambling problem. As with most addictions, if you suspect you have a problem, you probably do. If you can, you would be best advised to quit playing cold turkey. Give up your professional playing dreams. Poker is not for you. If you stick with it, you will guarantee yourself a life of struggle and heartbreak, inflicting major damage on both you and your loved ones.

[46] Certain slot and sports betting, done in an expert fashion, can be long-term winning propositions. I'm not referring to this rarefied class here. But even these slot machines with mathematically exploitable payout structures are fast becoming extinct.

Gamblers Anonymous Test

This organization has the following self-diagnosis test to determine if you have a gambling problem. They say that "most compulsive gamblers will answer yes to at least seven of these questions."

1. Did you ever lose time from work or school due to gambling?
2. Has gambling ever made your home life unhappy?
3. Did gambling affect your reputation?
4. Have you ever felt remorse after gambling?
5. Did you ever gamble to get money with which to pay debts or otherwise solve financial difficulties?
6. Did gambling cause a decrease in your ambition or efficiency?
7. After losing did you feel you must return as soon as possible and win back your losses?
8. After a win did you have a strong urge to return and win more?
9. Did you often gamble until your last dollar was gone?
10. Did you ever borrow to finance your gambling?
11. Have you ever sold anything to finance gambling?
12. Were you reluctant to use "gambling money" for normal expenditures?
13. Did gambling make you careless of the welfare of yourself or your family?
14. Did you ever gamble longer than you had planned?
15. Have you ever gambled to escape worry or trouble?
16. Have you ever committed, or consider committing, an illegal act to finance gambling?
17. Did gambling cause you to have difficulty in sleeping?
18. Do arguments, disappointments or frustrations create within you an urge to gamble?
19. Did you ever have an urge to celebrate any good fortune by a few hours of gambling?
20. Have you ever considered self destruction or suicide as a result of your gambling?

American Psychiatric Association Test

According to DSM-IV, which is the manual written by the American Psychiatric Association, you are diagnosed with a "pathological gambling" problem if 5 of the following 10 characteristics are present:

1. Is preoccupied with gambling (e.g., preoccupied with reliving past gambling experiences, handicapping or planning the next venture, or thinking of ways to get money with which to gamble).
2. Needs to gamble with increasing amounts of money in order to achieve the desired excitement.
3. Has repeated unsuccessful efforts to control, cut back, or stop gambling.
4. Is restless or irritable when attempting to cut down or stop gambling.
5. Gambles as a way of escaping from problems or of relieving a dysphoric mood (e.g., feelings of helplessness, guilt, anxiety, depression).
6. After losing money gambling, often returns another day to get even ("chasing" one's losses).
7. Lies to family members, therapist, or others to conceal extent of involvement with gambling.
8. Has committed illegal acts such as forgery, fraud, theft, or embezzlement to finance gambling.
9. Has jeopardized or lost a significant relationship, job, or educational or career opportunity because of gambling.
10. Relies on others to provide money to relieve a desperate financial situation caused by gambling.

(The gambling behavior is not better accounted for by a Manic Episode.)

Where To Find Help

If you failed either of the above tests, I have little doubt that you have a gambling problem. Even if you answered yes to just below the allowed number of questions, I don't think you can feel very secure in concluding that you don't have a problem.

Ideally, you should be able to answer "no" to every one of these questions.[47]

If you fail these tests or suspect you have a problem, you must seek help and try as hard as you can to avoid playing poker or any other form of gambling until you have better assessed your problem.

I am not a psychiatrist or psychologist and am in no way able to give you solid advice on how to solve your gambling problem. I cannot even attest to the credibility of the following organizations, although I suspect that they may be helpful. If you have a gambling problem, I suggest you do your own research and speak with your personal doctor to discover your best options. These are two places that at least appear to me, on the surface, to be credible places to look for help.

Gamblers Anonymous

They have many local branches, especially in most areas near gambling institutions. You can check your phone book or GamblersAnonymous.org to find the branch nearest you.

The National Council on Problem Gambling

Call their toll free number at 1-800-522-4700 for further information.

[47] Except #12 from Gamblers Anonymous, which is proper bankroll management

Chapter 29
Health Insurance and Savings Plans

If you are used to working for a larger company, you may take your health insurance and retirement plans for granted. Professional poker players do not have this luxury. Do not consider quitting your current job to play poker before you first have a health insurance and retirement savings game plan.

Health insurance plans should be a particularly immediate concern. You want to have an individual plan already in effect before you quit your job. If you don't, you are putting yourself at risk in two ways. One is that you could have an expensive medical need and be forced to pay for it out of your own pocket. Kiss your saved-up bankroll goodbye. Also, if this medical problem is something chronic, you may have a very hard time finding any company that is willing to insure you in the future. If one does insure you, the monthly rates might be through the roof.

If you currently have a chronic medical problem, your poker dreams may not be worth giving up your current job with your already established insurance coverage. Keep your current job and just play poker on the side.

♦ ♣ ♥ ♠
Chapter 30
Paying Taxes

Most people who play poker recreationally don't think about paying taxes. They win or lose a relatively small amount here or there and may not even know that they are supposed to report this to the IRS. In truth, they usually get away with this because the IRS can't easily keep track of these small wins. If you ever have a bigger win like a tournament cash-out over $600, the casino will issue you a W2-G form and notify the IRS. Also, if you make a $10,000 or higher transaction at the casino cashier, they will also notify the IRS of this.

As a professional player, just be smart and pay your taxes. Why risk major fines or even prison time over this? It's hard to make a living playing poker from a prison cell, unless you count a few cartons of cigarettes from Sticky Fingers McCoy and Bruno The Butcher as a living.

Do Gambling Losses Offset Wins?

There is a common misconception that you can offset your gambling wins with gambling losses. It's close to true, but not exactly. You report all your winnings for a given year and then you claim all your losses as <u>itemized deductions</u>. Depending on whether or not you would otherwise be itemizing or crossing the standardized deduction threshold, these may not exactly cancel each other out.

Keep Records

You must keep an accurate gambling diary in case the IRS ever wants to audit you. This is easy because you already are keeping accurate records. At least keep the following items in your diary:

- The date you played and at what game and limit.
- How much you won or lost.
- Name(s) of others with you. (Probably just note the floorman on duty.)
- The name of the casino or card room, along with the address.

Also save any paper trail of anything gambling related. Bank withdraws, checks, casino account receipts, and definitely any W2-G's you are issued. Since you can deduct all kinds of gambling losses, also save your lottery tickets, horserace bet tickets, etc.

Hire An Expert

Find a good tax preparer who is knowledgeable about gambling issues. Why waste your time trying to figure out everything for yourself? As with many other things in life, hiring an expert actually saves you money when you factor in your time. You could spend 20 hours trying to figure it all out and still fill out a wrong form or something. Meanwhile, you could have just played poker for a couple of extra hours and paid an expert with the money you average in that time.

Two Ways To File

When you consult your tax person, you will learn that there are two ways you can file, either as a recreational player or as a professional. Recreational players don't have to pay into Medicare or Social Security. But they also don't get to deduct their gambling business expenses. Like the price of this book! If you file as a professional, you are basically treated just like any other sole proprietorship business. You get to deduct many of your expenses, but you must be able to prove that you are treating your playing as a business. You also must pay into Medicare and Social Security. But if you don't have another job, you may want to pay into these programs so that you get benefits when you retire, especially considering the advantage of making additional deductions. You also get to make larger contributions into certain tax advantaged retirement plans.

If you want to bone up on some of these issues before you even discuss things with your tax specialist, I highly recommend you get *The Tax Guide For Gamblers* by Roger C. Roche and Yolanda Roche. I have links to in on my website, MarkBlade.com.

If you play internet poker, I would recommend that you do what many top poker pros do. Report your winnings and pay your taxes just as you would if you won the money in any brick and mortar card room.

♦ ♣ ♥ ♠

Chapter 31
Is Poker Still Fun When
You Play It Full-Time?

It can be, but it will probably never be as fun as when you are new to the game. But that's not a big surprise. Most experiences lose a little of the fun and excitement with a lot of repetition. Your first kiss, first visit to Disneyland, and the first time you saw Star Wars were probably the most fun.

The bigger question is can this be enjoyable after years or even decades of regular, full-time play?

Maybe.

This seems to depend a lot on the player. Toward the start of this book, I recommended that you only pursue poker as a career if you really have a deep love for the game. That's because these people are the most likely to be able to sustain a satisfying level of enjoyment of the game for years to come. However, I must warn you that even many of these types of people burn-out on poker after years and years of regular play.

Are You An Entrepreneur?

That's why I'll recommend another beneficial attribute for an aspiring pro. An entrepreneurial spirit. Why? Because in about ten years you may get tired of playing poker for 40 hours a week, 50 weeks a year. You may want to start looking for a new well-paying career and it won't be very easy without anything on your resume for the past ten years besides "Proficiency in Texas hold 'em and Omaha high-low split." If you can forge a new entrepreneurial career, however, who cares about your work experience? Actually, poker is a great job to have while you're starting your own business. You can make money on the side whenever you want while your start-up goes through some slow times during the initial phases.

If you are going to sustain a long-term career, here are some ideas to help you keep it from becoming a grind.

TABLE DISTRACTIONS

Get An Ipod

Most casinos allow players to wear headphones while playing. I know of many players who always listen to music while playing, even some top tournament pros. Invest in something like an Ipod where you can have thousands of songs at your disposal. This is where you are going to be spending a good portion of your waking hours. Put some effort into it. Don't just rely on local radio stations with a $20 Walkman. How about getting satellite radio? You could pay your monthly fees with less than a half an hour of extra play a month, which would in turn make the other 175 hours much more enjoyable. Or check out books on tape from the library.

Many experts would say that to play your absolute best you need to be 100% focused on the game. They're right. Maybe your hourly rate will be reduced by 10% or more because of your music distraction. But maybe the enjoyment music brings you will enable you to spend 50 or 100% more time at the table each session. Also for some people who struggle to control their emotions when luck turns bad at the table, a soothing song may improve their results. Just be sure that headphones don't cause you too much of a distraction. And keep the volume low enough that you can still hear the dealer and other players almost perfectly.

Watch TV

Many casinos have TV sets all around for the players. Popular sporting events will usually be shown. If you are a regular, you will quickly understand the protocol for requesting channel changes. Usually you can ask a floor man. I also tip a dollar for a TV channel change. Hey, that's an entertainment bargain if I can watch the show of my choice for an hour or more. Of course, be sensitive to what the majority wants to watch. But during non-sports times like late night, nobody really cares what's on. That's when I usually make most of my requests. I'll have them put Leno or Letterman on. Of course the volume is muted. That's where special Sony Walkmans, which are able to get local TV station's audio feeds, come in handy.

These Walkmans only tune in sound from local TV channels 2-13, but that is still a nice addition to your entertainment options. Even if you don't have a TV to watch along with, you may want one of these for your listening pleasure.

Just realize that every second your eye is glued to the TV is time you aren't paying attention to your opponents' betting patterns or learning their tells. This will definitely reduce your profits. How much depends on the quality of multitasker you are.

Read

Many casinos also allow you to read at the table. I've seen many players reading entire novels. Newspapers and magazines are very common. You may be reading this very book right now at a poker table for all I know. The problem with reading is that it is much more distracting than just listening to something on a Walkman. So be careful. For the very experienced player, it is possible to read and still play profitably, though certainly not nearly as profitably as if you were giving your full concentration to the game. Again, it is a trade-off that may be worth it to you.

If you do read, you must really stay on your toes. It is very rude to constantly have to be elbowed by your neighbor when it is your turn to act. Do not read at the table if you can't do so without holding up the game.

Talk On The Phone

Some players may consider this to be slightly rude at the table, but I don't have any problem with it. In some card rooms, at least, cell phones are always used at the table and no one seems to really care. Keep your voice down, of course. But if you need to touch base with a friend, why not kill two birds with one stone.

Keep in mind that all these distractions should only be indulged in by the very experienced player who can still play profitably on auto-pilot. For less experienced players, it will require your complete attention and concentration to play well.

PLAYING EXCITEMENT

Vary Your Games

Once you've been playing poker for a long time, one of the main ways you will keep it fun and exciting is to play different games. Try seven-card stud or Omaha high-low split. Different games require a lot of different strategies. It is exciting to veer off of your normal well-established auto-pilot at hold 'em, for example. Don't just play another game for kicks. Try to become an expert at it. Read the best Omaha book you can find and try to see if you can remember all the advice to the letter. If no-limit is available, only play it if you've really done your homework.

Increase The Stakes

When you are ready, in both bankroll and preparation, you will eventually step up in stakes. This always adds some excitement. Even if you've been playing for years, whenever you graduate to higher stakes, it is more exciting for at least a while. But don't just to this for kicks. That may be a signal that you could have a compulsive gambling problem.

Play Tournaments

If you don't normally play in tournaments, try one every now and then. This is often an exciting sporty atmosphere for just about everyone who plays in them. The rapidly changing stakes, table turnover, and frequent precariously short chip positions make for elevated excitement.

I believe you can have a fun and exciting long-term career in cash games. Many pros have enjoyed such a career. But if I were to guess which is more likely to provide long-term fun and excitement for the average professional, it would be playing in the major tournaments. I also think that the aspiring big-time tournament player also has the lesser chance of long-term financial success. But hey, maybe that's what makes it more exciting.

Cautionary Note: Playing With The Rent Money

This chapter has focused on the long-term sustainability of fun and excitement when playing full-time. There is another hurdle you must first cross whenever you finally decide to quit your day job. That hurdle is how you deal with playing when poker is now your only source of income. Many aspiring pros think they love poker because when they play on the weekends, they have a blast. Then an odd thing happens the day they start playing for a living. Instantly the game loses its fun. No longer is it a recreational endeavor. Even though you have an adequate bankroll with padding for living expenses, it just becomes a psychological burden. All you can think about is what if a bad luck streak hits. If you're in the middle of one, you pull out your hair worrying about if it will ever end. If you are someone who craves security, it doesn't matter how well you understand bankroll and living expenses management. Poker will never be enjoyable for you as a full-time job.

I don't know if there is any foolproof way of knowing if this is you before you make the leap. But maybe deep in your heart, you know. There's nothing wrong with keeping your day job and playing poker as a profitable hobby. In fact, if I could meet every reader of this book personally, and assess your particular life situation, I'd probably recommend that route for most of you.

Chapter 32
Is Professional Poker Conducive
To A Healthy Lifestyle?

The simple answer to this question is no. But poker is not unique in this respect. Many of the following health negatives are shared by numerous other professions.

Sedentary Job

Just like most office jobs, poker players sit down at the job. But it is as bad as any office job can possibly get. Many casinos will roll food right up to you on a roll-away tray. In an office, at least, the water cooler doesn't come to you. Most office jobs occasionally require walks down the hall to other offices or meetings in the conference room. In poker, you only have to get up for two things: bathroom visits and table changes.

Proposed Solution

If your card room takes a rake, you may choose to sit out a round a couple of times during a session so that you can take a 15 minute stroll. Walk around the block or at least take a lap around the casino floor. If you pay a time-based fee, you are losing money anytime you step away from the table. Here's what I do. Notice when the next dealer is waiting to take over at your table. Get up and take a quick stroll. You have the time that it takes for the rest of the current hand that's being dealt, plus the new dealer taking the seat and getting situated. I tell the upcoming deal to "deal me in" before I walk away. This gives you even a little more time as you only have to get back in time for your first action. This is also a way to shake some life into you as you play into the later tired hours.

Stressful

Many professions have their unique stressors. But poker is unusual in that your actual paycheck is on the line every single hand. It is very rare to find another job where basically every working minute of every working day you are making specific decisions that will sway your salary one way or the other.

Proposed Solution

The upcoming section on mental and emotional tips should provide a lot of help in this area.[48] Also the next chapter on a healthy poker mind is pertinent. You must get a handle on this, not only for your health but your financial livelihood. An increased level of stress can reduce your ability to think clearly and make you much more prone to going on tilt.

Irregular Sleeping Patterns

If you choose to play poker during the most profitable hours, you will be a night owl. There are some health ramifications to this, most having to do with the disruptive effect on your sleep. Anyone who works a graveyard type shift will attest to this. If you live with other people, they will probably not be on your same time schedule. Family obligations may require you to wake up earlier than you like. Even if you don't have to wake up, household noises might wake you up anyways. The outside world certainly won't comply with your needs. Car traffic or trash trucks will roll as usual despite the fact that you just finished playing at 4:00 am this morning.

Proposed Solution

You may decide that even though a game is very profitable, you will not put in any overtime because you value a regular schedule. Even if you work late hours, the more regular you make your schedule, the better your chance of adapting to it in the healthiest way. Other solutions include ear plugs when you sleep or more firm instructions to family members to be quiet during certain hours. Some graveyard workers find that it is just best to sleep in a different room than their spouse. Like stress, proper sleep is not only a health issue but also a bankroll issue. If you start your next playing session when you're already tired, you can expect your results to also take a snooze.

[48] As will my book, *Profession Poker 3: The Mental Game*, if it is available by the time you are reading this. Check for it at MarkBlade.com

Second Hand Smoke

This is fast becoming a problem of the past. Most major tournaments are now smoke free and many poker rooms are banning smoking as well. This is a trend that I believe is here to stay. If you still play in a smoke filled casino or home game, however, it is a health risk. Some years ago when smoking was still allowed in California card rooms, a dealer who had never smoked a day in her life told me that she had a lung x-ray and her doctor told her that her lungs looked like those of a one or two-pack-a-day smoker.

Proposed Solution

There are just two ways to counter this. Switching seats, tables, or card rooms is one. The second is to buy a miniature, battery-powered personal fan that you rest on the table along with your chips and point as necessary.

Unhealthy Food

If your card room offers food at the table or even just within the casino, you will find that most of the menu items are quite unhealthy. This is no different than the majority of non-casino restaurant and fast food. If you regularly indulge in these, you do so at significant risk to your health.

Proposed Solution

This isn't too difficult. Just be careful to order the healthy choices from the menu. If all they offer are hamburgers and hotdogs, pack a lunch. There's usually no reason why you can't eat a sandwich at the table. Or sit out a round and find a nice little spot to take a break from the action, dig into your backpack, and enjoy a healthy meal.

Miscellaneous

Poor posture while playing is quite common. Hour after hour of chip shuffling might lead to carpal tunnel syndrome. Airline passengers are warned that prolonged sitting can lead to dangerous blood clots in your legs called deep-vein thrombosis. Why would poker sitting be

much different? A recognized tell for bluffing is when someone stops breathing or only allows for the shallowest of breathing. I suspect that many players regularly breathe in a more shallow way than other professions. It may seem trivial, but years of this can only have negative health effects. Close proximity to others in less than ideally ventilated areas can make you more prone to catching air-borne viruses, particularly during flu season.

Proposed Solution

Nice and simple. – Sit up straight, don't play with your chips, stretch your legs, take some deep breaths, and wash your hands. Oh, I almost forgot – Don't talk with your mouth full and hold your mommy's hand when you cross the street.

There Are Health Positives

A study of elderly gamblers was commissioned in 2004 by an anti-gambling faction. They were hoping to demonstrate the health hazards of gambling. Instead, these university researchers found a positive health correlation. Who knows? Maybe this study was flawed, but it stands to reason that there could be very beneficial aspects to playing poker.

Any kind of stimulating mental activity is known to keep people's minds sharp and counter common aging-related declines. Playing poker, particularly when it is played well, requires a lot of complex thinking. Poker can also be a positive social outlet. I know of many players, particularly older ones, who maintain a satisfying level of human engagement simply through their regular poker playing. It is an engaging hobby/retirement side job that gives many people an attractive reason to get up every morning.

Also, I don't doubt that as long as poker can be played for money on the internet, there will be a number of players with disabilities who have a viable career option that they otherwise wouldn't were it not for poker.

♦ ♣ ♥ ♠

Chapter 33
A Healthy Poker Mind Through
A Healthy Poker Body

Think about this. The top 100 poker players in the world all work at occupations that are incredibly sedentary. Considering the level of obesity in our nation, you'd expect most of them to be severely overweight. Yet, with a few very noticeable exceptions, I'd guess that these top 100 players are below the average in weight compared to any random 100 people you'd pick off the street. In fact, many of these top players are very athletically active when they aren't playing poker. You've probably heard the expression, "sound mind, sound body." Do you believe it? I sure do. Keeping yourself in tip top health can only have a positive correlation with your poker results.

Exercise

Try an experiment for yourself. Do some moderate exercise before your next playing session. Then notice if you feel more alert. Are you better able to psychologically shake off a bad beat when you're feeling healthy or when you're feeling lethargic?

Many top tournament pros have a fairly rigorous exercise routine when they are playing major tournaments. They will jog or swim laps before they enter the card room. This is particularly helpful for reducing stress. Entering a tournament without a ball of nerves attached will enable your mind to focus with laser accuracy on the task at hand.

Food

Scientific researchers have done studies on people where they have either been eating less or eating more before a test. Those that have eaten less perform better on these cognitive tests. The same results have been shown on rats running through a maze. Are you in optimal shape to take the SAT right after a Thanksgiving feast? Of course not. I wouldn't be surprised if they did experiments someday on post-big-meal poker players and found that they earned 25 to 50% less than their loose-belted counterparts.

Chapter 34
Proper Etiquette Maximizes Poker Profits

Although the technical definition of a professional poker player is simply someone who plays poker for a living, I believe there is another factor. How the player behaves at the table. Ridiculing fellow players or criticizing dealers in a disrespectful way is an embarrassment not only to the offending player, but also to our cherished profession.

The stupidity and irony of this behavior is that it is usually perpetrated by players who think they are better skilled at making money at the poker tables than just about everyone else. Yet these despicable actions actually cost them quite a bit of profit.

Ridiculing Other Players

This is probably the single most costly mistake you could ever make at the poker table. Yet many players, who have memorized every starting hand recommendation from every position along with every conceivable mathematical odd that ever occurs in poker and pride themselves on never making a mistake at the table, ignore the biggest mistake of them all. They ridicule bad players.

As you'll remember from the previous chapter on poker profitability, the large majority of your winnings comes from the worst player(s) at your table. If you ridicule a bad player, he will likely respond in one of a few ways. The player may stop enjoying himself and decide pretty soon to just get up and leave the table. If this happens, you have dealt a severe blow to your profit expectations, possibly wiping them out completely for that particular table. Another likely response is that the player will be very embarrassed by your comments. In an attempt to avoid further ridicule, he may try to play better. He will no longer draw to crazy long-shots. You will have turned a bad player into a good one at the expense of your pocketbook. Real smart. The player also might decide to go to war with you. This isn't optimal poker so you will have an advantage if you know how to counter this. But your advantage may very well not be as great as it was when he was playing poorly in his previous way.

And that is just the start of the adverse effects you will have caused. Your ridicule will likely dampen the mood of everyone else at the table. Fun filled games where everyone is laughing and enjoying themselves are the most profitable games you can find. You might remember this lesson from the chapter on table selection. If you kill off this collective good mood, you could tighten up everyone's play. No more poker party thanks to your behavior.

Act like a lady or a gentleman at the table always. If your opponent just put a horrendous beat on you, summon up all the strength you can muster and say, "Nice hand." If you act like you mean it, you will maximize your profit potential. Think about it from the bad player's perspective. He's obviously unstudied in the game and looking for a good time above all else. He will actually enjoy giving you his money in future hands if he likes you. I've seen it happen countless times at the table. Sure he'd like to win, but if he's having fun losing, it's a very close second for him.

Can Ridiculing Ever Be Profitable?

Theoretically, it is possible that in certain situations you could profit by your ridicule. For example, if you could somehow throw an expert off his game, this might work. Or in a tournament where a player can't just get up and leave, this at least eliminates one of the possible downsides to ridiculing other players. But the risks of it backfiring are too great to even merit an attempt. Phil Hellmuth is infamous for his unwelcome ridicule of other players. Maybe he does it on purpose, hoping to play it to some advantage. And I'm sure occasionally this does benefit him. But he'd have to be an academy award winning actor to fake acting upset as well as he does. I honestly believe that as much money as he's won during his career, he would have made even more had he always been on his best behavior at the tables. Howard Lederer and Daniel Negreanu don't seem to have much difficulty making a lot of money while retaining their polite composure.

And forget about just the effect that ridiculing has on the ridiculed player and mood of the table. If you are that upset by a bad beat, you can't possibly think with the perfect clarity and focus necessary to play your "A+" game.

Criticizing Dealers

This is another self-defeating behavior at the table. If you are very rude about it, it can have the same chilling effect on the table as criticizing players. But the main way that this affects you monetarily is that it almost invariably ends up slowing down the game. If you want a dealer to slow down, one of the surest ways is to repeatedly chasten him to speed up. He'll end up making *more* mistakes which often have to be resolved by calling over a floor-person. The same result happens when you tell a dealer to stop messing up. This just increases his nervousness, causing more mistakes.

A helpful tip, on the other hand, that you share in a kind and calm manner can be quite helpful to the dealer and speed up the game. Realize that many dealers are just beginning and rookie mistakes are inevitable. I wish casinos would be stricter about ensuring proper player etiquette. I've seen players throw cards at dealers or cuss them out countless times without almost any repercussions at certain casinos. I think this is bad for business long-term. Even if this player is a regular, the card room should kick him out for the day. No need to worry about business, he'll be back tomorrow. But a timid beginning player who observes this kind of behavior at the table might be scared away from public poker for life.

We All Have A Stake In This

Most polite players sit back and do nothing when abusive players act out. But as I've pointed out, if this behavior chases a bad player away from the tables either temporarily or permanently, all of us good players are affected. These abusive players are stealing money from us. They're taking food right out of our babies' mouths! Until we start to see their actions for what they are, we might become complacent, selfishly concluding that it's the poor berated player or dealer's problem, not mine. It's all of our problems!

The safest and easiest thing you can do is to complain to your card room management. Tell them that you are sick of how lax they are in their weak attempts to curtail abusive behavior. Until they start to fear losing the polite majority's business, they will never have a financial incentive to deal with the rude minority.

Another thing you can do, especially if you know the abuser well, is to have a non-confrontational talk with him about his behavior. It is probably wise to not do this when he is currently heated, as your safety could be at risk. But if you see the abuser during one of his better moods, pull him aside. Tell him that you understand how frustrating bad beats from bad players can be, but that you are saddened by his actions and remarks, both from a human and a financial self-interest perspective.

If you have the courage and the tact, you could say something right there at the scene of the crime. Natural charmers might say something humorous to diffuse the situation. At the very least, you can say something non-confrontational and calming like, "C'mon guys, let's just play the next hand. I'm just here to have some fun."

Chapter 35
Tipping

Dealers often work for minimum wage and rely on your tips for their livelihood. All players, pros and amateurs alike, should tip dealers for their services. The usual going rate for most casinos is a buck a pot. If the hand doesn't even go to the flop, I think it is quite alright to not tip anything on that hand. For a very large pot, more than $1 is also quite common. I also wouldn't object to a small variation in your tipping depending on the dealer's skills. But unless the dealer is extremely inept, please realize that your tips are relied upon to make up a dealer's real wage.

Ideally, it would probably be easiest if casinos just collected a higher rake or hourly fee to pay dealers fairly from the start. Faster dealers could be paid more, as long as they weren't making more mistakes, as they would be bringing more money to the casinos that charged fees in a per hand rake.

While I can never fault a player for his generosity, please be aware that acting like a big shot by tipping $5 or $10 per hand will quickly eat away at your profits.

Tournament Tipping

This is a very controversial subject. Many pros disagree on what you should tip. In a normal cash game, you usually tip for every pot you win. Because you win pots so regularly on average, you usually personally tip most every dealer that sits down at your table. But in a tournament, you could win lots of pots, but if you don't make the money cut, you probably won't be tipping a dime. On the one hand, that seems fair because you didn't win anything. On the other hand, you still received hours or even days of great service that deserves to be fairly compensated.

Luckily, the trend for tournaments seems to be heading toward tips being baked right into the entrance fee. If that is the case, and I hope it gets to the point where all tournaments are run like this, you should feel comfortable not tipping anything, even if you win.

But for tournaments that don't factor gratuities into the entrance fee, you should probably consider somewhere in the range of 1-5% of your winnings. Some players only tip when they win first place. Others tip for any amount they cash out. I agree with the latter. Tip on the higher percentage end if the buy-in is small. If it is very large, you could tip on the lower end. I don't think you should ever feel required to tip 10% or more. If you won $1,000,000, you'd be tipping $100,000. To me, that's ridiculous.

Not Just For Dealers

In a cash game card room, don't forget to tip other service personnel besides the dealers. Of course, waiters and drink servers should be tipped. Also consider tipping floor people, particularly those who are instrumental in getting you seated. A quick seating or a desirable table change can mean a significant difference in profits for a day. Why not reward good service and encourage future favorable treatment with a buck or two.

One other slight consideration to consider regarding tipping is the play of marginal hands. When there is a raked pot, many hands that are very close calls profitability-wise should be folded because the rake would cost more than your profit. Likewise, extremely close calls can be avoided just because of tipping. If a certain hand has a long-term profit expectation of 45-cents per hand, it would not be worth playing if you normally tip $1 per hand.

Chapter 36
Will You Be Able To Look Yourself In The Mirror?

One final question for you to ponder before you make the plunge into professional poker is how you will feel about yourself if you do. Some people ask, "How can you feel good about yourself if you're just taking people's money?" That's a fair question and one that you should take some time to consider before you make any decisions. Personally, I don't have any problems with it, but you very well might. I can understand that. Here are some thoughts to consider.

Is It Honest?

First, it isn't as if you are stealing from them. Everyone who sits down to play poker realizes that there is some skill involved and that they may be playing against skillful players who have a better chance of beating them. Knowing this, they chose to play anyways. So if they are fine with it, why shouldn't you be?

You're A Casino Owner

I like to think of myself the same way I would if I were a casino owner. People are enjoying playing against me. Sure, they have a long-term likelihood of losing to me but so does anyone playing craps or roulette. In the short-run, they could win if they get lucky. It is fun for them to take that chance. If I owned Caesar's Palace, I wouldn't sweat it. People get a lot of enjoyment out of playing at Caesar's. I'm certainly friendly and polite enough at the table that I am adding to their positive experience in some respect.

Recreation Money

People have discretionary income that they can spend on many non-necessity items. If they decide to spend it on poker, who am I to argue? They could spend it instead on a sports car, jewelry, plasma TV, or a vacation. All of these things are recreational or frivolous in a way. But they are things that make people happy, as does playing poker.

Playing Against Problem Gamblers

This is probably the strongest argument against playing poker for a living. If you play enough, you are certain to occasionally play against people who have a gambling addiction problem. They are losing money to you that they really can't afford to lose. One thing you can do if you encounter someone you know to be in this category is suggest that they seek help. You can recommend they look up Gambler's Anonymous or that they call it a night at least. I wholeheartedly support that. But if they refuse your suggested help, what else can you do? If you leave the table, they will still play without you. At some point, if they are not a family member or close friend, you have to turn your back and just let them make their own decisions.

Plus, identifying a problem gambler isn't always that easy. Some guy could come in every day and lose a couple thousand dollars. This seems like an obvious problem. But if he has a trust fund with multimillions in it, this might be nothing to him. He could buy a Picasso and you almost certainly wouldn't object. But, really, what's the difference between the enjoyment from a painting and the enjoyment from playing poker? It's all subjective. And what if you ran a Vegas buffet and a morbidly obese person walked in? Would you refuse to serve him? If not, why not? That fattening food is probably going to kill him sooner or later. It's the same concept as dealing with a problem gambler.

It's Not A Meaningful Career

Ok, strike what you just read in the previous topic. This is the strongest argument against playing poker for a living. If you really want to make a strong positive impact in the world with your career, then this isn't it. Some poker pundits argue that professional players provide a valuable service because they often provide the foundation for games to regularly get going at casinos. This is somewhat true. There will be times that a table is just waiting for one more player before they will start it. Your arrival could enable all the other players to start enjoying themselves. Or your presence might prevent a table from breaking up in the late night or early morning. But most of the time, the same number of tables would run if you were there or weren't there.

On the list of meaningful careers, poker playing certainly isn't at the bottom. You aren't making cigarettes or telemarketing some useless product. There are many highly respected careers such as certain wall-street traders who basically add almost nothing of value to the human experience. If you ever become a famous tournament pro, you could give people a great thrill, maybe even one of the most exciting times of their lives, by simply playing against them, or entertaining them on TV. That's nothing to sneeze at. But again, there are probably many more noble or spiritually enriching careers than playing poker.

But who says that your job has to make the world a much better place. To me, it's an honest living. And, if you want, you can do great things with the money you make. You could certainly donate a portion of your earnings to a worthy charity. Barry Greenstein, the so-called "Robin Hood of poker," donates all his tournament winnings to charity. What a cool, meaningful thing.

Final Thoughts

Playing poker can be a great career for the right person. You can earn a great living. Have enormous flexibility in your work schedule. It can be both challenging and exciting, fun and quite social. You can raise a family on the money you earn. Or you can just choose poker as a side career. A way to turn an enjoyable hobby into a source of supplemental income.

Poker can be whatever you want to make of it, as long as you go into it with your eyes wide open, and with all the necessary information at your disposal. By reading this book, you will know exactly what it takes to play poker for a living.

♦ ♣ ♥ ♠
SECTION 5
ADVANCED MENTAL
& EMOTIONAL TIPS
♦ ♣ ♥ ♠

♦ ♣ ♥ ♠
Section 5 Introduction

Your ability to play poker can be basically broken down into two parts.

<u>**YOUR POKER PLAYING ABILITY**</u>
Part 1 – Your Knowledge of Poker Strategy
Part 2 – Your Ability To Execute This Strategy

This may appear to be quite obvious, and it is. Yet, despite this fact, probably 99% of all poker literature focuses on part 1 only. This is extremely short-sighted. It is hard to mathematically give a numerical weight to the importance of each part, but I think it is helpful to consider them each as 50% of what makes up your playing ability.

Importance Of Mental Control

How important is mental control to a professional poker player? It is probably the single greatest determining factor in the level of success you attain. At some point, the profit return from additional poker strategy knowledge becomes smaller and smaller. It may still be significant and well worth learning, but you've already mastered most of the frequently occurring plays. If you occasionally lose mental control, however, and shift from your "A" game to a "B" or "C" game, your profits could be drastically affected. Many professional players would get the biggest payoff for their study time away from the table if they focused solely on learning how to control their mental game.

I believe that there are countless players who know how to play winning poker, but because they lack mental control, they simply don't. What a tragedy. It's as if a potentially great baseball hitter could always hit .350 right-handed, but he insisted on batting left-handed half of the time instead. He ends up averaging only .200 and gets cut from the majors. He later kicks himself, thinking how stupid he was to keep batting left-handed when he almost never got a hit from that side. In the real world, that could never happen. The baseball manager would smack the player in the head and make him bat from the right side. Unfortunately, when a poker player plays too many starting hands, chases too much, or raises when he knows he should fold, I can't always be there to smack him in the head.

Maybe that player is you. You could be making 1 big bet per hour if you could only play your best at all times. But you lose control and start doing all the things that you know you shouldn't. Then you go home and lie in bed scolding yourself.

Most poker experts seem oblivious to your problems. They teach you everything about strategy, but then leave you to fend for yourself when it comes to execution. Not me.

Shameless Plug

In this section, you will learn many different ways to control the self-destructive thought patterns that plague the vast majority of players. This aspect of your game is so critical to your profit potential that another book of mine, *Professional Poker 2: The Mental Game* goes into even much greater detail on this subject, along with many other subjects related to the mental side of the game.[49] I believe that *Professional Poker 2* is as important, if not more important, to your bottom line than any other poker book you'll read. The only exception is for those people, who for whatever reason (maybe it's in their DNA), do not have any problems whatsoever with controlling their mind and emotions when playing, even when losing. If that's you, you can skip to the next section and also skip the portions of *Professional Poker 2* which deal with these issues. You don't need my help here. For the rest of you, probably 99% of you, please pay careful attention to this section. It is not a comprehensive treatment on the subject, as that would require hundreds of pages. And it doesn't contain all my best ideas, as many are too drawn out to fit in here (and, of course, I'm saving some of the best ones so that you'll want to buy my other book!). But this section will go a long way toward helping you maintain complete control over yourself.

Even though the chapters are categorized for "bad beats" or 'bad days" etc., most of these tips can help you deal with any poker playing situation in any time frame. I sincerely hope that that you won't dismiss this material as too wishy-washy or soft for you.

Mental and emotional control at the table can change a loser into a winner, and a small winner into someone who crushes the game.

[49] If not currently available, check MarkBlade.com for the anticipated date.

Chapter 37
Dealing With Bad Beats

If you aren't familiar with the common poker term "bad beat," it refers to those times when your opponent beats you with a hand that he should not have played in the first place, or at least not stuck with to the end. They usually involve your opponent hitting a long shot when you were the heavy favorite to win the hand.

Know The Odds

Many players get extremely upset any time an opponent hits any kind of improbable hand. For example, if your opponent hits an inside straight, you may bemoan your bad beat. But really, how bad was it? Even with just one card to go, your opponent had an 8.7% chance of hitting his hand. That means he'd hit it 1 out of every 11.5 times he tried. People are going to repeatedly chase you down throughout your entire career with 4-outers. Are you going to get upset every time they hit it?

If you know your odds well, you won't even blink an eye when a player hits a 4-outer. You know that this is expected to occur rather frequently. Even a 2-outer will get hit on the river 1 out of 23 times. Don't you expect to see your favored hand to the river countless times over your playing career? Then expect to see even 1-outers countless times. It's not so unusual when you know and completely understand the odds.

Bad Beats In Big Pots

Bad beats affect players the most in big pots. It stands to reason as this seems especially cruel to have a huge pot that you believe was rightfully yours stolen right out from under you. But the fact that there is a large pot usually means that your beat wasn't that bad after all. Let me explain with an example. Let's say you have J♠J♣. The flop is J♥10♥3♦. Fantastic! You've got the stone-cold nuts right now. You start to salivate like Pavlov's dog. Chips fly into the pot from you and four others. It's capped. Nice! The turn is a 7♣ and the same thing happens. All five of you put in the maximum amount of raises. Wow, you're going to win a huge pot if your hand holds up.

Then the river comes. It's a Q♠. Again it's capped. One of your opponents turns over the winner. It's an A♣K♦ for the nuts. You curse the poker gods from the top of your lungs! If it wasn't for this lucky bastard's four outer, you would've won a huge pot. But stop and think about this. Why do you think the pot got so huge? It's for the same reason that most big pots get that way. Because many players have many great hands or draws.

Let's look at what your other three opponents had in this hand. One had J♣10♦. Another had 9♠8♦. And the last had Q♥3♥. When you only think of your chances vs. the eventual winner, it seems like a much worse beat then it really was. Now that we can see what everyone's hands were, let's see what your actual chances were. Before the flop, you only had about a 21% chance of winning if all these four opponents saw their hands to the river with you. Your opponents had hands that ranged from 7% to 32% chances of winning. So you certainly weren't the favorite pre-flop. No bad beat so far. Even on the flop, when you had flopped your top set, you only had a 47% chance of winning the hand. That means that you are favored *to lose* this pot. Just the guy alone with the Q♥5♥ flush draw wasn't that far behind your chances. So I wouldn't call what you suffered a bad beat. If anything, had you won the hand, you could call that a "lucky win." On the turn, things really took a turn for the worst. You only had about an 18% chance of winning at that point. The guy with the 9♠8♦ had much more reason to complain. He had a greater than 50% chance of winning at that point.

So the moral of the story is that you must not have tunnel vision when you get beat on the river in a big pot. It is not just the winning hand that you should be comparing your chances of winning against. If you could see all the other hands and had a poker odds calculator at your disposal, you would realize that most of the time in very big multi-player pots, not only is the beat you suffer not bad at all, but when you win, you should usually consider yourself very lucky.

Cracked Aces and Kings

Feeling bad after losing with pocket aces or kings is so common for the average player, that it deserves its own discussion. Let's get real about how vulnerable these hands really are. Imagine that four other

players see their hands to the river. You have A♥A♦. They have
A♠5♠, 9♥8♥, Q♣10♣, and 6♥6♣. Do you realize that you have a
61% chance of <u>losing</u> this hand? What if you have a K♥K♦ instead
up against these hands? Then your chance of losing is 68%. You call
this a bad beat? If you are going to get upset in situations where you
lose when you were, in fact, favored to lose, you might as well throw
a fit every single time you don't win a pot.[50]

Knowing The Odds In No-Limit

When it comes to dealing with bad beats, knowing the odds is even
more important in no-limit than in limit. The reason it's more
important is because bad beats can pack a much greater punch when
huge amounts of your chips are in play during just one pot. And if
you reel from a bad beat for even two minutes, you could lose all
your chips on the next hand because you are on tilt. You'd have to
be pretty short-stacked in a limit game to lose all your chips on just
the next hand. Also, in no-limit, there are many more all-in
situations. An opponent who would never chase a long-shot in limit
hold 'em to the river, would be along for the entire ride if all-in pre-
flop.

Remember from the odds chapter that if you have A♥K♥ and your
opponent has 7♣2♠, he still has a <u>31% chance</u> of beating you. Most
players would think they suffered one of the worst beats imaginable
if they had the suited ace-king and lost this hand. But this is actually
the same severity of a beat as if your opponent had an open-ended
straight draw on the flop and made his straight by the river, which is
also a 31% possibility. Would you consider that a bad beat? You'd
better not, because it's going to happen to you almost one out of
every three times you face that situation. What's really funny is that
many players will get very upset if they have A♥K♥ and get beat by
7♣2♠ when both are all-in before the flop. Yet many of these same
players will also get upset when they themselves have an open-

[50] These hands were used to make a point. There wouldn't be that many
flops where all these specific hands would catch enough hope that they
would all call to the river. But I could've devised some other situations that
are very possible where your aces or kings would have even worse odds
than shown here, as often occurs in loose games. So the example is very
valid in practical terms.

ended straight draw on the flop and <u>don't</u> get there. It's crazy! On the one hand, they're upset when a 31% probability occurs. Then, on the other hand, they're upset when a 31% probability doesn't occur. You can't have it both ways.

The moral of this story is that if you insist on letting bad beats affect you, then at least know when you've actually encountered one. Most of the so-called "bad beats" that people complain about aren't really that bad at all.

Bad Beats Are Your Best Friends

So how should you react when you experience a so-called "bad beat?" You should shout inside your head, "Yippee!" And do a little mental jig while you're at it. I'm not kidding. Bad beats mean that there are still players out there who play badly. That means the games are still beatable. The day you stop having any more bad beats is the day when you should crawl into a fetal position in the corner of the casino and bawl like a baby. Your career is over. The worst case scenario mentioned earlier in this book in the chapter "The Long Term Prospects For A Poker Career" has just played out. Your competition all plays as well as you do and you are just passing money back and forth among yourselves with only the casino rake coming out ahead. Don't scoff at the title for this topic. Bad beats truly are your best friends.

Beware Of Selective Memory

You almost never hear a player who whines about bad beats thanking his lucky stars when his opponent <u>doesn't</u> draw out on him. The reason for this is that these potential bad beats that never come to fruition are rarely seen. For example, you bet on the river and your fishy opponent folds his missed 2-outer. Or he calls with his unimproved pocket twos, but just mucks it when you show your pair of aces. Because you don't actually see these things, they do not register in your head as the many, many potential bad beats that never came to fruition. If you did remember his many previous bad beat misfires, you wouldn't be nearly as bothered by his occasional hit. You make most of your money when people chase you with unprofitable hands. Don't forget it.

Don't Embarrass Yourself

Have you ever seen a player cry, I mean literally cry like a baby, when they suffer a bad beat? No? I haven't either. And you probably never will because people are too ashamed to act like a baby when they are all grown up. Wait, I take that back. Players whine like babies over their bad beats all the time. What do they expect their opponents to do? Walk over to them with a big comforting hug? "Oh, there, there, wittle baby. Don't cry. It'll all be better in just a wittle while." When you whine about your bad beats, you prolong your bad feelings just like a baby prolongs his anger by throwing a temper tantrum. You're a grown-up now. Stop acting like a baby.

Take A Couple Of Deep Breaths

Deep breathing relaxes your nerves. The next time you encounter a bad beat, try to take a couple of deep breaths. Maybe stand up and stretch your legs a little between hands. Or go to the restroom and splash some cold water on your face. Anything to clear your head so you can play the next hand without any lingering mental baggage.

Great Players Suffer More Bad Beats Proportionally

When you are a great player, you must realize that out of all the hands you see to the river, you are going to suffer proportionally more bad beats than anyone else at your table. The bad players are always going to the river. Most of the time, they have the worst hand so most of their beats are going to be well deserved. They will have more <u>total</u> bad beats because they are seeing so many more hands to the river. But proportionally, you are going to suffer many more bad beats. A good portion of the time you see the river, you will have had the best hand on the flop or the turn. So when you lose, it is often going to be because you were drawn out on.

It's a strange, interesting twist that a consequence of improving your play is that the better you get, the more bad beats you will proportionally get vs. the total number of your showdown hands. Now that you know this, you can expect it, and not let it affect you so much.

♦ ♣ ♥ ♠
Chapter 38
Dealing With Bad Days

A Bad Day Can Be Your Friend Too

I've noticed an interesting anecdotal pattern with my own results related to swings. Some of my bigger winning sessions started with fairly big initial losses. I'm convinced that this is more than just random as there is a logical reason for it. If you are playing in a very bad game (a game with many skilled players), there will be fewer fluctuations (unless the game is *extremely* aggressive). Players won't chase you with long-shots. Most pots will include only a couple of players. You will raise pre-flop with your big favorite hands and get no callers sometimes. Your expected hourly profit will also be lower.

Very profitable games, on the other hand, can be very fast and loose. If you have many opponents calling to the river with a lot of chips hitting the pot, your fluctuations are going to be quite high. So if you are a good player and you lose a lot of money rather quickly, and the competitors don't seem world-class, the chances are pretty good that you are actually in a very good profit expectation game. Bad games just don't often have rollercoaster dips that are that steep, that fast. So the next time you are having a very bad day right off the bat, fasten your seatbelt and smile. You should be happy because you are probably in a real sweet spot with very positive expectations.

A word of caution: You must be sure that this fast and loose game has not made you also play too fast and loose yourself. Particularly when there is a maniac or two in the game, you may start to follow suit and play recklessly yourself. If this is the case, then your big loss may not just be a random fluctuation, but well deserved.

Why You "Never Get A Hand"

A major frustration for many players is when they seem to get dealt nothing playable, hand after hand after hand. Finally, the frustration pushes them past the tipping point and they feel compelled to play just about anything in order to get in on the action. Just as knowing the odds can put bad beats into a better perspective, knowing your odds of being dealt certain hands can help you here too.

For example, the chances of you being dealt two aces are 1 out of 221 times. If you're curious, this is how you figure this out. Your chance of the first card coming to you is 4 out of 52. Do you understand why? Because there are 4 aces out of the 52 possible cards. After getting this first ace, the chances of getting another are 3 out of 51 (the three remaining aces out of 51 remaining cards).

So you multiply 4/52 x 3/51.

You can reduce 4/52 x 3/51 to get 1/13 x 1/17, which equals 1/221.

How about your chances of getting any ace-king combination? First you figure out your chances of the first card being an ace or a king. That is 8 out of 52. What about the second card? Well, if the first card was an ace, then there are four kings to complete your desired hand. Or if the first card was a king, then there are four aces. Either way, your chances of that second card completing your ace-king combo is 4 out of 51.

So you multiply 8/52 x 4/51.

You can reduce to 1/6.5 x 1/12.75, which equals 1/82.875

So your chance of getting any ace-king is 1 out of almost 83.

It should be evident to you that it's not so bizarre for you to go hours without getting a real strong hand like AA, KK, QQ, or even AK. Be patient, the cards will all come eventually. Try to remember all those fluke times when you've been dealt pocket aces three or four times in one session. That's well above average luck, but I bet you didn't jump for joy and kiss the dealer just because you received pockets aces once every three hours.

Reset Your Goals

Ideally, your goal should just be to always play your best and let the results sort themselves out. You should never even need to count your chips at the table (except to keep track of your table image and how that relates to your playing decisions, and to make sure you aren't short-stacked.) For many people, though, this is impossible.

You are so programmed to be results oriented, that you are obsessed with your bottom line. Alright, let's deal with it. If you've been losing, you must change your goals. Tell yourself that this is just one of those days that every professional player can expect to regularly have. Let's say you are down $1000 playing $15-30. Your new goal is to just get back to being down $800. No need to gamble it up in the hopes of getting even. Just keep playing solid and a good pot or two will get you to your new goal.

View Your Results As Relative To Your Luck

If you average making $300 a day, normal fluctuations will cause you to have significant swings one way or the other. If you are experiencing bad enough luck (poor starting cards, missed draws, many bad beats, etc.), even your playing expertise will not be able to make you a winner for that particular session. Totally understandable. In these situations, just view your results as being relative to the luck you've been having. For example, if you are down $300, you could tell yourself, "Wow, I've been having something like negative $500 worth of bad luck. A typical player would be down that $500 or even more if they were dealt my cards. I'm playing so well that I'm only down $300. My expert playing ability really saves me a bundle on these bad luck days." Now you can view your results for what they really are. A reflection of your superior play. Just because you're losing, doesn't mean you're not playing perfect poker.

Stop Loss

In the money management section, you remember that I conceded that if you can't control yourself psychologically that you should utilize a stop loss strategy. It can't be set so close to zero that you often hit it or else you won't play enough hours to sustain your career. But if you can't control your play once you've lost a certain amount, you must admit your weakness and go home. Mike Caro often writes about a "threshold of misery" where once you've lost a certain amount, any dollar more that you lose doesn't feel any worse psychologically so you just keep losing and losing without additional pain snapping you out of it. This is a very powerful concept. You must train yourself to recognize this point in yourself. And deeply understand another truth that Mike Caro also frequently mentions which is that every dollar you lose has exactly the same value as every

dollar you win. So if you are down $800 and think that being down $1000 is almost no different, you're wrong. It is exactly as important as when you are down $100 on a particular day and get yourself back up to being plus $100 for the day. Of if you are just even at the start of the day and finish with $200 at the end. That $200 is exactly the same $200 in all three situations and can be spent by you in the future in exactly the same way.

Take A Walk

If you aren't in need of such a dramatic step, how about just sitting out a round and taking a walk around the card room or step outside for some fresh air. Just this small action can really interrupt your negative thought patterns.

Chapter 39
Dealing With Bad Weeks

Take A Couple Of Days Off

If you have a losing week, particularly if you have lost every single day that you played over that week, you may want to consider taking a couple of days off. The time away from the table can really clear out your head and give you a fresh start. It is much easier after some time away to feel like you are starting from scratch instead of digging yourself out of a deep hole.

Check Your Game

A week of losses can start to affect your game in ways you don't really even notice unless you are very vigilant. Lowering your starting hand requirements or unprofitable chasing are easy to spot and correct. But becoming more passive or gun-shy about betting, raising, and check-raising are less obvious. Try to notice if you are playing differently because you expect your hands to never come in or for someone to always draw out on you. Just because you have had a week of bad beats doesn't mean that there is any greater likelihood of a disproportionate amount of bad luck in the future. Always play according to the actual poker odds, not what your bad luck mental baggage is tricking you into thinking the odds are.

Fake It 'Til You Make It

When you feel like a loser, your opponents sense this. As previously mentioned in the chapter on table selection, this perception by your opponents can dampen your profit potential. Simply as good playing strategy, you should fake that you are feeling lucky. Smile like you're a winner. Put that swagger back in your step. Psychological experiments have been done on depressed people where if they are forced to smile, they actually end up feeling happier. The same thing goes for people who are nervous giving speeches. If they fake being confident, they actually end up feeling more confident. For you, if you fake feeling lucky, you will soon start feeling luckier, or in other words, more optimistic about your expectations. Of course, this will not have any effect over the cards but it will have an effect over your

mind, and lead to sharper, clear-headed poker decision-making. It will also have an effect on your opponents who will sense that they are playing against a strong winning player. And that always has a positive impact on your bottom line.

Have Pride In Being A Pro

Once you have studied enough and gained enough experience, you can consider yourself a pro. Take pride in your self-appointed status. You earned it. Along with this new professional status comes the professional player mindset. You no longer suffer from amateurish thinking. Bad beats? C'mon, that's kid stuff. Pros aren't shaken by that stuff. "It's just poker, baby. I'm a pro now."

Read A Note From You

Dealing with bad luck swings seems a lot easier to handle when you are from the table. Being down one, two, or even three racks is easy to understand if it's just a bankroll fluctuation equation on a piece of paper. Then it really happens to you and it's a whole different story.

- "That's the third time in a row I've had my pocket aces cracked!"
- "Every time that same guy gets there with his damn flush!"
- "I can't win. No matter what hand I get, I swear, I <u>cannot</u> win."

Sound familiar? Just about every player has been there. What if your frustrated, at wit's end, pulling your hair out at the poker table self could talk to your calm, rational, reclining on the couch at home self? In a way, you can. When you are at home sometime in a peaceful mindset, write out a thoughtful, heartfelt letter to yourself about how you should react to bad luck at the poker table. Really inject your own colorful words and personality into the letter. Mention how you should feel and think at these moments. Scold yourself, comfort yourself, whatever your personality dictates. Then fold that valuable letter (so valuable, it could probably be carved in a gold tablet and still pay for itself) and stick it in your wallet. The next time you feel as if you've been struck by a bolt of lightning from the sadistic poker

gods, pull out that letter. You'll probably get a chuckle when you read it. Your words will help transport your unhinged frame of mind back to that grounded self you were when you wrote it.

Listen To A Message From You

Maybe even more powerful than reading your own words is hearing them. If you regularly bring a walkman or mp3 player with you when you play, make a cassette, cd, or mp3 of yourself talking to you just like in the written letter. If you don't know how, ask someone you know who is electronically savvy. It's not hard. This recording and/or the letter could really save you a fortune if you do it. Don't put it off. Set this book down right now and do it. I'm serious. Right now! Anyone can at least write the letter easily enough.

It's All One Long Session

In the money management chapter, you learned how ridiculous it is to fixate on the results of one particular day because it is such an arbitrary construct of a session. The same goes for a week. In the long run, who cares what your results were specifically from April 8th to the 13th, or for November 12th through the 19th. Does the casino give you matching money for what you earn these particular days? As long as your results don't reveal a new underlying flaw in your game, it doesn't matter when they occur. So if you've lost $2000 this week, you can just look at it as you're just up $1500 so far this month, or $32,000 for the year, or $194,000 over your career. It's really insignificant in the long run and absolutely meaningless as to which particular days you lost which amounts of money.

Stop Win

If you cannot cope otherwise psychologically, then a stop win money management technique may be required. After many losing sessions in a row, you may feel doomed. You'll start to believe that for some unknown reason (maybe you offended the poker gods), you just can't win. The next time you start off a session up by any noteworthy amount, just quit. Go home. You can log a win in your record book. You can sleep on the fact that your losing streak is now officially over. You aren't doomed after all. It's just bad luck that you've been having, not a full-fledged curse.

♦ ♣ ♥ ♠

Chapter 40
Dealing With Bad Months

Get Real First

As you've learned from the bankroll section, you can have a losing month even if you are a winning player. But don't misinterpret this fact to assume that it necessarily applies to you. Let me be perfectly clear about this. If you have a losing month, especially in cash games, you are probably a losing player. Particularly if you don't have a long history of winning results at the limit you've been playing. You should always first suspect that there may be something wrong with your play. And even if you do have a long history of winning results, you should still suspect that you might be at fault. A simple rule of thumb is the converse of our legal system. If you have a losing month, you are *guilty until proven innocent*.

If You Don't Have A Long Winning History

1. Drop down in limits immediately regardless of the size of your bankroll. You are probably not ready for these games yet.
2. Assess your current mental state. If you are feeling doomed, take some time off. Work on ways to improve your psychological outlook.
3. Reread your favorite poker strategy books and figure out if you've been making any major mistakes.
4. Sadly, you may want to seriously consider giving up your poker dreams. Maybe you just don't have the drive, dedication, and discipline required for it. Or maybe you have a gambling problem that consistently prevents you from playing the way you know you should. As I've stated before in this book, professional poker is not for everyone. Many people would be much better off treating poker as an occasional recreational hobby.

If You Do Have A Long Winning History

1. Ask yourself if you've had any major life stressors recently. If you have, you may want to consider taking some time off from the game. Time off is also a good idea if just this bad luck streak has become a major stressor for you.
2. Check your bankroll to make sure you still have enough to play at this limit.
3. Double check your game to make sure that this bad streak hasn't caused you to play less aggressively than strategically optimal.

A Bad Month Can Also Be Your Friend

If you are confident that you haven't been responsible for your month-long negative results (and remember that it is human nature to be in denial about your lack of poker playing skills), you should embrace the phenomenon of long losing streaks. If it wasn't possible to have bad months, there would be very little chance of professional caliber players ever going broke. Because you have learned proper bankroll management, you will never go broke, but other pros will. This is the poker gods' way of thinning out your competition. This possibility of extreme fluctuations due to mere luck is also the way that horrible players can sometimes amass very large bankrolls. Bad players with big bankrolls mean huge future profits for you. And if the poker gods are devious enough to make a bad player win consistently for a month, especially when he's first introduced to the game, they will have hooked this poor sucker on poker for life.

Poor Sucker: "Of course I'm a great player. I won for a month straight when I first started playing in April of 1978."

Mark Blade: "Okay, brainiac, then how do you account for the subsequent decades of consistent losses?"

Poor Sucker: "Oh those? That's just because I've had the worst bad luck streak in history."

Phone A Friend

If you want to be a poker millionaire, then phoning a friend is probably your best lifeline. If you have a supportive friend or family member, they may be able to lift your spirits. Especially someone who is poker savvy enough to understand the nature of fluctuations. It's strange how you can totally understand that you have a chance of losing so many big bets merely due to bad luck, yet when it happens, your logical brain turns to mush. "Why, why, whyyyy meeeee?" Step away from the table, pull out your cell phone, (and if it's not too late at night) call your friend or family member right then and there. A few words of encouragement could save you thousands of dollars if it prevents you from going on tilt.

Use Every Mental Trick In The Book

A month or longer of losses, especially if they are quite consistent and large, can really knock you off your feet. Read self-help books. Try meditation and yoga. Listen to Tony Robbins tapes while you play if you believe in him. Change casinos. Don't change your underwear. If you think it will help you, it probably will because so much of your play is affected by your mental state. Whether you admit it or not, you are probably responsible for at least a portion of your losses. To quote the music group The Smiths, the pain from a prolonged losing streak is "enough to make a shy, bald, Buddhist reflect and plan a mass murder."

Final Thoughts On Dealing With Bad Luck

I've just scratched the surface on this topic. Like I already mentioned, *Professional Poker 2* covers many different and additional mental tricks you can utilize to always stay on top of your game. That book also covers in detail all the many different things you should focus on at the table to elevate your game that aren't just related to dealing with the psychological effects from losing. Many things that most players never consider, and lots of things that have certainly never been written about in any form of poker literature.

The main lesson I want you to take away from this section is that you should be giving a lot of attention to improving your mental and emotional control at the table, and not just focusing on improving your playing strategy skills. Achieving expertise in either of these facets is worthless if you do not have a firm grip on the other.

♦ ♣ ♥ ♠

SECTION 6
ADVANCED POKER
STRATEGY TIPS

♦ ♣ ♥ ♠

♦ ♣ ♥ ♠
Section 6 Introduction

In this section, you will find twenty different poker strategy tips. Although this book was never intended as a comprehensive poker strategy book like *Professional Poker 3* is, I felt you deserved some tips as an added value. For complete poker strategy, please refer to the previous chapter "Study The Textbooks."

I have mostly included concepts here that the average player either doesn't know or doesn't emphasize enough in his game. Even if you are already a pro, I doubt that you will know all of them. And even if you did, reviewing them again wouldn't hurt.

They aren't arranged in any particular order of importance, although some are much more important than others because they come up more frequently during your play. And they aren't generally grouped into any meaningful categories. Just think of these as some profit icing that you can spread on your poker cake.

♦ ♣ ♥ ♠

Chapter 41
Twenty Advanced Tips

Players Who Muck Their Bluff

Some players, especially some frequent bluffers, will regularly muck their bluffing hands if you call them on the river. By muck, I mean that they will toss their hole cards unseen into the dealer's discard pile. This is because they are either embarrassed that their bluff attempt didn't work or just so resigned to their obvious loss that they just want to quickly move on to the next hand. But look at the opportunity this provides you.

If you were just drawing to a flush, let's say, and didn't get there on the river, you have a choice to make if heads up against a "bluff mucker." If he bluffs frequently enough, you may want to call him. Even though you have <u>nothing</u>! In fact, your call is actually a counter-bluff. Normally, the only way to bluff someone who has already bet into you is to raise him. That is a very risky proposition as your bluff costs you two big bets in limit poker and at least the size of the previous bet in no-limit. Many opponents who have already bet on the river cannot stand to fold for just one more bet in limit or even in no-limit if the pot is big enough in proportion to the raise. But calling a bluff mucker only costs you one bet, yet accomplishes the exact same thing as a bluff raise. If done against the right players, it is a move that can win you many pots over your career.

There are two additional pieces of advice that go with this. One is that if he does have a hand and begins to reveal it after you've called him, you should then muck *your* hand. You do not want to show the bluff mucker that you were just calling with your nine high. If another player insists on seeing your hand and you can't muck it in time, you might want to pretend that you misread your hand and thought you had a pair or something. Otherwise, the bluff mucker might catch on and never muck his hands like that anymore. Also, a lesson you should take away from this is that you should never muck your own hand when your bluff bet fails until your opponent has shown you the winning hand. Otherwise you could fall prey to someone like me who knows how to handle bluff muckers.

Bluff Raises On The River

In the last topic, I touched on full (two big bets) bluff raises in limit poker on the river. I mentioned that this is risky. Let me state it again here so you didn't miss my point. It's very risky! Only the best players with the most advanced player and card reading skills can utilize this play profitably. Yes, there are side benefits when you get caught. You may get future calls from observant players on those times when you raise on the river with the winning hand and they would not have otherwise called. Or you may get future calls in other situations just because you've shown an unpredictable, somewhat reckless side to your game. But these benefits still usually don't make this type of play profitable, especially considering that there are benefits to not being pegged as a bluffer in that you can steal many entire pots with this solid reputation. This bluff raise on the river is so rarely profitable, even for most discerning pros except at the very high levels, that if you never tried it for the rest of your career, I would not object.[51] And if you are ever tempted to bluff re-raise in limit poker, please seek medical attention. You would need an almost foolproof tell on the previous raiser to even think about it.

Never Slowplay In Suspicious Situations

Slowplaying, although often overused, definitely belongs in your poker arsenal. One time you should almost never slowplay, however, is when your opponents would suspect you of bluffing anyway. For example, you have pocket fives on the button and the flop makes you a set. If everyone checks around to you, don't check in hopes that people will catch up a little. Bet, because many opponents will think you are just bluffing. This may seem like common sense, but I see many skilled pros on slowplay autopilot with certain hands. It's not just the hand, it's the situation. When opponents are already suspicious of you, play fast.

[51] Let me be perfectly clear here. I'm not saying that a bluff raise is never a profitable play. I'm just saying that the vast majority of players, and even most pros, do not have the skill to identify these specific situations. Therefore, they'd be better off abandoning the idea entirely.

Don't Bluff Someone Who Is Short-Stacked

This is advice for cash games, not tournaments. In tournaments, especially near the bubble or when people are hoping to move one more notch up the payout ladder, bluffing a short-stack is often recommended. But in cash games, most players who are already invested in the pot, and only have a bet or two left will almost always call with even the most foolish of hopes of taking down the pot. They have usually lost so much at this point that they don't care anymore about that last bet or two. So don't ever bluff them, but value bet (bet when you believe you have the best hand) everything. This is just one reason why you should keep a rough track of how many chips each of your opponents has on the table at all times.

Beware Of The Bluffer Who Checks

If there is a very aggressive player or bluffer who raises pre-flop, particularly from later positions, and then checks it on the flop, run for the hills. Unless you've seen this odd sequence before and know otherwise, it should be obvious to you that he actually has something quite strong. If the player had nothing or something minor, he'd surely follow up his pre-flop show of strength with another show of strength. Remember, no one bet into him on the flop. If he doesn't bluff now, he'd have to turn his Bluffers Of America membership card in and resign in shame.

Chronic Bluffers Are Not Always Pre-flop Bluffers

One mistake that even observant players make is pegging a bluffer as a bluffer across the board. It is very easy to notice an opponent who bluffs like crazy and then get it stuck in your head that you should always be suspicious of this player. Let's say that on some hand, he raises before the flop. You look down and see that you have AJ. Normally you'd fold this against a pre-flop raiser. But c'mon, not against this guy. You decide to call or raise. This would be correct except for one important thing you forgot to notice. All those times you caught him bluffing before, it was on the flop, turn, or river. He hasn't raised before the flop even once in the past hour. You would be making a big mistake if you didn't notice this fact. Do not just peg

an opponent as a bluffer. This is too simplistic. You must take it to another level and decide exactly what kind of a bluffer he is.

Don't Bet On The River Just Because You Have The Best Hand

This is a concept which almost all beginners, and even a surprising number of professionals, don't have a solid grasp on. On the river, if they aren't considering a check-raise, most players go on autopilot. They decide between two options. If they think they probably have the best hand, they bet. If they fear they may not have the best hand, they check. But there is much more to it than that. You must not bet just because you think you have the best hand <u>now</u>. You should only bet because you think you'll have the best hand <u>if called</u>. There's a world of difference between these two. Let me explain. Let's say that you have Q♥6♦ (you played this trash because you were in the big blind). The board has come out Q♣9♣4♠-A♦-2♥. Your opponent has never shown any strength, so you guess that he was probably on a straight or flush draw. You figure your hand is probably good, so you think you should bet. But wait. What hands would your opponent call you with? He's a good player so you know he doesn't usually call with just anything. If he calls you, you should be very worried. Why would he call unless he probably has at least an ace or a queen? And your kicker is only a 6, so if he has a queen, he probably has you beat. This is what you should be thinking about. Do you still probably have the best hand <u>if he calls you</u>? Absolutely not. So don't bet. On the other hand, against bad players, who call too much regardless of what they suspect you might have, betting is often the right decision for you.

Now if you are first to act and are against someone who you know will bet (regardless of what he has) if you show weakness by checking, then go ahead and check. If you bet, he might fold his bad hands and certainly call (and possibly raise) with his good ones. By checking and calling, you accomplish three things. First, you get the same amount of money from him as if you had bet and he called with a lesser hand. Second, you don't risk being raised if he has a strong hand. And third, you also get money from him when he has a weak hand. Checking and calling is a no-brainer against this aggressive type of player. All this advice doesn't cover everything you should be considering on the river, but it's a nice start.

Calling On The River: Why Intermediate Players Can Be Better Than Both Beginners And Very Experienced Players

Most beginners call too much on every round including the river. But when these beginners start getting serious about wanting to improve their game, they start to give up on some of these long-shot prayers. On the river, they may correctly begin to realize that their missed flush draw is not going to hold up even if they do have a pair of twos. So they smartly choose to not payoff their opponent's river bet. But then they read an expert poker strategy book. They learn the correct lesson that you should call on the river if you think your chances of having the best hand are greater than your pot odds.[52] But this can be a very dangerous lesson. Now every time there are 9 big bets or more in the pot, it is easy for even an experienced, and otherwise very skillful player, to start thinking, "Well, I know I'm probably beat, but I only need to have a 10% chance of having the best hand to justify a call. I'm sure there is at least a 10% chance that he's bluffing so I'll call." Yes, there are *often* situations where there is at least a 10% possibility that your opponent is bluffing. But not *all* situations. Not by a long shot. Learn to recognize those situations where it is extremely unlikely that your opponent could be bluffing. Then save yourself a bet on the river, even if the pot is rather large.

Marginally Profitable Bluffs Can Hurt Your Profitability

A concept that many experienced players are aware of is that bluffs don't always require a great probability of success to be profitable. This is true. However, the underlying theory is often misunderstood. Many players evaluate a bluffing decision based on the current hand only. If the odds of the bluff succeeding exceed the pot odds, they attempt the bluff. That's it. But that's only part of what your decision making should be. You should also consider the effect on your table image should your bluff attempt fail.

[52] Assuming you are last to act.

Every time you are caught bluffing, your future chances of succeeding with a bluff are decreased.[53] There is a counter effect in that it will also increase your future chances of succeeding with value bets. But, overall, at least in limit poker, dampening your future bluffing opportunities usually outweighs the potential upside from future value bets.

A Tale Of Two Straight Draws

You can have an open ended straight draw on the flop when your hole cards are 10-9 and the flop includes an 8 and a 7. You can also have an open ended draw if your hole cards just include a 10 and the flop is 9-8-7. Many players play these two hands almost identically. Yet their differences are almost night and day. The latter situation where you have only 1 hole card involved is much weaker for three reasons. First, you can get your straight and often have to split the pot with another player (or even two or three others). Second, you can make your straight and lose it to another higher straight. And third, if you hit your straight, you may get very little additional action because the board will frighten everyone as they can obviously see the simple straight possibility. How great is the difference between these two types of straight draws? So great that in certain situations it might be right for you to fold with the 1-hole card draw, while you would have raised with the 2-hole card one.

One card flush draws also suffer for the same reasons, although to different degrees depending on how high your flush card is.

The Speed Of Bluffing

When someone bets unusually fast compared to his regular speed, there is an increased chance that he is bluffing. Not necessarily a probable chance, but certainly greater than you would otherwise have pegged him for. On the other hand, if he takes an unusually long amount of time to bet, he is rarely bluffing. Not just a decreased chance, but a remote one.

[53] This assumes that future hands are played against at least some of the same players, which is usually the case in most playing situations.

How To Counter The Effect Of Luck On Your Table Image

The luck you are having has a tremendous effect on how your opponents perceive you, even though it shouldn't. When you are winning, they will fear you. So take advantage of this by bluffing more. When you are losing, they won't fear you. So value bet more.

Flush Draws Revealed #1

Players often give away the fact that they haven't yet completed their flush draw. If three cards of a particular suit are present on the flop or turn and your opponent checks his hole cards, you can be pretty certain that he does not yet have his flush. He would've remembered if he had two of the same suit. The reason he's checking is because he has two different suited cards and can't remember which suits they were. This fact is fairly well known as you could've probably realized this with just your common sense. The real lesson here is that you should memorize your hole cards so you don't have to double check them. This double checking gives away a lot of information to your opponents and in situations other than just flush draws.

Flush Draws Revealed #2

This tip is the more advanced one that I really wanted to share with you. Because of the fact that players without a flush often check their hole cards, you should take advantage of this. If you are playing against observant players and you have already *completed* your flush, double check your hole cards. These opponents will think you are just on a draw. You can now play your flush nice and fast against them as they will think you are just betting on the come (semi-bluffing). On the river, when you show them you always had the flush, they will kick themselves because you tricked them. Don't gloat by commenting on any of this. Just realize that they picked up on your sneaky move.

Flush Draws Revealed #3

Now you have your observant opponent set up perfectly to pull the rug out from under him again. Wait for the next time when a third suited card hits the board and hopefully just you and this player are still in the pot. Now, even though you only have one (or even none) of that particular suit in your hand, double check your hole cards. Do it in a slightly exaggerated way. He will think that you are trying to pull a fast one on him again. You can now bet as a bluff and he will probably throw his hand away, thinking that he's so smart to have caught you trying your sneaky move again. Little does he know that you have been playing him like a fiddle.

Mike Caro On Feigning Bets #1

A very common tell, that Mike Caro probably popularized and that you can often help base your betting decisions on, is when an opponent to your left pretends that he is about to bet or call your bet when it is still your turn to act. This is a classic tell example of acting strong when he is actually weak. If you were going to bet, don't let his projected willingness to call scare you out of betting. That's probably what he wants you to be scared out of doing. In fact, even if you weren't going to bet, you may want to consider it now.

Mike Caro On Feigning Bets #2

This is a lesser known, but just as valid idea that I believe Mike Caro first came up with. You should not be feigning calls to discourage a bettor that you would call anyway. First let me state that if you are going to <u>fold</u> if he bets, then go ahead and do anything you think will keep him from betting. This is the only way you are going to have a free chance at the pot as you have already decided you won't call if he bets. Remember though, that against players who are aware of the advice in the previous topic, feigning a call may not help prevent your expert opponent from betting, but may actually encourage it. For most opponents, however, your projected willingness to bet or call may slow them down.

Now let's get back to this tip about if you were going to call anyway. Let's think about this. If he has a very strong hand, do you think he's

going to be scared by your posturing? No. He's going to bet his full house regardless of what you might do. The only hand you are likely to discourage him from betting is a weak hand or a bluff. If you are going to call him, then you probably have at least a fairly strong hand that can beat these hands. So you are only going to cost yourself money by feigning a call or bet when you were going to call anyway. Actually, there is something you should consider feigning – a fold. This will actually encourage a bluff that you would welcome. There is one exception. If you have a very strong reason to believe that your opponent probably has you beat <u>and</u> you were going to call anyway for pot odds reasons <u>and</u> you know that he loves to check-raise hands on the river, then you may save yourself some money by feigning a bet. He will check, planning on going for the check raise and you can then just check behind him. But having all three of these requirements at the same time does not occur very frequently.

Feigning A Fold As A Bluff Raise

Earlier I admonished you against going for bluff raises, although, I did admit that very skilled players know when to use them in those rare profitable situations. This is one of them.

It is a precise situation that comes up from time to time. You are on the river in last position with two opponents. The first player is either a frequent bluffer or someone who you have pegged as probably having a weak holding on this particular hand. The second player is skilled and observant. The first player bets. The second player stops to think for a while. It's obvious what is going on. He, like you, suspects that the first player is weak. He would call if you weren't in the pot or if he knew you would fold because it would be worth it to show his hand down against the first player. But he worries that if you have a hand worth calling with, then he himself is probably beat and so he shouldn't waste his money. Here's what you do. Act as if you are getting a little restless or impatient waiting for him to act. Maybe shift in your seat or something. Then, after another second, feign in a noticeable way that you are going to toss your hand away once it's your turn to act. This will finally trigger him to act. He'll call. Then you place your cards firmly back in secure territory, grab your chips and <u>raise</u>!

Both your opponents will instantly think that you were trying to snow them. That you had a monster hand the whole time and were just baiting the second player into calling so you could get more chips in the pot. They'll fold their cards, impressed by your sneakiness and also their astute observation skills. Only you know that they weren't that astute, as they just observed exactly what you wanted them to.

Advertising Is Overrated

Many so-called poker experts recommend that you should sometimes bluff with the intention of getting caught just so that future bets will get paid off. This is bad advice for a couple of reasons. First, as a great poker player, you will recognize many opportunities when it is profitable to try a bluff. By profitable, I do not mean that you necessarily have a <u>probable</u> chance of pulling off your bluff. You could, for example, only have a 25% chance of pulling it off. But if the pot is offering you better than a 3 to 1 payoff, then it is a profitable bet.[54] Anytime you make a bluff attempt, you can advertise at no additional cost. For example, if you get called, your bluff attempt will be revealed, thereby providing your advertisement. Also, if you don't get called, you can just turn your cards over and show the table that you were bluffing. With all these opportunities to advertise that don't cost any additional money than what you were already planning to spend, why throw money away to advertise? It's ridiculous. Also, semi-bluffs provide almost the same opportunity. Many opponents will not distinguish between a semi-bluff and a full-on bluff. So when your semi-bluff either hits or misses, they will notice that you did, in fact, bet when you didn't really have a hand yet. That's advertising.

In limit hold 'em, I believe the most profitable style of play is one where your opponents think you are less prone to bluff then you really are. So in limit, I would recommend that you never go out of your way to advertise by showing off your successful bluffs. The only player who should show off a successful bluff is one who almost never bluffs. But interestingly enough, the players who most often show off their successful bluffs are those who bluff the most.

[54] Disregarding the potential long-term downside of marginally profitable bluffs mentioned earlier.

They are just training their opponents to call them more often, which is a very profitable thing to do against a frequent bluffer. So if you bluff a lot, you are shooting yourself in the foot by showing off this fact.

In no-limit, it's an entirely different story. Players who are thought to be frequent bluffers can often win a lot of money when their opponents call down their large bets, hoping to catch a bluff but finding a strong hand instead. So you will see some top players on TV often revealing their successful bluffs to their opponents. This is not a mistake on their parts. They are setting up these opponents for future bets when they usually have the goods. The difference is that in limit being known as a *non-likely* bluffer enables you to take down some big pots with a *bluff*. In no-limit, being known as a *likely* bluffer enables you to take down some big pots with a *value bet*.

Calling Is Not A Bad Word

Many years ago, the average poker player was not aggressive enough. He called too much in situations where he should have raised or folded. Today, the opposite is becoming true. Some poker experts are going so far as to suggest that you should only have two moves in your poker arsenal when faced with a bet – either raise or fold. This is absurd. Calling is a tactic that still has its place in many playing situations. In fact, as your opponents become more aggressive, there are even more times when you should be just calling. For example, against an aggressive opponent who has position on you, it is often most profitable to check and call the entire way, as opposed to leading out betting or check-raising. Also, when you are in certain positions in the calling order with certain draws, like to a nut flush, you should often be just calling to get a larger field in so that you can get more bets in on the turn and river. Many draws want a large field. Folding or raising would be the two least profitable moves you could make.

If you rarely just call, contrary to current popular opinion, you are making a big mistake, and leaving a lot of potential profit on the table.

Index

D

E

F

G

muck advice, 272

V

W

T

Y

Z

Upcoming Books by Mark Blade

Professional Poker 2: *The Mental Game*

This book teaches some of the most neglected lessons in all of poker. Learn how to achieve total mental and emotional control when you are at the table so that you are able to consistently play your "A" game. Other sections of this book cover exactly what you should be thinking about at the table. What should you be concentrating on? What should you be noticing about the way your competitors play? All these topics and many more will help you to perfect your "mental game."

Professional Poker 3: *Strategy & Theory*

Learn all the major concepts of poker playing strategy, with examples primarily from no-limit hold 'em, limit hold 'em, and tournaments. This book introduces many ideas and profit-boosting tips that have never before been found in poker literature.

Mark Blade's Website: MarkBlade.com

- Receive updates on all Mark Blade's books.
- Sign up for the free Professional Poker newsletter.
- Be the first to know when upcoming books are available so you can get a jump on your poker competition.
- Discover tips and articles specially reserved for his web visitors.
- Find lists and reviews of the poker books by other authors that Mark Blade recommends, including links to internet retailers that sell these books at discounted prices.
- Find poker software or other poker products that can enhance your professional playing abilities or experience.
- Discover valuable poker resources that every poker pro can benefit from.